THE CASINO OF PIUS IV

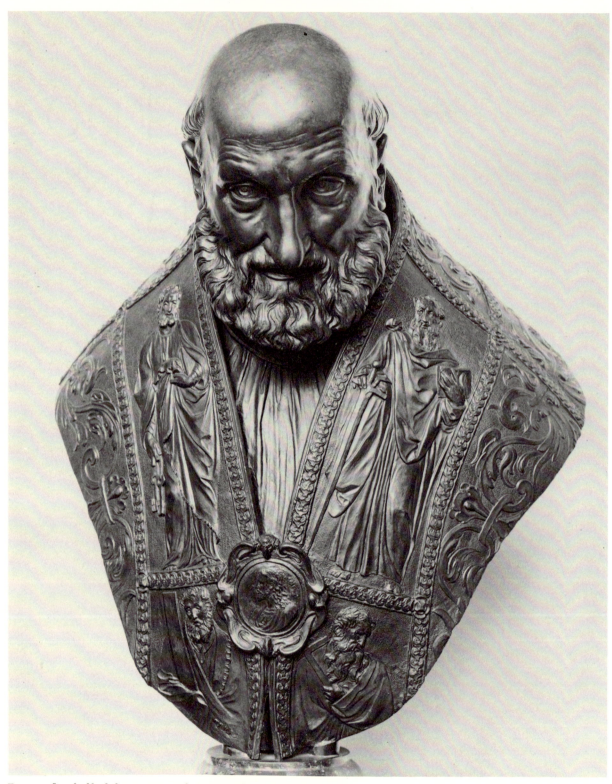

Roman, first half of the seventeenth century, *Pope Pius IV*. London,
Victoria and Albert Museum. Crown Copyright

GRAHAM SMITH

# The Casino of Pius IV

PRINCETON UNIVERSITY PRESS

Copyright © 1977 by Princeton University Press

Published by Princeton University Press, Princeton,
New Jersey
In the United Kingdom: Princeton University Press,
Guildford, Surrey

ALL RIGHTS RESERVED

Printed in the United States of America by
Princeton University Press, Princeton, New Jersey

*Library of Congress Cataloging in Publication Data*

Smith, Graham, 1942–
  The Casino of Pius IV.

  Bibliography: p.
  Includes index.
  1.  Stucco—Italy—Vatican City.    2.  Mural
painting and decoration, Renaissance—Vatican City.
3.  Mural painting and decoration—Vatican City.
4.  Symbolism in art—Vatican City.    5.  Vatican
City. Casino di Pio IV.    I.  Title.
N6920.S54      726'.5'0945634      76–3017
ISBN 0–691–03915–1

*To Marianne*

# CONTENTS

# LIST OF ILLUSTRATIONS

# PHOTOGRAPHIC SOURCES

Pirro Ligorio's *Pan* and *Panisca*, Figs. 9 and 10, are reproduced by gracious permission of Her Majesty Queen Elizabeth II

Alinari, Florence   Figs. 3, 4, 5, 7, 8, 15, 16, 17, 18, 24, 29, 30, 33, 34, 35, 36, 39, 40, 41, 42, 46, 47, 48, 49, 50, 56, 59, 61, 62, 63, 64, 71, 72, 78, 79, 80, 87, 88, 89, 90, 91

Archivio Fotografico, Monumenti, Musei e Gallerie Pontificie, Vatican City   Figs. 51, 52, 82, 83, 84, 85, 86

Archivio di Stato, Turin   Figs. 11, 12, 13, 14

Biblioteca Apostolica Vaticana, Vatican City   Fig. 28

Bodleian Library, Oxford   Fig. 44

British Museum, London   Figs. 6, 26, 27, 38

Colnaghi, London   Fig. 58

Detroit Institute of Arts   Fig. 55

Fototeca Unione, Rome   Fig. 43

Gabinetto Fotografico Nazionale, Rome   Figs. 32, 57

Gabinetto Fotografico, Soprintendenza alle Gallerie, Florence   Figs. 31, 51a, 53a-b, 54a-e

Graham Smith, St. Andrews   Figs. 19, 20, 21, 22, 60, 65, 66, 67, 68, 69, 70, 73, 75, 76, 81

Metropolitan Museum of Art, New York   Fig. 37

Staatliche Museen Preussischer Kulturbesitz Kupferstichkabinett, Berlin (West)   Fig. 52a

Victoria and Albert Museum, London   Frontispiece

# PREFACE

DESCRIBED by Burckhardt in *Der Cicerone* as "the most beautiful resting place for the afternoon hours which modern architecture has created," the Casino of Pius IV is a small but exceptionally complex monument. Built by Pirro Ligorio for two radically different popes, it contains two decorative programmes which at first appear to be opposed to each other. On the one hand there is the antiquity of the stucco decoration; on the other there is the Catholicism of the fresco decoration. The unity of Friedlaender's monograph on the Casino stems partly from the fact that that book has a clearly defined hero—Federico Barocci. Paradoxically, however, the precision of Friedlaender's focus blurs one's image of the Casino. One needs only to turn the pages of the account books of Pius IV to realize that Barocci was only one—even if a prominent one—of an astonishing number of painters, mosaicists, *scarpellini*, and *stuccatori* employed to decorate Pius IV's Casino. This book has no dominant character, and there is no single figure who inhabits all its pages, unless it is Pius himself. If the characters and concerns seem to change from chapter to chapter, I hope that this may reflect to some extent the complicated process of the construction and decoration of the Casino of Pius IV.

One of the dangers in dealing with a sixteenth-century multi-media piece is that at different stages in the writing almost every facet of it threatens to overwhelm the whole. Like some gases, art-historical topics seem to have the property of expanding to fill any given space. With this in mind, I set certain limits on this book at the beginning, and have tried to resist its subsequent attempts at expansion.

This study began in seminars taught by Professor David R. Coffin at Princeton University in 1967. In an earlier version it formed part of my doctoral dissertation, submitted to the Department of Art and Archaeology at Princeton University in December 1970. In a slightly different form, chapters 3 and 4 were published in *Zeitschrift für Kunstgeschichte* in 1974. I am grateful to Dr. Margarete Kühn for permission to publish that material again here.

I am deeply indebted to the Pontificia Accademia delle Scienze for allowing me frequent access to the Casino of Pius IV, and am especially grateful to Cavaliere F Colelli who invariably made my visits easy and enjoyable.

I should like to thank Professor Coffin once more for his gentle guidance in preparing the dissertation and for his kindness in many other respects. I am grateful too to Professor John R. Martin for his advice on earlier drafts of my text and for his help in many other ways. Professor Felton L. Gibbons read my dissertation very closely, and I appreciate his many valuable suggestions. Dr. Erna Mandowsky read the sections on the stucco decoration, and I am indebted to her for a number of help-

ful suggestions. I should also like to thank Dr. Harald Olsen for his generosity in responding to questions concerning Barocci. Finally, I want to thank my friend, John di Folco, who listened to the Casino on long runs in the countryside around St. Andrews. He was good enough to take this handicap in his stride, and I am deeply grateful to him for his company and criticisms.

Miss Alison Harvey Wood corrected my translations from Ligorio's manuscripts in Naples and Oxford, and saved me from more errors than I like to remember. I am greatly indebted to her. I am also grateful to my wife, Marianne, who translated Christian Elling's *Villa Pia in Vaticano* for me. I should also like to thank Mary Laing and Lewis Bateman, of Princeton University Press, for their interest in my manuscript and for the thoroughly agreeable manner in which they brought about its metamorphosis into this book.

I am deeply indebted to two institutions whose financial support made it possible for me to spend extended periods in Italy. Princeton University nominated me Porter Ogden Jacobus Fellow for 1968–1969; and the Canada Council awarded me a Research Grant which enabled me to return to Italy during the summers of 1970 and 1971. I am also grateful to the Department of the History of Art at the University of Michigan for allowing me the time needed to write the final version of this book.

In the course of my research, I received help from the directors and staffs of many libraries and collections. The Archivio di Stato in Turin, the Biblioteca Apostolica Vaticana, the Biblioteca Nazionale in Naples and the Bodleian Library at Oxford allowed me to study their Ligorio manuscripts, and arranged to have microfilms made. The Archivio di Stato in Rome was equally helpful in connection with the account books for the pontificate of Pius IV. The Gabinetto Disegni e Stampe degli Uffizi and the Kunsthistorisches Institut generously provided oases of calm and peace in Florence during many summers. Finally, I should like to thank Miss F. Oldach of Princeton University's Marquand Library, where this study was begun, Mrs. I. Longobardi of the Library of the American Academy in Rome and Miss M. J. Dwyer of the Fine Arts Division of the Library of the University of British Columbia, where my dissertation was written, and Mr. D. MacArthur of St. Andrews University Library, where this book was completed.

St. Andrews
1 December 1974

THE CASINO OF PIUS IV

# INTRODUCTION

Pirro ligorio's Casino of Pius IV (Figs. 1–3) was the last in an extraordinary series of papal villas built between the end of the fifteenth century and the middle of the sixteenth. Set in the Vatican gardens to the west of the Belvedere Court, it had, and, as the seat of the Pontificia Accademia delle Scienze, still has a curiously ambivalent relationship to the Vatican complex. The Casino is within easy reach of the Vatican Palace, it overlooks the west corridor of the Belvedere Court, and occasionally it is almost in the shadow of the dome of St. Peter's. In spite of this, the Casino maintains a tantalizing reserve, and, in many respects, remains remote from the environment which surrounds it.

This elegant seclusion partly explains why so little has been written about the Casino of Pius IV. (N.B. In the context of the present study, "Casino" refers to the architectural complex as a whole, and "casino" refers to the accommodation block opposite the loggia.) Walter Friedlaender's classic monograph on the building and its decoration was published in 1912, and it remains the only comprehensive study of the complex.[1] However, a great deal has happened to the Casino in the meantime, and, even if nothing substantial has been written about the structure itself, a great deal has been written about the sixteenth century, and this is bound to affect one's view of the building and its decoration. Apart from this, Friedlaender himself would have been the first to admit that his treatment of the Casino of Pius IV had a special emphasis. *Das Kasino Pius des Vierten* developed from Friedlaender's interest in the "light coloured ceiling frescoes" by Federico Barocci,[2] and one of the book's three chapters is given over to a discussion of Barocci's activity in Rome and his work in the Casino in particular. In fact, the history of the construction of the Casino of Pius IV is by no means clear, and the place of the building in the history of sixteenth-century Italian villa architecture needs to be brought up to date and redefined.

However, there is one aspect of the Casino of Pius IV which needs to be defined and described for the first time. Friedlaender made no attempt to interpret the decoration of the building. He did not ask why particular figures and scenes appeared rather than others, and, in a number of cases, he did not even identify the subjects represented. In the intervening sixty years, the desire to discover programmes has become so strong that, perhaps regrettably, it has become unthinkable that the fresco and stucco decoration of the Casino could be simply decorative. In this case, however, it is worth emphasizing that the drive to interpret stems partly from the setting itself.

[1] *Das Kasino Pius des Vierten* (Kunstgeschichtliche Forschungen, III), Leipzig.
[2] W. Friedlaender, review of *Federico Barocci*, by H. Olsen, in *Burlington Magazine*, cvi, 1964, 168.

3

When one sits in the oval *cortile* of the Casino of Pius IV, the stucco decoration is almost within reach, like books in a study or prints on a drawing room wall, and, as is the case with books and prints, one is drawn to study them, reading titles, selecting a volume, or deciphering a subject. Beyond this, the commemorative inscriptions and those which identify particular figures confirm that one was expected and intended to *read* the decoration and interpret its significance. If the subjects and the allegories occasionally appear obscure, this was surely part of their attraction and challenge, and extended the personal and private character of the building itself.

That the allusions were intended to be shared, even if only by a very select audience, is indicated by the inscription on the façade of the casino (Figs. 4, 5). This records that Pius IV dedicated the building and its amenities to his own use and to that of his successors:

PIVS · IIII · MEDICES · MEDIOLANEN · PONT · MAX ·

HANC · IN NEMORE · PALATII · APOSTOLICI · AREAM ·

PORTICVM · FONTEM · AEDIFICIVMQVE

CONSTITVIT · VSVIQVE · SVO ET SVCCEDENTIVM

SIBI PONTIFICVM · DEDICAVIT · ANN · SAL · M · D · LXI

The stucco decoration of the Casino of Pius IV was certainly designed by Pirro Ligorio himself. Ligorio's preparatory drawing for one of the arched panels in the central section of the façade of the casino is now in the British Museum (Fig. 6),[3] and, even if this drawing had not been preserved, there are numerous relationships in style and motif between figures on the Casino and other drawings by Ligorio. For example, Mnemosyne, in the right-hand tabernacle on the façade of the loggia (Figs. 7, 8), is very similar to Ligorio's *Figura Stolata* in his treatise on Roman dress, preserved in the Biblioteca Nazionale in Naples;[4] and Aurora, in the pediment of the loggia, compares closely with Ligorio's drawings of Lucifera and Latona Puerpera in another of the Naples manuscripts.[5] In the Royal Library at Windsor Castle there are two drawings, representing a Panisca and a Pan (Figs. 9, 10), which may record Ligorio's early ideas for the decoration of the garden façade of the loggia;[6] and in the Archivio di Stato in

[3] 1962—4–14–1. Pen and brown ink, 140 x 103 mm. Philip Pouncey purchased the drawing for the British Museum in 1962 (Sotheby's Sale, 21 February, lot 180). The drawing was then attributed to Peruzzi. Mr. Pouncey connected the drawing with the Casino of Pius IV and reattributed it to Ligorio. The drawing was first published by J. A. Gere, "Some Early Drawings by Pirro Ligorio," *Master Drawings*, IX, 1971, 241 and n. 9.

[4] MS XIII. B. 2, fol. 49r.

[5] Illustrated in E. Mandowsky and C. Mitchell, *Pirro Ligorio's Roman Antiquities: The Drawings in MS XIII. B. 7 in the National Library in Naples* (Studies of the Warburg Institute, XXVIII), London, 1963, Pls. 13b and 29a.

[6] A. E. Popham and J. Wilde, *The Italian Drawings of the XV and XVI Centuries in the Collection*

Turin there is a group of drawings of caryatids (Figs. 11–14), similar to those at the corners of the second story of the loggia.[7]

In the years immediately after the completion of the Casino of Pius IV, Pirro Ligorio completed a series of archaeological and encyclopaedic manuscripts which are now preserved in the Biblioteca Nazionale in Naples.[8] In fact, Ligorio mentioned the Casino of Pius IV more than once in his manuscripts, although he made no allusion to his own responsibility for it. One reference occurs at the end of a description of the *Luccia Telesina Altar* which is now in the Vatican Museums. Recording the sixteenth-century provenance of the altar, Ligorio mentioned that it was found in Rome, was moved to the *vigna* of Pope Julius III, and was brought ultimately into the *boschetto* of the Vatican Palace, "to have it at the nymphaeum of Pope Pius."[9] The third volume in the Naples series of manuscripts is particularly important for the interpretation of the stucco decoration of the Casino of Pius IV. The title page explains that the manuscript deals with various sacred themes, with the images and ornaments of the gods,

---

*of His Majesty the King at Windsor Castle*, London, 1949, Cat. Nos. 397 and 398. D. R. Coffin, "Pirro Ligorio and the Villa d'Este" (unpublished Ph.D. dissertation, Princeton University, 1954), II, 23–24 and n. 72 associated the Windsor drawings with the Casino of Pius IV.

[7] Eight in all, the drawings form part of a bound volume of drawings by Ligorio (MS J. a. II. 17, fols. 20r–27r). D. R. Coffin, "Pirro Ligorio and Decoration of the Late Sixteenth Century at Ferrara," *Art Bulletin*, XXXVII, 1955, 167–185 published a number of other drawings from this volume. The drawings of caryatids are close in style to the Pan and Panisca at Windsor Castle, and can also be associated in a general way with the stucco decoration of the Casino. The figure on fol. 20r (Fig. 11) compares generally with Veritas in the left-hand tabernacle on the court façade of the loggia; the figure on fol. 21r (Fig. 12) resembles a caryatid which once decorated the inner face of one of the piers on the second story of the garden façade of the loggia (see below, chapter 1, n. 27); the curious way in which the figure on fol. 22r (Fig. 13) holds her left hand resembles the gesture of Mnemosyne in the right-hand tabernacle of the court façade of the loggia; and the manner in which the figure on fol. 26r (Fig. 14) grasps a fold of her dress in her right hand connects her generally with the Ionic caryatids at the corners of the second story of the loggia.

[8] MSS XIII. B. 1–10 (hereafter NBN, MSS XIII. B. 1–10). The illustrations and related text of volume seven are published in an exemplary manner by Mandowsky and Mitchell, *Roman Antiquities*. Also see E. Mandowsky, "Some observations on Pyrrho Ligorio's drawings of Roman monuments in Cod. B. XIII. 7 at Naples," *Rendiconti della Pontificia Accademia Romana di Archeologia*, XXVII, 1952–1954, 335–358. Mandowsky and Mitchell, appendix III, 140 write that "Ligorio appears to have compiled Naples XIII. B. 7 in 1553 and to have inserted a few extra items some eleven or twelve years later." For the entire series, see Coffin, "Ligorio," II, 153–158. According to Coffin, "most of the dateable references in these volumes point to the middle of the 1560's as the period in which these manuscripts were written."

[9] NBN, MS XIII. B. 8, 189: "È stata prima questa Ara perata in Roma, nella casa del pergolella orefice et dopo fuor' nella vigna di papa Iulio quarto [sic], et ultimamente, è ridotta nel boschetto del sacro palazzo Apostolico havarne al limpheo di papa pio." Ligorio's drawing of the altar is illustrated in Mandowsky and Mitchell, *Roman Antiquities*, Pl. 29b, and is discussed in Cat. No. 48.

with their origins and with those who first presented them to the world for worship and adoration: LIBRO X. DELL' ANTICHITÀ DI PYRRHO LIGORIO, NEL QVALE SI TRATTA DE ALCUNE COSE SACRE, ET IMAGINI ORNAMENTI DEGLI DII DE GENTILI, ET DELLI LORO ORIGINI, ET DI CHI PRIMALE MOSTRO ALMONDO SYMBOLICAMENTE ADORARLI OREVERIRLI (hereafter *Libro X*). Ligorio's *Libro X* has much the character of the approximately contemporary manuals of mythology compiled by Giglio Gregorio Giraldi, Natale Conti and Vincenzo Cartari,[10] and can be used much as they are. On the other hand, *Libro X* is unique in that it serves as cicerone to a decorative programme which was certainly designed and was almost certainly conceived by Ligorio himself.

Unfortunately, there is no *Libro X* to guide one through the interior decoration of the Casino of Pius IV, and the author of this programme cannot be identified with the same certainty as that of the stucco programme. With the exception of the decoration in the vault of the loggia, four major scenes in the second room on the ground floor and minor scenes in almost all the rooms, the imagery of the interior of the Casino is predominantly biblical. This suggests that the programme was drawn up by a theologian. While there is no proof that Pius himself was the author, his extraordinary identification with the structure and the personal flavour of the programme suggest that he probably outlined, even if only orally, the main themes of the interior decoration.

Vasari named Marcantonio da Mula as coordinator of the fresco decoration of the Casino of Pius IV, and there is no reason to doubt the accuracy of this statement. Although Da Mula is not mentioned in the payments for the Casino, his name does appear in the papal accounts, particularly in connection with the nearly contemporary decoration of the Sala Regia.[11] Moreover, it is clear that his role in that context corresponded to that assigned to him by Vasari in relation to the Casino. Vasari described the fresco decoration of the Casino of Pius IV in his life of Taddeo Zuccaro, and referred to Da Mula as follows: "Not much time passed before Cardinal Emulio, to whom the Pope had given the responsibility, commissioned many young artists (so that the work would be finished promptly) to paint the little palace in the *bosco* of the Belvedere."[12]

Marcantonio da Mula arrived in Rome in May 1560 to replace Luigi Mocenigo as Venetian ambassador. His embassy coincided with dramatic events in the city, and the increasing closeness of his relationship to Pius IV can be gathered from his reports to Venice on the Carafa affair and the preparations for a General Council. On 27 May 1560, Pius commissioned Da Mula to sound out Venice on the possibility of hold-

---

[10] *Ibid.*, 46–47, this point is made in relation to volume seven.

[11] Coffin, "Ligorio," II, 40, n. 148 quotes a payment to Orazio Samacchini for a painting "nella Sala Regia sotto l'indrizzo di Mons.re Ill.mo et R.mo Il Car.le Amulio."

[12] Vasari-Milanesi, VII, 91.

ing the Council in Venetian territory, possibly at Vicenza.[13] In February 1561, Pius showed his confidence in Da Mula even more clearly. After appointing Cardinals Ercole Gonzaga and Giacomo Puteo legates to the Council of Trent, Pius walked towards the Belvedere with Da Mula, and described his hopes and plans for the forthcoming Council.[14] Twelve days after this conversation, in his second creation of cardinals, Pius made Da Mula a cardinal deacon.[15] Da Mula's acceptance of this honour resulted in his disgrace in Venice. He was banished from the Republic, and Girolamo Soranzo replaced him as ambassador in Rome.

Da Mula served Pius IV energetically and conscientiously for the remainder of his pontificate. When Paulus Manutius was summoned to Rome in 1561 to establish what might be described as an official papal press, Da Mula was named one of the officers of the press. In May and August 1563, when envoys were sent to search the libraries of Sicily for codices from which definitive publications might be prepared, their discoveries were to be sent to Da Mula. The natural culmination of this activity came in 1565, when Da Mula was commissioned to set up a central archive for the Vatican, and was appointed Vatican librarian.[16]

Da Mula's continued promotion indicates that Pius IV found him indispensable; and his involvement with the Manutius press and the Vatican library shows him to be eminently qualified to elaborate the programme of the interior decoration of the Casino. Mariano Vittori's edition of the writings of St. Jerome, the first volumes of which were published by the Manutius press in 1564 and 1565, contains a special acknowledgement stating that the publication was in large part due to the constant effort and enthusiasm of Marcantonio da Mula.[17] Late in 1560 or early in 1561, when arrangements must have been made for the decoration of the interior of the Casino, Da Mula must have brought the same attention to Pius IV's project that he later brought to Vittori's edition of Jerome.[18]

---

[13] L. von Pastor, *The History of the Popes from the Close of the Middle Ages*, xv, London, 1928, 184–185.

[14] *Ibid.*, xv, 243 and n. 5.

[15] *Ibid.*, xv, 162. Also see A. Chacon, *Vitae et res gestae Pontificium Romanorum et S. R. E. Cardinalium*, iii, Rome, 1677, 929, no. xi.

[16] Pastor, *Popes*, xvi, 14, 35, 407–409.  [17] Chacon, *Vitae*, iii, 929, no. XI.

[18] H. Olsen, *Federico Barocci*, Copenhagen, 1962, 51, also suggested that Da Mula formulated the interior programme. He also proposed the participation of Pius IV's nephew, Carlo Borromeo, who was created cardinal on 31 January 1560. The latter idea is attractive but difficult to substantiate. The biographers of Borromeo concentrate on his growing sanctity, and emphasize his life after the close of the Council of Trent. For example, eight of the nine books in G. P. Giussano, *Vita di S. Carlo Borromeo*, Venice, 1615, are devoted to Borromeo's activities after the death of Pius IV. Borromeo was also associated with the Casino by March Phillipps, who visualized the meetings of the *Noctes Vaticanae* taking place at the Casino of Pius IV. (See C. Latham, *The Gardens of Italy*, London, 1905, 46.) Giussano, *Vita*, 10, mentioned the *Noctes Vaticanae*, but the passage suggests that the meetings took place in the Vatican Palace.

# The History of the Building

Accord ing to Vasari, the Casino was begun during the pontificate of Paul IV and was completed during that of Pius IV.[1] The earliest reference to the Casino (or something which was to become it) occurs in an *avviso* of 30 April 1558. This tells us that Paul IV had begun a building in the *bosco*, that it was to be "a fountain with a loggia next to it and a few rooms," and that Paul "spends two or three hours there at a time, urging on the masons and labourers like a private person who is building, and between this and the Holy Office and prayers he spends the greater part of the day."[2] A few days later, in a report dated 6 May, the Florentine ambassador made a similar comment, writing that Paul IV was spending "two thirds of his time in the Belvedere, where he has begun a fountain in the *bosco*."[3]

While it is clear that Pius IV inherited the project for the Casino from his predecessor, the relationship between the legacy and what was made of it is more difficult to determine. This being the case, it is all the more tantalizing that one of the earliest references to Pius IV's Casino occurs in a letter written by Don Cesare Carafa to Alfonso Carafa, Cardinal of Naples and one of the nephews of the late pope. In this letter, Don Cesare Carafa gave his account of a long audience which he had with Pius IV on 15 April 1561, little more than a month after the execution of Cardinal Carlo Carafa and Giovanni Carafa, Duke of Paliano. Having first emphasized the affection and attention which Pius lavished upon him during the audience, Don Cesare then described how Pius took him into the Belvedere and showed him all the beautiful things which were there. He continued:

> In particular, he [Pius IV] went to the building, already begun by Paul IV, which he is having constructed in the middle of that pleasant *bosco*. To me this was no small indication of his goodwill towards our family. There he wanted me to see everything minutely, and in particular he showed me

[1] Vasari-Milanesi, VII, 91.

[2] Vatican City, *Biblioteca Apostolica Vaticana*, MS Urb. Lat. 1038, fol. 302v: "Nel bosco ha fatto p[ri]ncipiar una fabrica ch[e] sara una fonte con una loggia à canto et alc:ne c:re doue si ferma 2 ò 3 hore alla uolta solecitando li m:ri et manuali come uno priuato che fabrichi et cerca essa, et l'off:o et orationi passa la maggior parte del giorno." I am grateful to Professor David R. Coffin for this reference.

[3] Friedlaender, *Kasino*, 123, A. 1.

certain medals which he has had cast to put in the foundations; and he wanted me to see the place and the foundation stone which he will put there, and many other particulars of great consolation, which I will keep to describe thoroughly on my return.[4]

Clearly Don Cesare Carafa wanted to believe that the continuation of Paul IV's undertaking somehow symbolized the conclusion of what *il popolo minuto e grande* of Rome had interpreted as a virtual vendetta against the Carafa family,[5] and, perhaps for this reason, his assessment of the activity on the Casino erred on the side of optimism. His references to the foundation stone and the various medals which Pius had had made to place in the foundations in fact make it clear that Pius IV liked to believe that he had started the building afresh, and that probably he had constructed some part of it from the ground upwards.[6]

Unfortunately, the accounts from the pontificate of Paul IV do little to clarify the situation. In May 1558, a payment of 150 *scudi di oro* was made to a "M⁰ Hierᵒ muratore" for work in various parts of the Palace and in the *bosco*,[7] but this is the only payment which can be connected specifically with the Casino. Otherwise, Paul IV's expenditure on the building is absorbed into two general entries which give the total payments for work in the Vatican for the periods 21 May to 30 August and 31 August to 27 November 1558.[8] Beyond this, there is one payment made under Pius IV, to a Domenico Rosselli, for work done in the Vatican Palace and the "new building in the grove of the garden" during the pontificate of Paul.[9]

[4] R. de Maio, *Alfonso Carafa Cardinale di Napoli (1540–1565)* (Studi e Testi, no. 210), Vatican City, 1961, 286: "Et particolarm.te sen'andò alla fabrica che ella fa fare in mezzo à quello ameno bosco cominciato gia di Pavolo quarto, il che mi fu non picciolo argum.to della bonta sua verso la nostra casa. Dove volse ch'io vedessi minutam.te il tutto, et in particolare mi mostrò certe medaglie che ella ha fatto fare per mettere nei fondam.ti et volse chi'io vedessi il loco, et la prima pietra che vi metteria, et molte altre particolarità di gran consolatione, le quale serbo a ragionarne difusam.te al mio ritorno." Professor David R. Coffin kindly brought this letter to my attention.

[5] See Marcantonio da Mula's report on the Carafa affair, published by Pastor, *Popes*, xv, 404–406.

[6] P. Bonanni, *Numismata Pontificium Romanorum*, i, Rome, 1699, 282–283, xix, mentioned the Casino of Pius IV in his explanation of a medal inscribed SVMMI PALATII CVBICVLA. Dr. L. M. Tocci, Keeper of the *Medagliere Vaticano*, kindly informed me that he knows of no medals which might be identified with those mentioned by Don Cesare Carafa. In September 1561, a *Giouanfeder.ᵒ* Bongiouani was paid 138 *scudi* for 690 "medaglie di Metallo di diuerse stampe per metter nelle Muraglie di diuerse fabbriche," and he received a further payment for gilded medals, "Medaglie di Metallo indorate," and three new medals, "I uno con la testa di sua Sᵗᵃ I altro il porto di Ciuitavᵃ e l altro via Pia," in October 1561. (Rome, *Archivio di Stato, MS Camerale I Fabbriche*, 1521, fols. xxxi v and xxxv r.) The Civitavecchia and Via Pia medals are almost certainly those illustrated in Bonanni, *Numismata*, i, 271, xv and xxxiv.

[7] Friedlaender, *Kasino*, 123, A. 2.　　　　[8] *Ibid.*, 123, A. 3 and 4.

[9] *Ibid.*, 123, A. 5. On Paul IV's campaign, also see D. R. Ancel, "Le Vatican sous Paul IV. Contribution à l'histoire du Palais Pontifical," *Revue Bénédictine*, xxv, 1908, 63–65.

In contrast, Pius IV's expenditure on the Casino is recorded meticulously in two volumes which are now in the Archivio di Stato in Rome.[10] The accounts are precise and detailed, and, if anything, confirm one's impression of the essential autonomy of Pius IV's campaign.

Almost all the payments for construction and masonry work date between May 1560 and November 1561, although there are isolated payments recorded as late as March and June 1562.[11] In fact, the fabric of the casino at least must have been complete by the end of 1560. In July of that year there is a payment for travertine for the construction of the staircase,[12] and an inscription at the top of the stairs contains the date 1560; in September and October payments are recorded for window frames for the casino and its cellar;[13] and in August there is a payment of fifty *scudi* for beams for roofing the building.[14] Finally, in November 1560 there is a payment for two antique statues which were to be placed on the façade of the casino (Fig. 4).[15] Payments for paving the *cortile* appear frequently in the twelve months from August 1560 to August 1561.[16] Payments for the stucco and mosaic work of the exterior are made to "Rocco scarpellino da Montefiascone" from 31 October 1560 to December 1562, and the estimate and final payment were entered on 8 September 1563.[17]

Although a payment for perfecting the pool below the loggia (Figs. A, B; Figs. 2, 15) was entered in April 1563,[18] this fountain seems to have been essentially complete by the end of 1560. On 28 June of that year, Domenico Rosselli, who had been paid earlier for work under Paul IV, received 80 *scudi* and 80 *bolognini* as a final payment for work on the fountain "in the *bosco* of the Belvedere."[19] In February 1561, a "M.ro Antonio Scultore" received ten *scudi* for a statue decorating the fountain, and in

[10] MSS *Camerale I Fabbriche*, 1520 and 1521. In the first (hereafter ASR, *CF*, 1520) the payments are collected under the names of the recipients; in the second (hereafter ASR, *CF*, 1521) they are arranged in chronological order, with marginal notes providing references to the other volume. Friedlaender, *Kasino*, 124–132, gave a convenient and accurate break-down of payments under headings covering the various types of work. (For typographical reasons certain abbreviation signs have had to be omitted from my transcripts from the account books. However, spelling has been kept as close to the original as possible.)

[11] ASR, *CF*, 1521, fols. XLV r, 46, 56v.

[12] *Ibid.*, fol. VI v: "per comperar Treuertini per far la scala dell hedifizio del Boschetto e per lauorare un Arme di nro S.ore che ha ad andare in fronte della Loggia."

[13] *Ibid.*, fol. IX v, 183 *scudi*: "per compito pagam.o di 8 finestre grandi da camera e dieci quadrate per la catina di Treuertino." *Ibid.*, fols. XII v and XIV r each records payments for two travertine window frames.

[14] *Ibid.*, fol. VII r: "per comprar Traui per la copritura dllo hedifizio del Boschetto."

[15] *Ibid.*, fol. XIII r, thirteen *scudi* and twenty *bolognini*: "per compera di due statue antiche per metter nella facciata del Boschetto."

[16] Friedlaender, *Kasino*, 126–127, B. VIII.     [17] *Ibid.*, 127, B. IX.

[18] ASR, *CF*, 1521, fol. 71, twenty *scudi*: "per finimento del fonte del boschetto."

[19] *Ibid.*, fol. VI r: "lauori fatti di scarpello alla Fontana del Bosco di Beluedere."

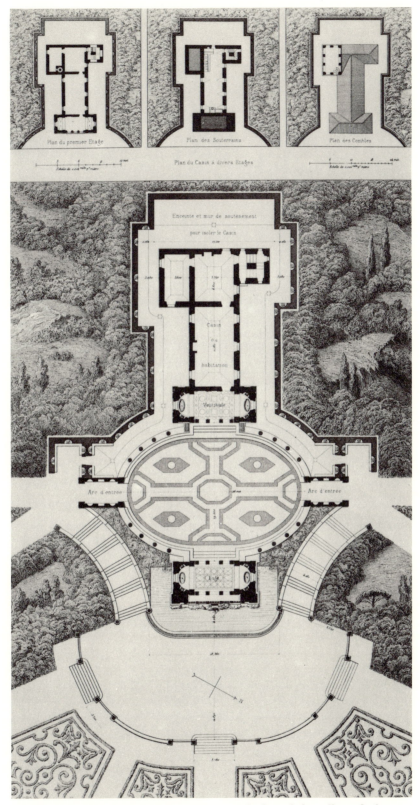

Figure A. The Casino of Pius IV, general plan of the villa and plans of the various levels of the casino. From P. Letarouilly, *Le Vatican et la Basilique de Saint-Pierre de Rome*, III, Paris, 1882, K. 1

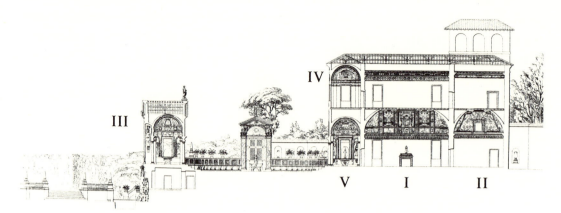

Figure B. The Casino of Pius IV, section through the loggia, court and casino. From P. Letarouilly, *Le Vatican et la Basilique de Saint-Pierre de Rome*, III, Paris, 1882, K. 4

March he was paid a further sixteen *scudi* for "two good antique vessels carved with figures . . . to decorate the fountain of the *Boschetto*."[20] Work on the fountain at the centre of the *cortile* (Figs. 7, 16) extended over a longer period. Although the estimate and final payment were made in October 1563, after a great deal of discussion, the two *putti* were not paid for until August and November 1564.[21]

Although Pius did his best to obscure the fact, there was once a Casino of Paul IV, and one can make some attempt at reconstructing it. The *avviso* of 30 April 1558 provides a brief but precise description of what was intended, mentioning a fountain, a nearby loggia and a few rooms. If one extracts those sections from the Casino of Pius IV, then Paul's villa emerges as a relatively modest structure in which the entrance loggia and ground floor of the present casino were probably separated from an architectural fountain (most likely corresponding to the first story of the present fountain-loggia) by an informal open area. The relationship between Paul IV's casino and the fountain had been rather similar to that existing between the accommodation block and the nymphaeum in the initial scheme of the Villa Giulia, as reconstructed by John Coolidge.[22] There had been no second story to the casino (and no stair tower on its northwest side), no loggia over the fountain, no entrance portals and no formal oval *cortile*.

---

[20] *Ibid.*, fols. XVII v and XVIII r: "per pagamento di due Pili Antichi intagliati con figure 1 uno ouato e l altro quadrato buoni per l ornam° dell opera del Fonte del Boschetto." As Friedlaender pointed out (*Kasino*, 128, n. 3), this payment probably refers to the free-standing fountains in the interiors of the loggia and the entrance portico.

[21] *Ibid.*, fols. 91, 115, 122.

[22] "The Villa Giulia: A Study of Central Italian Architecture in the Mid-Sixteenth Century," *Art Bulletin*, XXV, 1943, 187 and Fig. 16.

12

If this reconstruction is accurate, it is interesting that Pius IV altered and expanded Paul IV's villa in ways which are very similar to the changes made between the early and later plans at the Villa Giulia. That is, Pius added a story to the fountain at the level of the casino, and he tied the fountain-loggia to the casino by means of the enclosed *cortile* and the two entrance portals.

There is evidence of various kinds to support this reconstruction. First, by providing detailed information on the later campaign, the accounts of Pius IV tell us indirectly what Paul IV's building did *not* have. For example, the payment in July 1560 for travertine for the construction of the staircase suggests that the Casino of Paul IV had no upper story (although it does not prove that it was never intended to have one); and Pius IV's inscription at the top of the stairs and the presence of other inscriptions with his name on the lintels of two of the doors of the second story (the door lintels on the first floor bear no inscriptions) tend to confirm that Pius was entirely responsible for the second story of the casino.

The less extravagant appearance of Paul IV's fountain can be deduced from the present character of the fountain-loggia and from the accounts. The loggia (Figs. 15–18) is an exceptionally complex structure, and this complexity is due in part at least to its Janus-like character. The southwest façade (Fig. 7) is a pendant to the façade of the casino (Fig. 4); and the northeast façade becomes the superstructure of the fountain (Fig. 15). The sides of the loggia (Figs. 16–18) have to change step between the three stories of the court façade and the radically different three stories of the garden elevation. As a result, the sides of the loggia have four distinct levels, one corresponding to the first level of the fountain proper, and three corresponding to the levels of the court façade. However, just before the corners of the garden façade the four levels are reduced to three by the insertion of giant pilasters extending from the top of the fountain structure to the corners of the segmental pediments. The giant pilasters are placed over the corner pilasters on the sides of the fountain, and, because of this, the short pilasters and caryatids on the sides of the loggia have no support from the fountain. Conversely, there is nothing over the fountain's other pair of pilasters. Consequently, the loggia is less deep than the fountain structure by slightly more than the width of the giant pilasters. This and the fact that Ligorio aligned his windows over the niches on the sides of the fountain make the windows of the loggia seem to edge towards the *cortile*, giving the impression of a correspondence between the sides of the loggia and those of the entrance portico (Fig. 3).

The existence of two systems on the sides of the fountain-loggia suggests that the fountain and the loggia were in fact two distinct structures, and that the loggia was superimposed upon the earlier fountain. This impression is heightened by the appearance, within the pedimented frame of the second story of the fountain, of the columns, entablature and inscription which constitute the verso of the first two levels of the court façade of the loggia (Fig. 15).

The complex and slightly eccentric character of the loggia is visible evidence of Ligorio's struggle to harmonize the loggia and the fountain, and further supports the idea that the fountain was first planned as a single story structure. There is also some support for this in the accounts. Payment was made on 31 January 1562 for work carried out on ten granite columns for the Casino, and the late date of this entry also suggests that the loggia (which contains eight of the columns) was late in the sequence of construction at the Casino.[23]

There are similar reasons for arguing that the enclosed court and the entrance portals belong exclusively to Pius IV's campaign. Most important, the casino and fountain-loggia are tied into the retaining wall of the *cortile* by projections off the oval into their façades (Fig. A; Figs. 3, 4). The juncture of the retaining wall and the fountain-loggia is especially awkward (Figs. 17, 18). The pilasters on the fountain are slightly higher than the level of the court, and the encircling wall is, in turn, slightly higher than the top of the fountain. Perhaps for these reasons, the space between the loggia and the retaining wall was filled flush with the sides of the loggia, whereas this was not done with the casino.

In contrast to the disjointed relationship between the court and the casino and loggia, the inner faces of the entrance portals follow the sweep of the oval (Figs. A; Figs. 16, 19) with a fluidity which proves that they were designed in precise relation to the enclosed court.

The fact that, between August 1560 and August 1561, there was a clear run of payments for paving the court (with a payment specifically for the entrance portals in May 1561) also implies that the court and the entrance portals date entirely from the campaign of Pius IV.

Clearly, Pius IV's desire for a more ambitious and elaborate villa was the main factor in the expansion of the Casino of Paul IV. However, there may have been practical reasons for the additions too. The Casino is set on a steeply sloping site (behind the casino the hillside is more or less level with the second story of the building, and the court is almost level with the top of the original fountain structure), and the casino covers an area which may have been excavated from the hill itself (Fig. 3). The casino now stands in a dry moat, surrounded by high retaining walls (Figs. 3, 20) which may have been completed only during Pius IV's campaign.

Between October 1561 and February 1562 there were eleven payments (amounting to 450 *scudi*) for excavating earth from the cellar of the *casino*, and there was a final payment (amounting to 205 *scudi* and 89.5 *bolognini*) in June 1563.[24] These pay-

---

[23] ASR, *CF*, 1521, fol. XLIIII r, 248 *scudi* and fifteen *bolognini*: "per pagam⁰ di giornate di scarpⁿⁱ che hanno lauorate le X colone della fabbrica del Boschetto di granito Numidico li quali si pagano in nome di 36 persone che hanno lauorate in dea Opa."

[24] ASR, *CF*, 1520, fol. 78. The total of 655 *scudi* 98.5 *bolognini* includes payments for "opera

ments may record work done to extend or deepen the cellar, but this seems unlikely since the windows of the cellar were already paid for in September and October 1560. More probably, this work was made necessary by a landslip of some kind, and earth may have had to be removed from the area around the casino as well as from the cellar specifically.

Faced with possible problems of this kind, it is conceivable that the addition of the loggia and the construction of the enclosed court were intended partly to prevent any further movement of the site and to consolidate the entire fabric, first by increasing the weight of the fountain building, and secondly by binding the fountain-loggia to the casino and to the retaining wall around it.[25]

There is nothing to suggest that the interior of Paul's villa was to be decorated, but that the existing decoration is entirely due to Pius IV is clear from Vasari, from the accounts and from the decoration itself.

The decoration of the interior of the Casino (Fig. B) began in 1561, by which time most of the other work was drawing to a close. The first payment for painting was made to Pietro Venale in May 1561.[26] Work continued through 1562, and the estimates and final payments were made in June and September 1563. The accounts of Federico Barocci, Pierleone Genga and Santi di Tito were settled on the first date, and those of Giovanni da Cherso, Pietro Venale, Federico Zuccaro and Lorenzo Costa were settled on the later date.[27]

The Casino of Pius IV is one of the best preserved Roman villas of the sixteenth century, and its decoration is remarkably intact. Nonetheless, the Casino has had its share of alterations and restorations, and, before beginning any discussion of the decorative programme, one should first indicate their impact upon it.

Throughout the construction and decoration of the Casino, the accounts record purchases of antiquities to decorate the complex, expenditure on their transportation, and payments for their restoration and installation. The statuary clearly formed an important part of the decoration of the Casino. In many cases, the accounts describe

---

di portar la terra" at sites other than the Casino. In particular, there are references to the "portatura della Terra del cortile grande di Belvedere" (ASR, *CF*, 1521, fols. xxxvii r, xxxviii r, xl r). One entry (*ibid.*, fol. xxxviii v) refers to "uotazione e incrostazione della Cantina del Boschetto."

[25] The preceding reconstruction of Paul IV's structure was first presented in a seminar on the patronage of Pius IV, given at the University of Michigan in the winter term of 1974. I should like to thank the members of the seminar for their suggestions and corrections. The recent discovery that the inscription over the entrance portico once began "PAVLVS IIII" confirms my belief that the first story of the casino belongs to Paul IV's campaign. (See M. Fagiolo and M. L. Madonna, "La Casina di Pio IV in Vaticano. Pirro Ligorio e l'architettura come geroglifico," *Storia dell'arte*, xv/xvi, 1972 [in fact published in May 1974], 237 and Fig. 4. I am pleased to see that Fagiolo and Madonna's reconstruction [237–238 and n. 4] agrees with mine in most respects.)

[26] ASR, *CF*, 1521, fol. xxiii r.          [27] Friedlaender, *Kasino*, 129–132, B. xi.

pieces with a precision which suggests that the entries were drawn up from memoranda written by Ligorio himself. This is true for an entry for May 1561 recording a payment of 100 *scudi* to a certain "Niccolo Scarpellino" for three antique figures for the Casino: "that is, one over life-size figure of Iuventas, seated and clothed in exceptionally fine draperies; and the other two standing, one representing Hygieia or Health, and the other the nymph Dirce who, according to the fable, was changed into a dove." During December of the same year, a further payment was made for two statues: "that is, one life-size, representing one of the Graces; and the other smaller, representing Memory, named Mnemosyne, mother of the Muses."[28] Entries of this kind reflect Ligorio's knowledge and his succinct literary style, and confirm what one would in any case have supposed—that is, that Ligorio selected the antiquities to decorate the Casino of Pius IV, as he did a few years later for the *teatro Belvedere*.

This being the case, the Casino suffered its most significant loss when much of this antique sculpture was removed. Soon after his election, on the grounds that "it did not become the successor of Peter to have such idols in his house," Pius V purged the Vatican of many of its antiquities.[29] He made gifts to the people of Rome and to Emperor Maximilian II, and, in September 1569, gave twenty-six of the Casino's sculptures to Francesco de' Medici, the eldest son of Cosimo I, Grand Duke of Tuscany. The manner in which the statues in the *bosco* and the *palazzina* were acquired for Francesco de' Medici is described in five letters written by Alessandro de' Medici between 9 September and 30 September 1569.[30] In addition, Alessandro added an inventory of the twenty-six statues to his letter of 16 September, and commented on the statues remaining in the Casino as follows: "And it is true that there remain four to half a dozen statues, some of which are high on the façade and others of which are over certain entrances or form part of the fountain, and which *il Sangalletto* said had to stay put. I did not make much of an issue of this because they are pieces of little value."[31] Alessandro de' Medici's raid on the antiquities at the Casino of Pius IV was slightly less successful than he wanted to suggest to Francesco. The Casino still has eight antique sculptures which can be considered part of its fabric, and there are

[28] ASR, *CF*, 1521, fols. xxiii v and xli r: "per inter pagᵗᵒ di Tre statue antiche per lornamᵒ della fabbrica del Boschetto cioè luna di Jouenta che siede grande piu del Naturale uestita di ueli sottiliss. Laltre due in pied luna Hygia o uogliamo dire la Sanita e l'altra Derce Ninfa che fu seconda la fauola mutata in Colomba"; and "per pagameto di due statue antiche cioè una grande due uolte il Naturale di una grazia laltra piu piccola della Memᵃ detta Mnemosine Madre delle Muse."

[29] Pastor, *Popes*, xvii, 111, n. 1 and 110–116.

[30] See A. Michaelis, "Geschichte des Statuenhofes in Vaticanischen Belvedere," *Jahrbuch des kaiserlichen deutschen archäologischen Instituts*, v, 1890, appendix II, 65–66.

[31] *Ibid.*, 66, no. 3: "Et ben [so] vero che ve ne remane da quattro o sei, che sono parte nella facciata alte et parte sopra certe entrate et parte alla fonte, le quali il Sangalletto ha detto che hanno a restare e io non ne ho fatto molto caso perchè sono cosa di pocha stima."

other, more portable pieces set in niches in the loggia and in the entrance portico. The accounts give one a sense of the number of antiquities brought to the Casino by Ligorio, and Alessandro de' Medici's handlist tells one what was purloined from it. However, one is also fortunate in having a detailed inventory of the antiquities at the Casino, prepared in 1566.[32] Not only does this record the total number—fifty—and the subjects of the pieces, but it also gives information as to their original placement. This makes it possible to work out what was where, even if one can never know what it looked like there.

The other major loss to the Casino affected the garden façade of the loggia. Early views of the Casino of Pius IV show four Pan figures articulating the lower level of the fountain-loggia. The Pans are represented particularly clearly in Giuseppe Vasi's engraving of 1761 (Fig. 2), and they are also mentioned in Giovanni Pietro Chattard's description of the Casino, published in 1767.[33] In addition, Vasi's engraving indicates a caryatid on the inner face of the pier at the level of the *cortile*.[34] As Friedlaender mentioned, the Pans were removed in 1824, during the pontificate of Leo XII.[35] The caryatids must have been removed in the same campaign, at which time the piers were extended to overlap the balustrade. An Anderson photograph (Fig. 15) records the appearance of the garden elevation of the fountain-loggia after Leo XII's renovation.

Its present appearance is even less satisfactory. The pilaster-strips which were once faced by the Pans have been refaced with mosaic panels, which, despite the fact that they echo the treatment of the sides of the fountain (Fig. 17), are inappropriate and unsuccessful in this position. As can be seen from Giuseppe Vasi's engraving (Fig. 2), this was originally the most plastic of the various façades of the Casino. Now, the first level of the fountain-loggia has a papery quality, and it appears to be incapable of supporting its superstructure.

[32] *Ibid.*, 60–63 and 62 in particular. R. Lanciani, *Storia degli scavi di Roma e notizie intorno le collezioni romane di antichità*, III, Rome, 1907, "La fabbrica del Boschetto di Belvedere," 217–228, listed the purchases in terms of their provenance. However, not all the sculptures recorded by Lanciani are specified as being for the Casino of Pius IV.

[33] *Nuova descrizione del Vaticano o sia del Palazzo Apostolico di San Pietro*, III, Rome, 233: "alcuni termini di Satiri travagliati con maestria di stucco a guisa di pilastri."

[34] Panini's engraving of the Casino (Friedlaender, *Kasino*, 11, Fig. 6) shows a second caryatid on the other pier. One of the caryatids is clearly represented in a section of the Casino, *Spaccato per il largo*, in the Royal Institute of British Architects in London. This and two other drawings of the Casino in the same collection were probably drawn in the eighteenth century for an English *amateur*. (See Coffin, "Pirro Ligorio," II, 23–24, n. 72). The caryatid's pose compares with that of one of Ligorio's Turin drawings (Fig. 12). J. Bouchet, *La Villa Pia, des Jardins du Vatican, Architecture de Pirro Ligorio*, Paris, 1837, Pl. III, and P. Letarouilly, *Le Vatican et la Basilique de Saint-Pierre de Rome*, III, Paris, 1882, Pl. 2, also show the caryatids.

[35] *Kasino*, 10.

The mosaic panels are one of the results of what was the most comprehensive restoration of the Casino of Pius IV. Between 1931 and 1935, some twenty years after the publication of Friedlaender's monograph, a major renovation of the stucco and mosaic decoration of the Casino was carried out by the Direzione delle Sculture.[36] The effects of this campaign are difficult to assess precisely since the published report was quite summary. However, there is a sizeable body of photographs, but no negatives, preserved in the Archivio Fotografico of the Vatican Museums, and from those and the report it emerges clearly that the campaign involved renovation and reconstruction of a thoroughgoing kind. The additions to the stucco were given an artificial patina so that they would tone in with the original decoration. Consequently, the restoration of the stucco is less obtrusive than is that of the mosaics. In addition to the refacing of the pilaster-strips, large areas of mosaic on the sides of the loggia and inside the small entrance portals were entirely redone. However, although this campaign of restoration has affected the quality and style of the stucco panels and mosaics, it has not seriously modified the more literary aspects of the exterior decoration of the Casino of Pius IV. Nonetheless, I have made a point of using photographs taken before this restoration.

The last major event in the history of the Casino of Pius IV also took place after the publication of *Das Kasino Pius des Vierten*. From 1847, when it was reinstituted by Pius IX, until 1936, the Accademia Pontificia dei Nuovi Lincei had its seat in the Casino. This body was replaced by the Pontificia Accademia delle Scienze in 1936. This was founded by Pius XI, who donated the Casino of Pius IV to the Academy, and had an extension added to it by the architect Giuseppe Momo. The new structure continues back from the rear of the casino, and is joined to it by a small, closed loggia (Figs. 21–22). Because the site slopes sharply, the single story of the new building connects directly with the second floor of the Casino. The new structure is planned around a sizeable assembly hall, in which the meetings of the Academy take place. In its general character and design the addition agrees well enough with Ligorio's Casino, and is in any case essentially invisible when one is in the original area of the Casino of Pius IV.[37]

Nowadays one enters the Casino of Pius IV through the new building, and finds oneself first in the rooms of the second story.[38] However, one need only walk down

---

[36] See G. Galli, "Relazione: Nei giardini del Vaticano," *Rendiconti: Atti della pontificia accademia romana di archeologia*, XII, 1936, 341–352.

[37] Information for this paragraph was drawn from *Pontificia Academia Scientiarum: Le Siège*, Vatican City, n.d., 17–27.

[38] It is interesting that an Alinari photograph of the Casino (Fig. 3), taken from the dome of St. Peter's before the additions were made for the Pontificia Accademia della Scienze, shows that even then one could enter at the second story level by means of a bridge thrown over the moat at the rear of the casino. As far as one can judge from the photograph, the door seems to be at

Ligorio's staircase (rather than using the Academy's elevator), pausing if necessary at the resting places that he considerately provided for Pius IV, and pass through the rooms decorated by Federico Barocci, to reach a setting which is largely as it was in the sixteenth century, and which retains the qualities of intimacy and privacy that were built into it then. Sitting in the oval *cortile*, which is surely the most important "room" in the Casino, one can easily persuade oneself that one is among Pius IV's successors, mentioned in the dedication on the façade of the casino (Fig. 5), free to enjoy the setting, or privileged to ponder Pirro Ligorio's elegantly wrought allegories and allusions.

---

precisely the point occupied by the present doorway leading from the modern to the sixteenth-century building.

# The Architectural Sources of the Building

I N view of Ligorio's reputation as an antiquarian and archaeologist, it is not surpris-
ing that relationships between the Casino of Pius IV and the architecture of
antiquity have been drawn many times. In a description of the Vatican Palace, pub-
lished in 1750, Agostino Taja suggested that the Casino derived in large part from the
example of ancient buildings.[1] Ridolfino Venuti was more specific in his guide to
Rome, published sixteen years later. He maintained that Ligorio had copied an
antique villa at Lake Gabino, about ten miles from Rome. According to Venuti, the
ruins of this structure were still visible at the beginning of the eighteenth century.[2] In
an almost precisely contemporary publication Giovanni Pietro Chattard pointed out
that the entrance portals and their winged Fames had antecedents in Roman trium-
phal arches.[3] In contrast to Taja, Venuti and Chattard, in 1837 Jules Bouchet dis-
missed Ligorio's indebtedness to ancient architecture, and stated that the Casino of
Pius IV was a building entirely without precedent.[4]

Friedlaender approached the problem in a more systematic manner than had his
predecessors. He considered sources in antiquity and in the sixteenth century, and
presented the Casino as a highly complex fusion of a wide variety of sources. Fried-
laender connected the oval of the *cortile* with the ellipse of the antique amphitheatre;
he drew relationships between the interiors of the portals and late antique tombs; he
connected the scalloped shells in the arches of the portals with late antique sculpture;
and he compared the loggia, with its caryatids, pediments and *aediculae*, with late
antique sarcophagi.[5]

Naturally the Casino of Pius IV has been compared with antique villas, partic-
ularly Hadrian's Villa at Tivoli and Pliny the Younger's Villa at Tusci.[6] To a certain

---

[1] *Descrizione del Palazzo Apostolico Vaticano*, Rome, 500.

[2] *Accurata e succinta descrizione topografica e istorica di Roma moderna*, Rome, 1766, 501.
According to the T.C.I. guide, *Roma e dintorni*, Milan, 1965, 633, the area occupied by the lake
was reclaimed in the nineteenth century.

[3] *Nuova descrizione*, III, 237.

[4] *Villa Pia*, 23–24. Bouchet wrote that the Casino was "un édifice qui n'avait point d'exemple, ni
chez les anciens, ni chez les modernes."

[5] *Kasino*, 20, 24–25, 36.

[6] *Ibid.*, 15. In a very recent publication, which appeared after this chapter was written, Wolfgang
Lotz connected the Casino with Pliny the Younger's Villa Laurentina, and suggested that the oval

extent these comparisons depend upon similarities in function and intention, rather than clearly defined formal relationships. For example, Pliny the Younger ended the description of his Villa at Tusci by emphasizing its comfortable informality and peaceful privacy.[7] Pius IV's Casino certainly was intended to have similar qualities, and, to this extent, it was bound to echo the antique complex.

However, the connection between the Casino of Pius IV and Hadrian's Villa may be a more tangible one. With interruptions, Ligorio explored and excavated Hadrian's Villa at Tivoli for eighteen years, from 1550 to 1568. He prepared the first complete plan of the complex (Fig. 23), and wrote three separate descriptions of it.[8] Hadrian's Villa at Tivoli was a virtual encyclopaedia of ancient architecture and a natural source of inspiration for the Casino of Pius IV. In fact, it is likely that the so-called island nymphaeum (Fig. 24) was close to the front of Ligorio's mind when he designed the Casino and its decoration. When planning a building as sympathetically involved with water as the Casino of Pius IV is, Ligorio had surely thought of the *luogo delizioso d'acqua* at Hadrian's Villa.[9] The fundamental community of the structures is suggested by the fact that Giovanni Pietro Chattard's observation that the Casino appeared to be surrounded by water[10] can be applied literally to the island nymphaeum. There is also a more circumstantial reason for connecting the Casino with the island nymphaeum. The entrance portico of the casino contains a painted frieze representing a fantastic chariot race, and a similar frieze (in sculpture) once decorated the island nymphaeum. Ligorio certainly knew the frieze at Hadrian's Villa,[11] and he probably selected the non-biblical subjects in the entrance portico and the loggia.

The most sustained and at the same time the most restricted attempt at associating the Casino of Pius IV with ancient architecture is found in a small book by Christian Elling.[12] Since this study has been published only in Danish it may be helpful to summarize Elling's argument in some detail.

Elling believed that the Casino of Pius IV was a miniature reconstruction of the

---

*cortile* of the Casino might be regarded as "a 'literal' copy of the Laurentina court." (See L. H. Heydenreich and W. Lotz, *Architecture in Italy 1400–1600*, Harmondsworth, 1974, 265 and n. 8, 381).

[7] See H. H. Tanzer, *The Villas of Pliny the Younger*, New York, 1924, 25–26.

[8] Coffin, "Ligorio," I, 89–90, and II, 177–180. The most readily available version of Ligorio's plan is that illustrated here, from the *Pianta della villa tiburtina di Adriano cesare*, revised and published by Francesco Contini, Rome, 1751.

[9] *Pianta della villa*, 8.        [10] *Nuova descrizione*, III, 232.

[11] See L. Vogel, "Circus Race Scenes in the Early Roman Empire," *Art Bulletin*, LI, 1969, 158 and n. 38. For copies after drawings by Ligorio of reliefs of this kind, see *Biblioteca Apostolica Vaticana*, MS Vat. Lat. 3439, fols. 52r, 58v and 61r. The middle drawing on fol. 52r copies the fragment illustrated in Vogel's Fig. 17.

[12] *Villa Pia in Vaticano* (Studier fra Sprog- og Oldtidsforskning, No. 203), Copenhagen, 1947.

antique naumachia, the setting for mock sea battles. After reminding us that the forms of hippodromes and stadia were often incorporated into antique villas and palaces, Elling attempted to establish a specific iconographic relationship between the Casino and a naumachia. In the sixteenth century it was believed that the Church of St. Peter stood on the site of the Circus of Nero; and some authorities believed that the Naumachia of Nero was located in the same general area, somewhere within what had been the Imperial gardens and were to become the Vatican gardens. Arguing that the Belvedere Court was inspired in part by the Circus of Nero and pointing out that it perpetuated some of the functions of the antique circus, Elling suggested that the Casino of Pius IV paraphrased the Naumachia of Nero in a similar manner. As Elling put it: "If a circus could be transformed into a palace-court, then it was surely possible for a naumachia to be translated into a villa."[13]

Elling next set out to examine what was known of the form and location of the Roman naumachiae in the sixteenth century. On the authority of Andrea Fulvio's *Antiquitates urbis*, Ligorio placed the Naumachia of Augustus at the foot of the Pincian hill in his 1552 and 1553 maps of Rome and in his *Libro delle antichità di Roma*, published in 1553. In his elaborate perspective map of Rome, published in 1561, Ligorio represented the Naumachia of Augustus on the same site (Fig. 25). According to Elling, Ligorio's Naumachia of Augustus established a type which was followed closely by Dupérac in his 1574 plan of Rome and in a single sheet published at the same time, and provided the basis for a woodcut illustration of the Naumachia of Nero in the 1588 edition of Fulvio's *Antiquitates urbis*.

Having classified the Naumachia of Augustus as the standard type, Elling then turned to a naumachia which Ligorio located in Trastevere, downstream from the Ponte Sublicio (Fig. 26). He described this as a strange and capricious type, and decided to concentrate entirely upon the Naumachia of Augustus. Maintaining that no Roman coin or medal represented a naumachia, Elling decided that Ligorio's Naumachia of Augustus was a product of fantasy, combining details from other oval building types.

Elling concluded that the Casino of Pius IV was a paraphrase of Ligorio's standard naumachia:

> The oval court and the surrounding stone benches echo the form of the basin. The Papal casino on one of the long sides represents the Imperial loggia, and the loggia with its columns, on the opposite side, corresponds to the entrance portico of the naumachia; that it does not function as one here is due to the fact that the garden façade of the loggia is combined with a fountain, a nym-

---

[13] *Ibid.*, 30: "Kunde et Circus omtydes til en Slotsgaard, var det vel antageligt at digte en Naumachi om til en Villa." For this and the following paragraphs, see *ibid.*, 11-38.

phaeum. On the other hand, the smaller portals of the naumachia, at the ends of the oval, do have counterparts in the free-standing portals of the villa. We must acknowledge that it pleased Pirro Ligorio, archaeologist-architect and specialist in the history of the oval form, to give the shape of the naumachia to the Papal summerhouse. The water from the fountain not only suggested a nymphaeum, but also, by association, brought to mind the basin of the arena.[14]

For a number of reasons, Elling's thesis is unconvincing.

Ligorio left no reconstruction of the Naumachia of Nero, and, despite the fact that Fulvio located Nero's Naumachia in the area of the Vatican, he neither recorded nor illustrated a naumachia near the Vatican in his maps of Rome. In fact, in his map of 1561 Ligorio represented a hippodrome (HIPPODROMVS · HADRIANI · AGV ·) on the actual site of the Vatican Naumachia (Fig. 27).[15] The inscription "hoggi di qui e' san pietro" appears within the Circus of Nero; slightly to the north there is an annotation "Qui il palazzo di sanpietro"; and still further north the information "Qui si dice' Beluedere" is inscribed within the grounds of an ancient villa, the VILLA · L · RVSTII ·. Dedicated to Pius IV and precisely contemporary with the Casino, the map of 1561 in fact demonstrates that for Ligorio the Casino of Pius IV neither occupied nor was near the site of a Roman naumachia.

Secondly, Elling's rejection of the Naumachia in Trastevere is entirely arbitrary. In fact, in Ligorio's mind the Naumachia of Augustus and that in Trastevere had equal authority. Both were derived from coins recorded by Ligorio in his *Libro primo delle medaglie de greci* in the Biblioteca Nazionale in Naples (Fig. 28).[16]

Thirdly, the formal relationship between the Casino of Pius IV and the Naumachia of Augustus is rather general. Although four architectural blocks are disposed around the circumference of an oval in each case, the arrangement is a basic and

---

[14] *Ibid.*, 36: "Den ovale Plads med de rundtløbende Stenbaenke gentager Bassinanlaeggets Grundform. Det pavelige *casino* for den bageste Langside repraesenterer Kejserens Logebygning, det modstaaende, symmetriske Loggiahus med dets Søjlefronter svarer til Naumachiens Indgangs-Porticus; at den ikke her kan fungere som en saadan, skyldes den Omstaendighed, at Loggiaens forreste Front er kombineret med en *fontana*, et Nymphaeum. Derimod har Naumachiens smallere Portalpartier for Ovalens Ender deres nøje Sidestykker i Villaens fritrejste Sideportaler ind til Gaardspladsen. Vi maa anse det for godtgjort, at Arkaeolog-Arkitekten Pirro Ligorio, Specialist i agonale Anlaegs Historie, har fundet Behag i at iklaede den pavelige Lystgaard en Naumachis Former. Fontaenens Vande motiverede ikke blot et Nymphaeum, men ledte maaske ogsaa ad associativ Vej Tanken mod Arenaens Bassin."

[15] On Ligorio's large archaeological map of ancient Rome, see Coffin, "Ligorio," I, 46–47. For illustrations of all three maps, see Mandowsky and Mitchell, *Roman Antiquities*, Pls. 73–75.

[16] NBN, MS XIII. B. 1, fol. 405v. The illustration used here is from a manuscript in the *Biblioteca Apostolica Vaticana* (Vat. Lat. 3439, fol. 168v) which contains extracts mainly copied from the Naples manuscripts. On the Vatican manuscript, see Coffin, "Ligorio," II, 158, 1.

predictable one. Distinguishing the Casino of Pius IV from the Naumachia of Augustus is the fact that the portals of the naumachia are tied much more closely to the Imperial loggia than are the entrance portals to the casino. In fact, Elling himself emphasized the sharpness of the contrast between the low wall of the *cortile* of the Casino and the isolated cubes of the casino, loggia and portals.[17] The fact that the present plan of the Casino was the result of expanding and altering an earlier structure also contradicts Elling's belief that it was a miniature reconstruction of an antique naumachia.

Elling's thesis is unsatisfactory for a fourth reason. Although he demonstrated that the circus form was appropriate to the Belvedere Court, Elling did not really establish the relevance of the naumachia to the Casino of Pius IV. The Belvedere Court was consistent with the Circus of Nero in scale, and was in fact used as a setting for celebrations and tournaments in the sixteenth century. (In fact, on one imagined occasion the Belvedere Court itself was transformed into a naumachia. In a fresco attributed to Perino del Vaga, a naval battle is represented in the lower court which had been flooded for the occasion.)[18] The Belvedere Court revived some of the functions as well as the form of the Roman circus, but the Casino of Pius IV neither has the scale of the naumachia nor could it perform its functions. In 1589 the court of the Palazzo Pitti in Florence was flooded, and a naval battle (involving some twenty ships, ranging in size from frigates to galleons) was fought.[19] Quite apart from the physical impossibility of introducing so much as a single ship into the *cortile* of the Casino, salvoes of gunfire, whistling cannon-balls, toppling masts and drowning Turks are as alien to the exquisitely civilized architecture of the Casino as they are appropriate to the massive brutality of the Palazzo Pitti.[20]

Perhaps the most important objection to Elling's thesis is the fact that it exists in a vacuum. Elling was concerned almost exclusively with relationships between the Casino of Pius IV and antique architecture, and it seems that he lost sight of the fact that the Casino was also a product of the sixteenth century. As Elling himself put it:

[17] *Villa Pia in Vaticano*, 11.

[18] J. S. Ackerman, *The Cortile del Belvedere* (Studi e documenti per la storia del Palazzo Apostolico Vaticano pubblicati a cura della Biblioteca Apostolica Vaticana, III), Vatican City, 1954, Fig. 19, Cat. No. 19.

[19] See J. Shearman, *Mannerism*, Harmondsworth, 1967, 110–111, and Fig. 57. The occasion was the marriage of Ferdinando de' Medici and Cristina of Lorraine.

[20] P. Portoghesi, *Rome of the Renaissance*, trans. by P. Sanders, London, 1972, *Villa Pia*, 238–241, seems to accept Elling's thesis (although he does not refer to *Villa Pia in Vaticano*), as do Fagiolo and Madonna, "La Casina di Pio IV," 240–244. Fagiolo and Madonna argue for a complex association "Naumachia-nave-navicella della Chiesa," and Portoghesi also connects the Casino with the bark of St. Peter. This does suggest that the naumachia may be more relevant to the Casino than I had thought; and it parallels part of the argument which I develop in chapters 6–8 in relation to baptism and baptism-related themes.

24

"The Villa Pia demands to be named *the most radically antique work of Italian Renaissance Architecture*."[21]

In fact, as Friedlaender recognized, the Casino of Pius IV has antecedents in sixteenth-century Roman architecture.

In a sense, the Casino of Pius IV is a rustic version of Baldassare Peruzzi's Palazzo Massimo alle Colonne (Fig. 29).[22]

Pirro Ligorio certainly admired Peruzzi's architecture, and it has been shown that he had access to his drawings.[23] Ligorio's study of Peruzzi is perhaps most obvious in his earliest building, the Palazzo Lancellotti at the south end of the Piazza Navona (Fig. 30), a stone's-throw from the Palazzo Massimo. The rather monotonous austerity of the façade of the Palazzo Lancellotti surely reflects the severity of the façade of the Palazzo Massimo. The third story windows of Ligorio's palace are stripped-down versions of those on the *piano nobile* of the Palazzo Massimo, and they rest directly on top of the first story, just as Peruzzi's stand directly upon the Doric cornice of his entrance portico. Finally, Ligorio clearly copied the cornice of the Palazzo Lancellotti from the Palazzo Massimo.[24]

Despite the obvious disparity from the point of view of decoration, the façade of the casino (Fig. 4) does compare with that of the Palazzo Massimo. Both stand on raised bases, both have central entrance loggias under high façades, and both have rather ambiguous upper stories. In each case the entablature of the Doric order introduces a horizontal accent which is strong enough to suggest that the façades are composed of only two stories; and despite the obvious differences, above the colonnades the façades appear to be thin, weightless screens which conceal rather than reveal the natures of the interiors of the buildings.[25] As was the case at the Palazzo Lancellotti, the windows of the casino are simplified versions of those on the *piano nobile* of the Palazzo Massimo; and the stucco frames on the second level of the façade of the casino (Figs. 4, 5) rest directly on the Doric cornice, as do Peruzzi's windows at the Palazzo Massimo.

[21] *Villa Pia in Vaticano*, 37: "Kan Villa Pia vel gøre Krav paa at kaldes *det mest radikalt antikiserende Vaerk i den italienske Renaissances Arkitektur*." A secondary theme in Elling's book is his discussion of the relationships between the fountain-loggia and ancient Roman fountains, such as the Nymphaeum of Alexander Severus.

[22] Friedlaender, *Kasino*, 30.

[23] H. Burns, "A Peruzzi Drawing in Ferrara," *Mitteilungen des Kunsthistorischen Institutes in Florenz*, XII, 1966, 245–270. For further evidence of Ligorio's admiration for Peruzzi, see Coffin, "Ligorio," I, 2. In this connection, it is interesting that Sallustio Peruzzi (Baldassare's son) was Ligorio's second-in-command at the Vatican Palace. Sallustio received a monthly salary of eighteen gold *scudi* as compared with Ligorio's twenty-five (ASR, *CF*, 1520, fol. 20 and fol. xx).

[24] Coffin, "Ligorio," I, 11. For an illustration of the cornice of the Palazzo Massimo, see H. Wurm, *Der Palazzo Massimo alle Colonne*, Berlin, 1965, Pl. 10a.

[25] For sections of the Palazzo Massimo and the Casino, see Portoghesi, *Rome of the Renaissance*, 190–191, 239, and Friedlaender, *Kasino*, 21, Fig. 10.

To some extent the contrast between the extravagant ornamentation of the casino and the almost ascetic restraint of the Palazzo Massimo can be explained in terms of the different functions and settings of the structures. The Palazzo Massimo is an urban palace, and dignity and restraint had been expected of its façade. In contrast, the Casino of Pius IV is a *villa suburbana*, intended for the *boschetto* in the Vatican gardens rather than the centre of the city, and could present a gayer and less formal appearance. In fact, the Palazzo Massimo and the Casino become more obviously similar if one penetrates beyond the formal façade of Peruzzi's palace to the interior of the entrance portico, the passage leading to the court and the court itself. Those were once as richly decorated with stucco and statues as the Casino, and some of this decoration is still visible today. Conversely, the drafted *bugnato* on the sides of the casino (Figs. 3, 20) brings the Casino of Pius IV closer to the apparent austerity of the Palazzo Massimo.[26]

Vasari described the Palazzo Massimo alle Colonne as oval in form.[27] In view of the rarity of the oval or ellipse in Renaissance architecture, this in itself suggests an obvious connection between the Casino and Peruzzi's palace. Although Ligorio's casino and loggia do not bend themselves to the circumference of the oval, as does the façade of the Palazzo Massimo, the inner faces of the entrance portals do follow the sweep of the court. However, the relationships between Peruzzi and the Casino are not restricted to the Palazzo Massimo alle Colonne. In particular, Peruzzi experimented with the oval shortly before 1525 in a project for the Trivulzi villa at Salone, between Rome and Tivoli (Fig. 31).[28] This drawing shows that Peruzzi intended to connect the villa with an oval garden or *vigna* in a way which foreshadows Ligorio's association of the casino and loggia with the oval *cortile*.

As Friedlaender recognized, the Casino of Pius IV is also closely related to the Villa Giulia (Figs. 32–34), an earlier papal *villa suburbana* in which Ligorio himself may have had some part.[29] Certainly Pius had the Villa Giulia in mind during the construction and decoration of his own villa. Building materials, columns and antique sculptures were pirated from Julius III's villa to be used at the Belvedere Court and the Casino;[30] and Pius himself visited the Villa Giulia in September 1561.[31]

[26] On the Palazzo Massimo in general, see Wurm, *Der Palazzo Massimo*.

[27] Vasari-Milanesi, IV, 604, described the Palazzo Massimo as "girato in forma ovale, con bello e nuovo modo di fabbrica."

[28] On the Villa Trivulzi, see C. L. Frommel, *Die Farnesina und Peruzzis architektonisches Frühwerk* (Neue Münchner Beiträge zur Kunstgeschichte, I), Berlin, 1961, 62-64.

[29] *Kasino*, 18, 21, 35. Jacob Hess suggested that Ligorio acted as advisor in the early stages of the Villa Giulia. (See F. L. Moore, "A Contribution to the Study of the Villa Giulia," *Römisches Jahrbuch für Kunstgeschichte*, XXI, 1969, 175, n. 20.)

[30] Pastor, *Popes*, XVI, 243; and Lanciani, *Storia degli scavi*, III, 29 and 221.

[31] Pastor, *Popes*, XV, 86.

Despite the difference in scale, the Villa Giulia and the Casino of Pius IV are very similar in over-all character. Both are suburban villas, although the Casino is placed within rather than outside the context from which it retreats. In both cases the accommodation block is a relatively modest structure, the main focus of which is towards a court or series of courts. Both buildings look in on themselves, and both encourage a sense of intimacy and privacy.

The site of the Casino of Pius IV slopes steeply, while the natural site of the Villa Giulia was virtually flat (Figs. 3, 32). Nonetheless, both structures contain a great variety of ground levels, and they tease the visitor into discovering routes from one level to the next. Particularly at the Villa Giulia, the means of access are often indirect and sometimes concealed. Acknowledging the many differences, the entrance portico and loggia confront each other across the *cortile* of the Casino in much the way that the villa and nymphaeum loggias face each other from either end of the first court of the Villa Giulia (Figs. 2, 32); and the nymphaeum loggia has much the same Janus-like character as the fountain loggia at the Casino, being part of the first court on the one hand and part of the nymphaeum on the other (Fig. 33). From the second story of the casino, the *galleria* (Figs. 2–4) looks into the court and across to the loggia in much the way the second loggia at the Villa Giulia looks into the nymphaeum and across to the *giardino segreto* (Figs. 33, 34). Similarly, from the loggia at the Casino one looks down on the fountain in much the way that one looks into the nymphaeum from the second loggia at the Villa Giulia. In each case the attraction is sharpened by the apparent inaccessibility of the fountains.

In the sixteenth century the Villa Giulia and the Casino of Pius IV had seemed even more alike. Early descriptions and early views suggest that Julius III's villa was once as lavishly decorated with frescoes, stucco and statuary as is Pius IV's Casino. Remnants of the stucco decoration cling to the second loggia (Fig. 33).[32]

Although this is less easily demonstrated, the Casino of Pius IV may also be related to a late fifteenth-century Tuscan villa, Lorenzo the Magnificent's Villa Medici at Poggio a Caiano (Figs. 35, 36). Whether by accident or design, the tripartite arrangement of the court façades of the casino and loggia (Figs. 4, 7) and the combination of the open central sections with closed side sections associate the Casino of Pius IV with a villa type which Ackerman traced to the Veneto and followed to Tuscany (to the Medici villas at Fiesole and Poggio a Caiano) and to Rome (to the Belvedere of Innocent VIII and Baldassare Peruzzi's Villa Farnesina).[33] However, there are also more particular reasons for connecting the Casino of Pius IV with Pog-

[32] On the Villa Giulia, see T. Falk, "Studien zur Topographie und zur Geschichte des Villa Giulia in Rom," *Römisches Jahrbuch für Kunstgeschichte*, XIII, 1971, 101ff.

[33] J. S. Ackerman, "Sources of the Renaissance Villa," *Acts of the Twentieth International Congress of the History of Art, II. The Renaissance and Mannerism*, Princeton, 1963, 6–18.

gio a Caiano. When seen from the Belvedere Court, the loggia and pediment fuse with the façade of the casino in much the way that the pedimented loggia is impressed into the larger façade of the Villa Medici (Fig. 35); at the Casino the architectural fountain provides a base for the loggia in much the way that the arched podium does at Poggio a Caiano (Figs. 15, 35); and the Pan grotto behind Poggio a Caiano (Fig. 36) is an obvious prototype for the Pan fountain at the Casino (Fig. 2). Fluttering ribbons and the Medici coat of arms fill the pediment of the loggia at Poggio a Caiano, and Pius IV's coat of arms (set off by a curtain of drapery tied with ribbons) has a similar function in the pediment of the fountain-loggia. Finally, there may even be a hint of the stucco programme of the Casino in the terracotta frieze at Poggio a Caiano.[34]

It is unlikely that Ligorio had first-hand knowledge of Poggio a Caiano. However, Pius may well have seen it, and it is entirely possible that he had drawings of the villa sent to Rome when work was restarted on the Casino. Earlier in his career Gian Angelo de' Medici had cultivated the Florentine Medici, and he owed his coat of arms to Cosimo I. In the first months of his pontificate Pius IV acknowledged this patronage by making Giovanni de' Medici a cardinal; and in November and December of 1560 he entertained Cosimo I and Eleanora of Toledo in the Vatican Palace.[35] To some extent, Pius IV's obsession with building must have derived from a desire to emulate the Florentine family. In that case the idea of having his Casino echo the villa of the best-known of the earlier Medici becomes saturated with meaning.[36]

Although it is perhaps the most striking feature of the Casino of Pius IV, the stucco decoration has not been given the attention it deserves. Elling stated that the stucco was outside the scope of his study,[37] and Friedlaender gave it relatively little emphasis in his discussion of the sources of the Casino. Friedlaender did point to precedents for the stucco decoration in the architecture of Raphael, in particular the Palazzo Branconio dell'Aquila,[38] but there the stucco was still superficial decoration, applied to the surface of the building rather than being an essential part of it. In contrast, the drawing in the British Museum (Fig. 6) shows that the stucco reliefs were an integral part of Ligorio's design for the Casino of Pius IV. If the stucco decoration were to be removed from the Casino, the structure (like Cinderella) might vanish at midnight.

Rather than attempting to trace the stucco decoration of the Casino of Pius IV to buildings which sported some stucco, one can associate it with a rather different

[34] I am grateful to Dorothy Metzger for this suggestion.

[35] Pastor, *Popes*, xv, 77 and 98–100.

[36] On Lorenzo de' Medici's personal responsibility for Poggio a Caiano, see M. Martelli, "I Pensieri architettonici del Magnifico," *Commentari*, xvii, 1966, 107–111.

[37] *Villa Pia in Vaticano*, 10.          [38] *Kasino*, 16–17.

facet of sixteenth-century architectural decoration, the practice of façade painting.[39] According to Giovanni Baglione, when Ligorio arrived in Rome he was a painter of house façades;[40] and there is evidence to suggest that his style was modelled on that of the most famous of façade painters, Polidoro da Caravaggio.[41]

Polidoro's façade paintings were ranked with works by Raphael and Michelangelo, and a thorough familiarity with his work was a professional necessity for any aspiring façade painter in the first half of the sixteenth century. When Federico Barocci first studied in Rome, he copied antique sculpture, Michelangelo, Raphael and Polidoro da Caravaggio.[42] One drawing in Federico Zuccaro's series illustrating the life of his brother shows Taddeo copying a painted façade by Polidoro. Two others illustrate an episode which Federico recorded in his annotations to Vasari's life of Taddeo. On his way back to S. Angelo in Vado to visit his parents, Taddeo lay down to rest beside a river. When he awoke he fancied that the stones on the river-bed were painted like the façades of Polidoro. Feverishly he collected the finest of them, and staggered home bearing them as gifts to his mother. Finally, Polidoro's was one of the four allegorical portraits included in the series, the others representing Raphael, Michelangelo and Taddeo himself.[43] An important part of Polidoro's attraction was his apparent antiquity, and this had surely appealed strongly to Ligorio at the beginning of his career. In a sense, the vocabulary of antiquity could be studied as conveniently from Polidoro's façade paintings as from the ancient monuments themselves.[44]

By 1560 Polidoro da Caravaggio's type of façade painting no longer had complete authority. Taddeo Zuccaro was a façade painter in a strictly Polidoresque vein,[45] but his younger brother initiated a new and radically different manner in his first independent commission. For the house of Tizio da Spoleto, in the Piazza S. Eustachio

---

[39] *Ibid.*, 17, and Coffin, "Ligorio," I, 37, mentioned the practice of façade painting in connection with the Casino, but neither developed the relationship.

[40] *Le vite de' pittori, scultori ed architetti*, Rome, 1642, 8–9. Also see Coffin, "Ligorio," I, 3.

[41] J. A. Gere, *Taddeo Zuccaro: His Development Studied in His Drawings*, London, 1969, 54, n. 1.

[42] G. P. Bellori, *Le vite de' pittori, scultori, ed architetti moderni*, Rome, 1672, 172.

[43] The originals of this series are in the Rosenbach Foundation in Philadelphia. The drawings were published in a cursory fashion (and three were illustrated) in "Zucchero Drawings," *Connoisseur*, XCIV, 1934, 259–261. The portraits are missing from the Rosenbach series. However, versions of the portraits are in the Uffizi (11016 F., pen and brown ink and brown wash, 295 x 138 mm., inscribed POLIDORO; 11023 F., pen and brown ink and brown wash, 417 x 249 mm., inscribed MICHELAGNOLO BVONAROTI; 11025 F., pen and brown ink and brown wash, 367 x 232 mm., inscribed TADDEO ZVCCARO; and 1341 F., pen and brown ink and brown wash, 304 x 145 mm., inscribed RAFAELLO VRBINO, and wrongly identified as "Il Profeta Isaia" in the Uffizi file catalogue.)

[44] J. A. Gere, "Two Copies after Polidoro da Caravaggio," *Master Drawings*, VI, 1968, 249–251.

[45] Gere, *Taddeo Zuccaro*, 34–43.

in Rome, Federico painted atmospheric and illusionistic pictures.[46] In place of the soberly coloured friezes and relief-like compositions painted by Polidoro, Federico Zuccaro painted in natural colours and introduced landscapes. The dramatic novelty of Federico's façade painting is clear if one compares his *modello* for the *Vision of St. Eustace* (Fig. 37), for Tizio da Spoleto's house, with a characteristic early design by Taddeo (Fig. 38).[47]

Even in the most pictorial of the stucco scenes at the Casino, Ligorio is far removed from Federico Zuccaro's approach to façade decoration. With his antiquarian and classical bent, Ligorio must have seen Zuccaro's new manner as a corrupt form of an antique type of decoration, and, in a sense, one can think of the stucco reliefs at the Casino as his reply, aimed at purifying façade decoration and revitalizing the authentic tradition begun by Polidoro. In fact, Ligorio's antiquity is quite different from Polidoro's. The stucco reliefs on the casino and loggia bring to mind small-scale, private objects (coins, medals and plaquettes) rather than the triumphal friezes and public monuments which were behind Polidoro's façade paintings.

In a sense, Ligorio's reliefs on the Casino of Pius IV complete a cycle. The *grisaille* painting of Polidoro and his followers gave an illusion of sculptural decoration, much as, in early Netherlandish painting, the *grisailles* on the exteriors of altarpieces created an illusion of sculpture. At the Casino of Pius IV Ligorio substituted the comparative reality of the stucco reliefs for the illusionism of Polidoro da Caravaggio's paintings.

[46] On this commission, see Gere, *Mostra di disegni degli Zuccari* (Gabinetto disegni e stampe degli Uffizi, xxiv), Florence, 1966, Cat. Nos. 29 and 30. A drawing for *Justice*, to the right of Pius IV's coat of arms, is in the Krahe Collection. (See *Meisterzeichnungen der Sammlung Lambert Krahe* [Kunstmuseum Düsseldorf, 14 November 1969–11 January 1970, Catalogue by E. Schaar and D. Graf], Düsseldorf, 1969, Cat. No. 22.)

[47] On Federico's *modello*, see J. Bean, *100 European Drawings in the Metropolitan Museum of Art*, New York, [1964], Pl. xx, and J. [A.] Gere, *Il manierismo a Roma* (I disegni dei maestri, 10), Pl. xviii and 83. On Taddeo's drawing, see Gere, *Taddeo Zuccaro*, Cat. No. 105.

# The Iconography of the Stucco Decoration

Four architectural units are arranged around the *cortile* of the Casino of Pius IV (Figs. 1–3). The casino and the loggia face each other across the short axis of the oval, and the entrance portals similarly face each other across the longer axis. The loggia is decorated on all its four faces, and the entrance portals have façades for the approaches to the Casino in addition to those looking into the court. Nonetheless, the richest decoration is directed into the court, and, in the case of the casino, is concentrated exclusively on the court façade.[1]

The sense of growth on the façade of the casino (Fig. 4) is almost as strong as it had been in the *boschetto* which once surrounded the villa. Swags and wreaths of clustered fruits mingle with fluttering ribbons and fruit-bearing branches in an effort to take over the surface of the façade, and acanthuses and grape-bearing vines climb the pilaster strips of the second and third stories. In spite of first appearances, however, this riotous nature in fact submits to a clearly discernible discipline, which extends even to the literally rustic orders. The acanthus pilaster strips are placed above the Doric order of the first story, and the still lighter vines of the third story are placed above the acanthuses, in what amounts to a classical superimposition of orders.

The façade of the casino is organized in terms of units of three. It appears to have three stories,[2] and each of the stories reads horizontally as if it were a triptych. In addition, the central section of each of the triptychs itself forms a secondary triptych.

The entrance portico is guarded by heads of the Gorgon Medusa, emblazoned on the aegis of Athena, and framed by heavy garlands of fruit. The types of the Medusa heads, with their snakes and miniature wings, have direct precedents in antiquity, and also correspond to Ligorio's description of the Gorgon Medusa as "the face of a woman, encircled by two snakes and with wings on her head."[3]

---

[1] Vasi's engraving (Fig. 2) suggests that the sides of the forepart of the casino were once decorated with medallions and frames similar to those on the façade. However, Vasi is inaccurate in other respects, and there is no other evidence to suggest that the stucco decoration extended beyond the court façade.

[2] In fact there are only two stories above ground. (See Friedlaender, *Kasino*, 21, Fig. 10.)

[3] NBN, MS XIII. B. 3, 9: "La Gorgone, che è una faccia di Donna con due serpi che la circundano et le ale alcapo."

Pius IV's coat of arms and the framed inscription are the most prominent features of the central section of the second story (Fig. 5). Two angels almost detach themselves from the façade of the casino in the excitement of carrying the coat of arms heavenwards. This energy may reflect their personal interest in this particular apotheosis. Pius IV's baptismal name was Gian *Angelo* de' Medici.[4] The commemorative and dynastic aspect of this section of the decoration is expanded by the six small coats of arms, all but one of which contain the Medici *palle*. Four of the coats belong to cardinals who owed their elevation to Pius IV, and four belong to members of his immediate family.[5]

The remainder of the central section is filled by two arched panels, one on either side of the frame containing Pius IV's coat of arms. The panel on the left contains two figures whom inscriptions identify as HEGLE and SOLIS. They face each other, and their relationship is strengthened by the presence of a winged cupid who hovers between them, arms outstretched as if to bring the couple closer together. Hegle has a shield, emblazoned with a Medusa head, which she rests on a tall plinth, and her companion has a lyre which he rests on a similar plinth. While Friedlaender made no attempt at identifying the figures, Chattard described the panel as representing Apollo accompanied by Aegle,[6] and this identification is supported by Ligorio's preparatory drawing for the panel, where the inscription reads HAEGLE APOLLINIS (Fig. 6). The right

[4] Angels formed an important part of the decoration and meaning of the Porta Angelica. (See M. J. Lewine, "Vignola's Church of Sant'Anna de' Palafrenieri in Rome," *Art Bulletin*, XLVII, 1965, appendix, 224–229 and n. 140.) They also flank Pius IV's coat of arms on his palace on the Via Flaminia. (See G. Chierici, *Il Palazzo Italiano dal Secolo XI al Secolo XIX*, Milan, 1964, 309.) In July 1560 *Girolamo Scarpellino* was paid "per lauorare un Arme di nro Sore che ha ad andare in fronte della Loggia." (See n. 12, chapter 1.)

[5] Reading from left to right, the cardinals' coats of arms belong to Pier Francesco Ferreri, Carlo Borromeo, Gian Antonio Serbelloni and Giovanni de' Medici. Ferreri, papal nuncio to Venice, was created cardinal on 28 February 1561. The others were elevated in Pius IV's first creation of cardinals on 31 January 1560. (See Pastor, *Popes*, XV, 163 and 98.) Borromeo and Serbelloni were nephews of Pius IV. Giovanni de' Medici was the son of Cosimo I of Florence. When Gian Angelo de' Medici was created cardinal by Paul III, Cosimo invited him to adopt the coat of arms of the Florentine Medici (*ibid.*, 77). For the coats of arms of the cardinals, see Chacon, *Vitae*, III, 889ff., I–III and VII. The personal arms of Ferreri, Borromeo and Serbelloni are joined with those of Pius IV. In the case of Giovanni de' Medici, his arms are identical to those of Pius. For the practice of joining the personal arms and the arms of patronage (that is, those of the pope to whom the cardinal owed his elevation), see J. Woodward, *A Treatise on Ecclesiastical Heraldry*, Edinburgh and London, 1894, 134–135. The coat of arms on the extreme left is that of Federico Borromeo, whom Pius IV appointed Captain-General of the Church, with rank of count, on 2 April 1560. (Pastor, *Popes*, XV, 114.) The coat of arms on the extreme right belongs to a member of the Serbelloni family. It may be that of Gabrio Serbelloni, whom Pius appointed commander of the papal guard, or it may be that of Gian Battista Serbelloni, whom Pius made castellan of Castel Sant'Angelo (*ibid.*, 101).

[6] *Kasino*, 32; *Nuova descrizione*, III, 241.

panel contains three thinly clad, winged females, the closeness of whose relationship is shown by the fact that they stand with their arms around their neighbours' shoulders. Friedlaender simply mentioned this group, and Chattard described the figures as Muses.[7] However, the inscription identifies them as HIRENE, DICE and EVNOMIE.

Ligorio's most elaborate discussion of Hegle, or Aegle, occurs in a description of an antique cameo on which she, Night and Latona were represented. Aegle, "who represents the splendour and beauty of light," carried a round shield, emblazoned in the centre with the head of Medusa. The shield, which Aegle directed against beholders like a mirror, was so dazzlingly beautiful that no one could penetrate it with physical sight, but only with the intellect, "which sees and understands everything." Ligorio completed his description by telling us that Aegle "is a very shapely young woman, dressed in the thinnest of draperies," and that she rests her left hand on her hips.[8] The figure in the stucco panel clearly compares closely with that on the antique cameo. The prominence given to the round shield with its Medusa head corresponds to the emphasis placed by Ligorio on this attribute in his description of the cameo. In addition, the shield confronts us, the beholders, just as it apparently did in the cameo.

Aegle's relationship to Sol or Apollo is left rather vague, if it is mentioned at all, in most of the references to her in *Libro X*. In Ligorio's index to this volume, she appears once as "Egle ninfa" and on the other occasion is listed as "Luce figlia del Sole."[9] However, on other occasions she is identified precisely as Apollo's consort and mother of his daughters, Eirene, Dike and Eunomia, the Hours.[10] That this is her relationship to Sol on the façade of the casino is clearly indicated by the presence of the daughters in the companion panel, but is also suggested by the winged *putto* and by the use of the genitive of Sol (and of Apollo, in the case of the drawing in the British Museum). Despite his effeminate appearance, Aegle's companion is certainly Apollo. Apart from the inscription, the lyre "with which he guides and tempers the celestial harmony,"[11] identifies him securely.

Eirene, Dike and Eunomia make frequent appearances in the pages of *Libro*

---

[7] *Ibid.*

[8] NBN, MS XIII. B. 3, 608: "Hegle, cio è il splendore et bellezza della luce . . . havea il scudo rotondo per che essa per tutto si diffonde et ha nel mezzo il volto di Medusa, come quel scudo sia tanto fulgente per la sua bellezza che percuota nella vista de riguardanti in maniera che nisuno con visiva vista il puo penetrare, se non conlo intelletto che vede et comprende ogni cosa, et questo scudo a guisa di specchio porta in mano rivolto in contra de i riguardanti. Nel resto ella è una giovane molto formosa, di veli sottilissimi vestita, conla mano sinistra appoggiata ai fianchi."

[9] *Ibid.*, VI.                     [10] *Ibid.*, 42, 539, 631.

[11] *Ibid.*, 83: "Li davano la Lyra o vero la cethra, perche con quelli instrumento si significasse il moto con che egli guida et tempera l'armonia celeste."

*X* as "Le Hore," and Ligorio attributed a bewildering variety of roles and meanings to them. Despite this, he seems to have remained undecided as to their parentage. In the index, Ligorio referred to them as daughters of Themis and Jupiter, and Jupiter is described as their father and Themis as their mother on at least two other occasions.[12] More usually, however, Ligorio described the Hours as "daughters of Aegle and the Sun, that is of splendour and beauty,"[13] and this is surely the ancestry intended for them on the façade of the casino. Ligorio gave a full description of the Hours as they were carved on an antique Diana of Ephesus in the Vatican Palace:

> [The Hours] are three very beautiful young women, dressed in exceptionally ornate manner. Two of them have bird's wings. The third has the wings of a butterfly and is crowned with flowers, because she symbolizes Spring. One of the others holds a torch and is crowned with ears of corn, symbolizing the hot Summer season. The third comes close to the others, and is crowned with various fruits and a leafless branch, symbolizing the cold, bare Winter in which fruits are hidden. The Hours are so beautifully clothed in the finest of clothes that they seem to be nude; and each takes the other by the hand, as if to show that they are engaged in a dance.[14]

The figures on the façade of the casino compare fairly well with those described in this passage. All three figures in the arched panel are winged, even if one cannot be sure that one is distinguished by butterfly wings, they wear almost transparent draperies, and are linked together as if engaged in a decorous dance. In addition, Eirene seems to have a headdress of ears of corn, and her companions may once have been crowned with flowers and fruits. Eirene certainly has a bunch of flowers in her right hand, and Eunomia carries what appears to be a garland of foliage of some kind.

The various roles and interpretations given to the Hours in *Libro X* can be gathered into four main categories. The Hours served as guardians of the gates of heaven, in addition to being companions of the Sun on his daily run from east to west.[15] Probably because of this activity, they acquired seasonal and temporal connotations, personifying Spring, Summer and Winter, and symbolizing the Past,

---

[12] *Ibid.*, xi, 41, 43,

[13] *Ibid.*, 42: "Figliole di Egle, et del Sole, cio è del splendore et della bellezza."

[14] *Ibid.*, 44: "Le quali sono tre donne bellissime giovanette, con habito ornatissimo, due di esse hanno le ale di ucello, et la terza di farfalla coronata di fiori pèrche denota esser ella la primavera; una dell'altre tiene una facella et coronata di spiche demostrante la calda stagione estiva, la terza ne viene appresso, coronata di diversi frutti, con un ramo senza foglie, onde denota la freda et calva invernata in cui li frutti sono riposti, et queste sono si ben vestite di sottilissimi panni che paiono gnude, et luna a presa l'altra per la mano quasi mostrando in giro ballare."

[15] *Ibid.*, 177.

Present and Future.[16] According to Hesiod, "all three symbolize divine things. First, Eunomia is Good Law; Dike signifies Justice; and Eirene, the third, is Equity and Peace."[17] Finally, Eirene, Dike and Eunomia had what might be described as an aquatic aspect. "Some have it," wrote Ligorio, "that the Hours have three urns, or three cups, in which they carry the water drawn up into the air by the Sun, their father, and which they pour on to the earth below."[18]

The wings of the second story contain two lugged frames, similar to the frames of the windows on the third story, and two circular medallions, reminiscent of antique coins (Figs. 39, 40). Friedlaender identified the figures in the medallions as *Sileni*,[19] but the fact that each figure supports himself on a vessel from which water flows suggests that they are in fact river-gods. Chattard actually described them as such, referring to "two rivers, one representing the Tiber and the other the Ticino."[20] The introduction of two rivers appropriate to Pius IV is particularly attractive in view of the biographical emphasis of much of the decoration of the central section. Chattard was less specific in his identification of the figures in the larger panels, simply describing them as satyrs.[21] In fact, as Friedlaender recognized,[22] the figure in the left frame (Fig. 39) is certainly Pan, the god of shepherds.[23] Half-man, half-goat, he sits majestically on a rocky throne, his reed pipes ready at his left hand, and his curved staff held like a sceptre in his right hand. Apart from the figure's general appearance, the curved staff and the seven-reed pipes are mentioned by Ligorio among Pan's proper attributes,[24] and the two cup-shaped objects, hanging below the reed pipes, are also appropriate to him. Similar objects appear in close relation to Pan, in a drawing recording an antique altar dedicated to him, in another of the Naples manuscripts.[25] In fact, they represent cymbals or *crotali* (rattlesnakes in modern Italian), rustic instruments used by bacchantes and shepherds, according to Ligorio.[26]

---

[16] *Ibid.*, 43–44, 61.

[17] *Ibid.*, 45: "Significano tutte tre cose divine. EVNOMIE per la prima è la bona legga et Dice, significa la giustitia la terza Irene, che è la Aequita et la pace."

[18] *Ibid.*, 41: "Vogliono alcuni che le Hore habbiano tre Urne, overo tre tazze, con le quali portano l'acque nel'aere tirate dal suo padre sole insù, et le versano qua giù interra."

[19] *Kasino*, 32.

[20] *Nuova descrizione*, III, 240. The Ticino passes through Pavia, where Gian Angelo de' Medici attended university. (See Pastor, *Popes*, XV, 67.)

[21] *Nuova descrizione*, III, 240.   [22] *Kasino*, 32 and n. 2.

[23] NBN, MS XIII. B. 3, 146.   [24] *Ibid.*, 440.

[25] Illustrated in Mandowsky and Mitchell, *Roman Antiquities*, Pl. 13c.

[26] In the Archivio di Stato in Turin are preserved the thirty volumes of an encyclopaedia of antiquity compiled by Ligorio between 1574 and his death in 1583. (MSS J. a. III. 3–16 and MSS J. a. II. 1–16. On the manuscripts, see Coffin, "Ligorio," II, 159–169, and Mandowsky and Mitchell, *Roman Antiquities*, 134–139.) Under the entry entitled CROTALO (MS J. a. III. 8),

The identity of the figure in the right panel is less clear (Fig. 40). Friedlaender suggested that he was Olympos,[27] and referred in particular to two antique groups, supposedly representing Pan with Olympos, which were in the Cesi and Farnese collections in the sixteenth century. In fact, Ligorio himself had described those pieces in a section of *Libro X* entitled DI PAN ET CYPARISSO ET DI SILVANO, and identified Pan's companion as Cyparissus:

Again they represented Pan caressing Cyparissus, as if he wants to free him of unhappy thoughts; and it appears that he wants to teach him to play the syrnx pipes. In Rome there are two very beautiful antique statues, both of the same type, with Cyparissus and Pan seated on a rock, as is that in the great Palazzo Farnese and that in the portico of the lovely garden of Cardinal Cesi in the Vatican. . . . Cyparissus is an exceptionally beautiful adolescent, and although his body is sensual it nonetheless has an indefinable modesty; one leg is slung over the other; he looks downwards, and brings the syrnx pipes to his mouth, holding them with both hands; he has a beautiful face with long, graceful hair, unkempt so that it forms knots and curls like Amor's. Seated beside him, Pan looks affectionately at Cyparissus, holds the pipes out to him with his right hand, and embraces Cyparissus' shoulders with his left. Pan has a goat-like face with a bristly beard and goat's horns. From the waist up he is a muscular man, and below the waist he has the thighs and feet of a goat, as will be said in the proper place. For the rest, being entirely intent on and infatuated by the sensuality of the youth, Pan raises one leg, placing it beside that of his young lover, while leaving the other leg down. On the rock lies Pan's shepherd's staff, knotted and twisted at the top, like that belonging to a guardian of flocks, woods and mountains.[28]

---

Ligorio wrote that the instrument was "usato da pastori, et da Bacchanti, lo quale à suon di zampognalo accompagnavano."

[27] *Kasino*, 32 and n. 2.

[28] NBN, MS XIII. B. 3, 438: "Fecero Pan anchora che accarezzi Cyparisso come che lo voglia levare dal pensiero il dispiacere, et parche gli voglia insegnare a suonare la syringa. Si vedono due statue bellissime antiche a Roma, et tutte due sono a un modo, Cyparisso et Pan assisi in un scoglio come è quello nel gran palazzo della casa Farnese, et nel portico del bello giardino del cardinal di Cesis nel Vaticano. L'una delle quali fu trovata presso le radici del colle Viminale. Sono in questa forma. Cyparisso è un Giovanetto adolescente et bello oltremodo, et la sua bellezza sebene è lasciva ha nise nonso che poco di Vergogna, tiene le gambe sopra poste l'una nanzi dell'altra et riguarda basso et avicina la bocca alla syringa che tiene con ambo le mani, ha la faccia pulcra con cappelli vaghi lunghi et inculti per che fanno nodi et caprioli simile all'Amore. Pan essendogli assedere accanto lo riguarda con affettuoso atto, et le sporge la syringha con la mano destra. Con la sinistra l'abraccia nelle spalle. Pan ha il volto caprino con la barba hispita, con

Although Ligorio's figures are separated by the width of the façade of the casino, they are nonetheless closely related iconographically and visually. Clearly, the figure in the right frame is another pastoral creature. He sits on a rocky seat, plays the syrnx pipes, and has Pan's curved and knotted staff by his side. In fact, the hare which crouches by his feet also associates him with Pan, since Pan was represented playing with such an animal on at least one antique coin.[29] Despite their separation then, the figures in the two lugged frames form a pair, as did Pan and Cyparissus in the Cesi and Farnese groups. While one cannot be certain that Ligorio's Cyparissus ever had the beauty combined with the wantonness of the antique figures, one can perhaps recognize a hint of modesty in his pose, and he certainly does place his mouth to the reed pipes, which he holds with both hands. Conversely, while Pan clearly cannot sling his leg over that of his young lover, his pose in the stucco relief may reflect his active response to the sensuality of the youth in the antique groups. In any case, it seems clear that Ligorio intended the figures in the lugged frames to represent Pan and his lover Cyparissus.

The central panel of the third story of the casino contains two oval medallions and what Chattard described as "a lugged frame,"[30] enclosing swags, ribbons and a precariously tilted vase (Fig. 41). The left medallion shows a revealingly clad, winged female who rushes to the right, giddily poised on a globe; she sounds a horn, and holds a sphere in her left hand. Ligorio described Fame a number of times in *Libro X*, and, although no one description precisely matches another, this figure is certainly she. In the context of a description of an antique cameo—precisely the type of source one would expect for the oval medallions—Ligorio characterized Fame as "a woman dressed in a thin, transparent veil, very short below her breasts, and who appears to be running swiftly away; she has a trumpet at her mouth and wings on her shoulders and feet, indicating her swiftness and the fact that she never stops before she has proclaimed the news with her strident blast to every nation and city."[31] In keeping with this characterization, the figure on the casino sounds her horn so vigorously that five small spheres explode from it, much as balls might scatter from a musket. These

---

le corna di capra, dal mezzo insuso è homo muscoloso, et d'indi inguiso con le piedi et cosce di capra, come si dirra al suo luogo. Nel resto, egli essendo tutto intento et rivolto all lascivia del giovanetto alza una gamba accostandola a quella dell'amato giovane, rilassa l'altra in guiso, et nel scoglio è posto il suo pedo bastone ritorto incima et noderoso, come a protettore delli gregi et delle selve et monti."

[29] See C. M. Kraay, *Greek Coins*, London, 1966, Pl. 18.

[30] *Nuova descrizione*, III, 242: "Un riquadro orecchiato."

[31] NBN, MS XIII. B. 3, 498: "Una Donna vestita di un velo sottile e trasparente succinta sotto le mammelle, dimostrante di correre via velocemente, con una tromba alla bocca, con le ale alle spalle et ai piedi, per che questo denota inlei essere veloce e nei mai fermarsi sinche prima non ha dato annuntio col suo stridente suono a tutti i popoli e città del successo."

are surely intended to suggest the Medici *palle*, as do the fruits on the branches surrounding the medallions, and it is likely that the sphere held by Fame is the sixth *palla*, necessary to complete Pius IV's *impresa*. In an earlier passage in the Naples manuscript, Ligorio described Fame as follows: "Although Fame is nothing but a name borne from the mouths of sundry people to the ears of men, as Tertullian says, nonetheless they also made it a goddess, with wings on her shoulders and on her head, standing on a globe, with the palm in her hand and the double trumpet in her mouth, or, as some others have represented her, blowing two trumpets."[32] This passage accounts for the fact that Ligorio's Fame balances atop a globe, and the substitution of the Medici *palla* for the more usual palm reinforces the personal character of the stucco decoration.

Victory and Fame are natural companions. According to Ligorio, gold statues of Victory and Fame once stood on the Capitol in Rome, together with a figure personifying *Salus rei publicae*.[33] If only for this reason, one would expect the figure in the right medallion to represent Victory. Unfortunately, she does not correspond to any of the descriptions of Victory given in *Libro X*. However, Ligorio did write that Victory was represented in many ways,[34] and there is nothing to prevent this being one of them. In fact, the figure on the façade of the casino is very similar to Victory as she appears on a virtually contemporary Italian plaque in the Kress Collection in the National Gallery at Washington.[35] The Kress Victory carries a laurel branch in her left hand, as does Ligorio's figure, and in her right hand holds high a laurel crown. The Victory on the casino carries a globe, rather than the laurel crown, but this is surely a substitution of the kind described for the Fame.

Vases similar to that in the central frame appear frequently on antique altars, and one which is quite similar in design can be seen on the very altar which Ligorio mentioned as having been brought to the *boschetto* to decorate the Casino of Pius IV.[36]

Finally, two modestly clad women stand in the richly decorated niches on the wings of the third story (Fig. 4). They are certainly two of the antiquities saved from Alessandro de' Medici, but they are difficult to identify since they are distinguished only by their decorousness. Above the niches are lugged frames, identical to that con-

---

[32] *Ibid.*, 486: "Quantunque la Fama non sia altra, che un' nome portato dalle bocche di diversi nell'orecchi degli huomini come dice Tertulliano, nondimeno questa anchora fecero Dea, con le ale alle spalle et alla testa su un orbo con la palma in mano et la tromba doppia nella bocca, overo come alcuni altri hanno fatto che suona due trombe."

[33] *Ibid.*, 486.          [34] *Ibid.*, 486.

[35] See J. Pope-Hennessy, *Renaissance Bronzes from the Samuel H. Kress Collection*, London, 1965, Cat. No. 406, Fig. 411. C. Ripa, *Iconologia*, Rome, 1603, 517, described similar Victory figures on two antique coins. I am grateful to Dr. Erna Mandowsky for this reference.

[36] See n. 9, introduction. For a vase which is particularly close in design, see Mandowsky and Mitchell, *Roman Antiquities*, Pl. 21a.

taining the vase. In this case, they contain *paterae*, which again can be found on antique altars drawn by Ligorio.[37]

Medusa heads protect the entrance to the loggia (Fig. 7), as they did the entrance portico. Otherwise, however, the stucco decoration of the loggia appears both more varied and less coherent than that of the casino. On the second story (Fig. 8), the stucco is used in ways which are architectural, sculptural and pictorial. The caryatids, the tabernacles and the squat, acanthus pilaster-strips (partly obscured by Barberini coats of arms) belong in the first category. The figures occupying the tabernacles belong in the second, their placement on inscribed bases indicating that they are intended to represent sculpture, in addition to being sculpture. In contrast, the large, central frame, divided by the central tabernacle, has a strongly pictorial character. The figures move in a more natural environment. Plants, roots and snails share the ground on which they dance, and the background of the panel implies atmosphere and space.

The figure in the left tabernacle represents Truth. She carries a cornucopia in her left hand, holds a purse in her right hand, and stands on a base which is inscribed VERITAS. Although her attributes might appear to be more suited to Fortune,[38] Ligorio's manuscripts in Naples justify representing Truth in this way. In the sixth volume Ligorio recorded a coin, struck by the Emperor Nerva, on which Truth appears with a cornucopia and money bag, and she is also described with these attributes in *Libro X*. In one of the many descriptions given in a section entitled DELA VIRTU ET DELLA VERITA, Ligorio wrote that Truth was "dressed in fine, loose, transparent draperies," and held "a cornucopia in one hand and a purse in the other."[39]

The figure in the right tabernacle is also female. She carries no attributes, but is decorously clad, and holds her left hand at shoulder height, with her fingers conspicuously spread apart. MOSIN, the last five letters of an inscription, remain on the base. Friedlaender identified the figure as Elemosyne,[40] or Charity, but she is surely Mnemosyne, mother of the Muses. Ligorio described this lady in some detail in a section of *Libro X* entitled DELLE GRATIE ET MNEMOSINE:

> Mnemosyne is the mother of the Muses, that is the Memory of lofty intellects,
> and accompanies the Hours and the Graces. Usually this goddess is repre-

[37] *Ibid.*, Pls. 16a, 21a, 23a, 24c, 31c.

[38] See G. de Tervarent, *Attributs et symboles dans l'art profane: 1450–1600*, Geneva, 1958, 116–122, CORNE D'ABONDANCE. Vincenzo Cartari included a purse among the gifts of Fortune (*Imagini delli dei de gl'antichi*, Venice, 1647, 339).

[39] NBN, MS XIII. B. 6, 119. NBN, MS XIII. B. 3, 622: "Alcuni lhanno fatta scendere giù dal cielo vestita di veli sottili scinti et trasparenti, sollevata dal Tempo che ha le ale alle spalle et la rota sotto de piedi et tiene essa verita perli capelli, la quale da una mano tiene il corno pieno di frutti et la borsa dall'altro." Also see *ibid.*, 631: "Porta la Verità la Borsa perche è potente."

[40] *Kasino*, 37.

sented as a most beautiful woman, doubly clothed, with a mantle which covers her hands, arms and entire person, thus symbolizing the many things which Memory contains in all the parts of her body and mind, and which create a harmony of all things by means of memory. On medals one also sees her as a goddess, clothed as described; and for a diadem she has a lyre on her head, giving out brilliant rays like a sun. Some have represented her with a cup which pours water, and others with her hands veiled.[41]

The fact that the stucco figure's left hand is so conspicuously visible, rather than being covered as this passage requires, can be explained by another passage in which Ligorio referred to Mnemosyne. In the context of a long discussion of Faith, Ligorio described that figure as wearing a long tunic, almost entirely covering her feet. "Over this she has a fine, transparent mantle which almost completely covers her back, arms and hands, but in such a way that her fingers can be counted one by one, just as Memory, called Mnemosyne, is usually represented."[42] It is possible that the prominence given to Mnemosyne's left hand, whose fingers seem to record a series of arguments, stems from the last part of this passage. Finally, this identification is supported by the proximity of Mnemosyne's daughters, and is indirectly confirmed by the fact that four antique statues of Mnemosyne originally decorated the Casino of Pius IV.[43] In fact, Ligorio himself referred to one of the statues in a section on the Muses, writing: "With her hands veiled by her mantle and with the lyre of Apollo as a diadem on her forehead, one sees the image of Mnemosyne in the *boschetto* of the Vatican Palace, in one of the entrances of the building constructed by Pope Pius IV."[44]

Despite the inscription, PIERIVS, the subject of the relief in the central tabernacle

[41] NBN, MS XIII. B. 3, 46: "Mnemosine è la madre delle Muse, cio è la Memoria dell'alti intelletti, la quale accompagna de L'Hore, delle Gratie. Questa Dea secondo si vede ordinariamente, è una Donna bellissima vestita di doppia veste, con un' mantello che gli cuopre le mani le braccia et la persona. Perche denotano più cose, che la Memoria tiene inclusa in tutte le parti del corpo et del suo cerebro che fanno concordantia de tutte le cose mediante la memoria. Si vede anche nelle medaglie esser una Dea vestita come se detta, et ha una lyra sopra della testa per diadema, conli raggi aguisa di un sole tutta splendente. Alcuni lhan fatta una tazza che versa acqua, altri conle mani velate come sedetto."

[42] *Ibid.*, 123: "Inunaltro modo veggiamo anchora questa tal Dea, ella è una Donna bellissima, col viso giocondo, è allegro, è verile, disotta ha una tunica succinta sotto le mammelle longa che gli cuopre i piedi quasi tutti, et disopra un mantello sottile et trasparente, il quale quasi gli va cuoprendo tutto il dosso, le braccia le mani, ma talmente che si contano aduno aduno le ditta come dipingono la Memoria detta Mnemosyne."

[43] Michaelis, "Belvedere," appendix II, nos. 92, 107, 109, 115.

[44] NBN, MS XIII. B. 3, 531: "L'imagine di Mnemosyne si vede del Boschetto del sacro palazzo in una dell'entrate dell'edificio fabricato da papa pio quarto, la quale ha le mani velate dal suo mantello cola lira di Apolline per Diadema sul fronte."

is less clear. The relief is less completely sculptural than its companions. While the presence of the base and the inscription still assert the sculptural nature of the relief, the treatment of the figure's immediate setting and the inclusion of a background introduce a pictorial aspect. In the foreground, a nymph reclines on the upper slopes of a mountain; she holds a tragic mask in her right hand, and rests her left arm on an urn, from which water streams down a hillside; a hexastyle temple crowns the mountain. Both the mask and the vase suggest that the nymph may be Calliope, one of the Muses and the inventress of poetry. The mask was Calliope's usual attribute, signifying the literal and allegorical levels of poetry,[45] but Ligorio also emphasized her closeness to a river, which must be what the urn symbolizes. Describing the grove of the Muses, Ligorio wrote:

> On Mount Helicon was the dark and shaded grove of the Muses with the cave of the nymphs, placed on one of the elm-covered banks of the River Helicon. Over the waters of the fountain, which came from the cave, were the horse Pegasus, who was mirrored in the violet water, and images of Orpheus and Calliope, who stood apart from but near the other Muses.[46]

If the figure is Calliope, then it must be the Helicon which pours from her urn, and the temple must be the Temple of the Muses, mentioned in other descriptions of the grove of the Muses. Alternatively, the figure may represent the Castalian Spring, mentioned by Ligorio in another of his descriptions of Mnemosyne: "The poets say that Memory is a divine thing and the mother of the Muses. Perhaps for this reason, she has the cithara of Apollo and an urn pouring water, in imitation of the fountain sacred to her daughters in Castalia, where the chorus of the Muses themselves was and where their cave and temple were."[47] In either case, the relief as a whole is surely intended to represent a place sacred to the Muses, who dance in the large frame on either side of the tabernacle. In fact, this identification does not conflict with the presence of the inscription, PIERIVS. The proper names Pierio, Piero and Pieria appear from time to time in Ligorio's discussions of the Muses in *Libro X*, and, while

[45] *Ibid.*, 49: "Calliope trovo la poesia, per cio è coronata di lauro come à Musa Heroica et ha la maschera che denota il doppio senso piano et mistico."

[46] *Ibid.*, 296: "In Helicone monte fu il boscho delle Muse molto oppago et ombroso con l'Andro delle Nymphe, luogo sopraposto ad'un ripa dell'olmosa fiume Helicone, et dal fonte che usciva dall'Andro erano sopra l'acque poste il cavallo Pegaseo, che si specchiava nel violaceo fonte: con li simulachri di Orpheo et di Calliope, che particularmente stavano da parte ma circa l'altre Muse."

[47] *Ibid.*, 64: "Dicono i poeti, che la Memoria, è cosa divina et madre delle Muse, et per questo forse ella ha la cethra di Apolline et ha L'Urna versante acqua, ad imitatione del fonte sacrato alle sue figliole in Castalia, ove era la chorea dele Muse istesse col suo Antro et suo Tempio."

the first two belong to persons related to the Muses in some way, the last is the name given to their birthplace.

In *Libro X* Ligorio described Pieria on two levels. The first is factual, and Pieria is presented as an actual geographical location: "Others say that the nine Muses . . . were born of Jupiter and Mnemosyne, or Memory, who gave birth to them in Pieria, where Jupiter slept with her for nine days; and the Muses leap around in the region of Helicon, and praise their father."[48] However, Ligorio also presented Pieria in a more abstract and allegorical vein:

> [The Muses] were born of Jupiter in the neighbourhood of Pieria, that is in the dwelling of the mind, which is a place inside our brain, because the concerns of the Muses, intellectual things, abound in the mind. That Jupiter enjoyed himself sensually with his Mnemosyne for nine days simply means that he—that is, our mind—often turns over and recalls creative ideas. The Muses leap and dance in Pieria in Helicon, and sing praises to their father Jupiter. They turn over what is written in books, go everywhere, and circle like a chorus, praising the intellect which gave birth to them. Thus, Greek commentators declare Pieria to be the dwelling of the mind itself, and Helicon the books through which dance the Muses, who are aspects of knowledge and opinion.[49]

Ligorio emphasized the geographical rather than the cerebral aspect of Pieria in one of his later manuscripts, in the Archivio di Stato at Turin, naming a Mount Pierius within the area Pieria. He wrote: "PIERIO, Pierius and Pierus is a celebrated mountain in Thessaly, on which the poets have it that through the will of Jupiter the Muses were born. From this they became called Pieridas or Pierides. Or, as some say, they were named after Pieria, a region of Thessaly."[50]

[48] *Ibid.*, 49: "Altri dicono che le nove Muse . . . essono nate di Giove et di Mnemosine ò vogliamo dire Memoria che le partori in Pieria, dove con essa Giove dormi nove giorni, et queste al d'intorno di Helicone saltano, et suo padre lodano."

[49] *Ibid.*, 50: "Si generano presso in Pieria de Giove, cio è nell'Habitacolo della mente, che è luogo d'intorno del cervello nostro, per cio che le cose dele Muse nella mente abbondano copiosamente cose intellettuali. Che Giove nove giorni si delettasse carnalmente con la sua Mnemosine non è altro se non che egli; cio è la nostra mente spesso le generante cognitioni rivolge, et remembra. Queste in pieria in Helicone saltano et ballano, et il suo padre Giove cantando lodano, cio è scritte ne i libri si rivoltano, et portansi per tutto et aggiransi à guisa di Chorea, et ballo, decontando l'intelletto, che l'han'generate, cosi gli espositori Greci dichiarano pieria esser lhabitacolo dell'intelletto i stesso et Helicone esser i libri, ne quali van'ballando Le Muse, cio è le cognitioni et commenti."

[50] MS J. a. III. 15: "PIERIO, Pierius, et Pierus è celebre Monte della Thessaglia, nel cui Monte vogliono i Poeti essere per voluntà di Iove nati le Muse, donde Pieridas vengono appellati, ò pure Pierides, ò come alcuni dicono, chiamati da Pieria Regione Thessalica."

The inscription in the central tabernacle refers then to the setting, rather than the figure, and the relief as a whole is intended to suggest the mountain birth place of the Muses.

The identities of the figures in the large frame are clear. Apollo stands in the centre of the right section. He leads the nine Muses in a dance whose tempo quickens as it approaches Apollo himself. Two additional figures are represented on the extreme right, apparently intent on encouraging the enthusiastic pace around the prince of the Muses. The more prominent of the two figures is young, plump and mischievous. He struggles with an amphora, which presumably contains wine, and is assisted by his companion, who nonetheless succeeds in shaking a tambourine with his free hand. Both figures look and act like bacchantes, and the more prominent of the two may well be Bacchus himself, "young, merry and cheerful," whom Ligorio described as leader of the Muses.[51]

Draperies gently billowing in a silent breeze, Aurora floats towards us from the centre of the pediment (Figs. 7, 8). She is followed by the Sun's four horses, whose names, PYROIS, EOVS, AETON and PHLEGON, are inscribed below their hooves,[52] and a torch-bearer hovers above her. The entire group is circumscribed by a zodiac. All the members of this group, their relationships to each other, and, in the case of Aurora, even the details of dress are described in *Libro X*. In a section entitled DEL SOLE ET DELL'AVRORA ET CREPUSCOLO, Ligorio wrote:

> They had adorned the chariot of the Sun with two guides, Twilight and Aurora. They put Twilight on a horse with a burning torch in his hand before the Sun as guide to the chariot; and sometimes they put wings on his shoulders and other times not. Aurora is a beautiful woman with wings on her shoulders, dressed in the finest stuffs (as one sees on the medals of the Romans), the colours of which are yellow, red and green; and she leads the horses [of the Sun] on reins. The horses of the Sun number four and are red in colour. One is called Pyrois from fire; another Eous from the appearance of Aurora. The third is named Aeton from light, and the fourth Phlegon from heat. They also make out that Aurora may have her own chariot or biga drawn by winged horses, which Homer names Lampos from splendour and Phaethon from light. And so her chariot is below the Sun's horses, so that she may lead them by their reins. Aurora, according to the same poet's description, was depicted with a crown of entwined roses. She wears the

---

[51] NBN, MS XIII. B. 3, 451: "Fecero gli antichi Bacco capo delle Muse, come ne guida Apollo, et fu detto Musagete, et Philochro tra li poeti scrisse che Baccho fu allevato tra le Muse."

[52] The inscription which Friedlaender, *Kasino*, 37, recorded as being in the pediment is in fact a conflation of Bouchet's garbled transcriptions of EOVS and AETON. (See *Villa Pia*, Pls. XX and XXI.)

finest of garments, one long and divided up to the thighs so as to reveal her bare legs, the other a short over-dress, above the knees; both dresses flutter and blow about in the wind caused by Aurora's motion, and they are soft, with many varied and beautiful folds.[53]

In the pediment of the loggia, Twilight appears without his horse, and carries two torches rather than one. However, Aurora is exceptionally close to Ligorio's description of her. She is winged, and wears clinging, almost transparent draperies; she gently leads the four horses by reins which are casually draped over her outspread arms; she is certainly crowned, even if one cannot be sure that the crown is plaited from roses; and the arrangement as well as the motion of her draperies are just as Ligorio described in the final sentence.

A second passage in *Libro X* is less precisely related to the decoration of the pediment, but it does account for the zodiac, and suggests a precedent for the placement of the entire group. It is interesting too that it brings many of the personalities of the façade of the casino into close relationship with the cast of the loggia. The passage opens a section entitled ANTRO DEL GIORNO, and reads as follows:

At the height of the cave of the day the chariot of the Sun races through the celestial circle called the zodiac, his blazing light illuminating every open area which is capable of receiving it. The chariot is guided by Hegle and by three beautiful and imposing young girls, called Eirene, Eunomia and Dike; they are winged, and wear fine, iridescent draperies. They carry flaming torches taken from the hand of Lycophus, the son of Tithonus and Aurora, that is from Twilight. The said chariot is drawn by four winged horses, of a red which changes colour, the first to gold, the second to the palest yellows, the third reddish, and the fourth red and white. And following the chariot of the Sun is the veil of night, whose darkness is entirely covered with stars. And winged Hegle precedes the chariot, and with an urn sprinkles dew over

[53] NBN, MS XIII. B. 3, 89: "Il carro del Sole haveano ornato di due guide, del Crepuscolo et dell'Aurora. Il Crepuscolo ponevano guida del carro avante al Sol su un cavallo con la accesa facella in mano, et una volta gli poseno l'ale alle spalle alcuna no'. L'Aurora è una Donna bella che mena affreni i cavalli con le ale alle spalle vestita di sottilissimi veli come è nelle medaglie de Romani, il cui colore delle veste sono tra gialle rosso et verde. I cavalli del sole sono quattro di color rosso. L'uno chiamato dal fuoco Pyros, l'altro dal apparir dell'Aurora Eoo. Il terzo Aethon dala luce, il quarto Phlegon dall'ardore. Fingono ancora che l'Aurora habbia il suo carro particolare con li cavalli alati cio è una biga, i quei cavalli Homero chiama l'uno Lampo dal splendore et l'altro Phaethon dal lume. Tal che il carro di costei va sotto i cavalli del sole quanto che lei meni affreno quello di esso Dio. L'Aurora secondo discrive il medesimo poeta si facea conla corona tessuta di rose. Ella ha veste sottilissime l'una è longha et fesse nelle coscie tanto che mostra gnude le gambe, et l'altra è una sopra veste corta sopra delle ginocchia, et l'una et l'altra dall'andar demostra esser dal vento scosse et ventillante et piana di molte pieghe variate et belle."

the woods, fields and various buildings which fill the cave, above which wanders Pan with his pipes.[54]

Flora and Pomona[55] sit on either side of the zodiac, their gazes attracted towards the Sun, and the angles of the pediment are filled by their great baskets of fruit and flowers. Ligorio referred to Pomona once in a description of a marble base, carved with the figures of Vertumnus, Pomona and Victory. Pomona was represented "dressed in the thinnest draperies, with her lap full of different types of apples,"[56] much as she appears in the pediment of the loggia. However, what is more interesting, in that it further develops the relationship between the decoration of the loggia and that of the casino, is Ligorio's explanation of Pomona's association with Victory. He wrote that the Victory seemed to symbolize that victory generates peace, and "makes one enjoy the fruits of the seasons of the year, which are subject to Vertumnus and Pomona, his lover. That is, the year produces abundant fruits and happiness, and Victory governs them."[57] Ligorio's description of Flora could hardly be translated into stucco, but it is worth quoting for its colour: "Flora was a goddess depicted by writers of fables as being crowned with a garland of roses, her clothes decorated with flowers of many colours, and with her lap full of flowers, because they say that there are few colours with which the earth is not adorned when she is in bloom."[58]

The pediment of the loggia is crowned by an antique statue representing Salus (Fig. 7), precisely as Ligorio described her in a section of *Libro X* entitled DI SALVS Ò VERO HYGIA: "In one hand she holds a cup, and in the other the snake which climbs up around her arm and stretches out to feed from the cup."[59] This figure was men-

[54] *Ibid.*, 397: "Nella parte alta del Antro del Giorno, scorre il carro del Sole, per mezzo del celeste circolo detto Zodiaco, risplende et allumina ogni parte scoperta et atta à recevere lume. Il carro viene guidato da tre figliole et di Egle, chiamate Hirene, Eunomie et Dice, giovane belle et prestantissime, con le ali alle spalle vestite di sottili et cangianti veli. Portano le facelle ardenti prese di mano à Lycopho figliuolo di Titone et dell'Aurora, cio è dal Crepuscolo. Il cui carro è tirato da quattro cavalli alati di color rosso ma cangiante. L'uno si cangia in oro, l'altro in gialle manco flavo, il terzo più rosseggiante il quarto rosso et bianco. Et dopo il carro del sole è il velo della notte tutto coperto di stelle che cuopre una scurita e davante al carro, va Egle con le ali, che con una urna sparge la roggiata sopra dell'Antro, piano di selve, di campi et di diversi edificij, sopra del quale Pan si aggita con la sua syringa."

[55] Bouchet, *Villa Pia*, Pl. XXI recorded the inscription POMONA. This no longer exists.

[56] NBN, MS XIII. B. 3, 408: "Pomona vestita di veli sottilissimi col grembo pieno di diversi pomi."

[57] *Ibid.*, 408: "La qual Vittoria par che voglia denotare, chel vincere è cosa che produceva felice quiete che fa godere i frutti delle Stagioni dell'anno sottoposte à Vertumno et à Pomona sua amorosa, cio è l'anno produce i frutti abondanti et la felicita et la vittoria li governa."

[58] *Ibid.*, 429: "Flora . . . fu una Dea dai favolosi dipinta con il grembo pieno di fiori et di ghirlanda di rose coronata et la vesta tutta di fiori dipinta, di colori diversi, per che dicono che pochi sono i colori da i quali non si adornò la terra quando fiorisce."

[59] *Ibid.*, 286: "Ha di più alcuna volta il mantello con una mano tiene una Tazza, con l'altra il serpe che sale avvolge il braccio et si stende à cibarsi nella tazza."

tioned in the building accounts in May 1561,[60] and was recorded in the inventory of 1566.[61]

There are two large reliefs on the southeast end of the loggia, one in a rectangular panel, framed by caryatids, and the other in a segmental pediment (Figs. 16, 18). According to Friedlaender, the lower relief represented a river-god, lyre in hand, reclining on a boat which is drawn ashore by a girl.[62] In fact, the girl is Aurora, the river-god is her husband Tithonus, and the boat is an oversize cradle. The circumstances are explained and the lyre accounted for in a section of *Libro X* entitled DI TITHONE ET DELL'AVRORA. After paraphrasing part of his earlier description of Aurora, Ligorio continued:

> They say that Tithonus was the husband of Aurora. He lived for such a time that he grew so old that he could no longer stand. And Aurora kept him like a child in a cradle, from which he looked at her with longing. From this they suppose that, having begged the gods for immortality, Tithonus was unable to die, and continued to live feebly, so that he regretted that he had made his request without asking that he should not grow old. Virgil also says that he was buried when he died, so that the gift of eternal life must have been revoked. But other writers say that, having become a singer and musician in his cradle to delight Aurora, he did the best he could; but since he was not a good singer, Aurora changed him into a cicada. Therefore, one can represent Tithonus as a cicada, or as an old man playing the lyre in a cradle, with Aurora seated at his feet. On the Aventine there was a room, discovered among others in the construction of the ramparts, in which . . . one could see Tithonus seated plaiting a garland of roses, and Aurora coming with arms outspread before the chariot of the Sun.[63]

[60] See n. 28, chapter 1.

[61] Michaelis, "Belvedere," appendix II, 62, no. 85.

[62] *Kasino*, 38: ". . . auf der gegenüberliegenden Seite sieht man einen Flussgott (?) mit einer Lyra in der Hand in einem Boot, das ein kauerndes Mädchen, wie es scheint, auf das Land zieht."

[63] NBN, MS XIII. B. 3, 407–408: "Tithone dunque dicono che fu marito dessa Aurora: Il quale visse tanto tempo che venuto vecchio che non più si potea tenere impiedi. Et l'Aurora come un fanciullo lo teneva in culla ove la riguardava con vezzoso lusenghe per lo che fingono, che essendo impetrato degli Dij che fusse immortale, non potea morire, onde egli lamentava della domanda, che fusse stata senza chiedere di non invecchiare, vivea debolmente. Vergilio, dice pure che fu sepulto quando mori, per che debbe rivocar' la gratia di viver sempre. Ma gli altri favolosi dicono che essendo diventato un cantarino et suonatore cosi in la culla per dilettar' all' Aurora, faceva quel che potea. Ma non sapendo ben cantare L'Aurora lo trasmuto in cicala. Pertanto dunque Tithone si puo dipingere in cicala, ò vero giovane in compagnia dell' Aurora, ò vecchio in culla che suona la lira et l'Aurora che gli siede appidi. Era nel colle Aventino una stanza tra l'altre scoperta nel farvi il muro di bastioni, dove nelle pitture che poche erano intero visi veda Titone

Clearly, the relief in the rectangular frame shows Tithonus with Aurora kneeling at the end of the cradle. The prominence given to the lyre perhaps suggests the imminence of Tithonus' metamorphosis into a cicada. While the painting found on the Aventine has no direct bearing on this relief, the description of Aurora might well be transferred to the figure in the pediment of the *cortile* façade.

The relief in the segmental pediment is certainly a companion to the rectangular panel below. Breasts uncovered, draperies streaming behind her and a flaming torch in her hand, Aurora and her two horses, Lampos and Phaethon, rush past a sleepy river-god on their way to rouse Apollo.

Friedlaender identified the scene on the northwest end of the loggia as representing the infant Jupiter, tended by the nymph Amaltheia.[64] While one cannot be sure that it is the nymph rather than the goat who is Amaltheia, there is no doubt that the relief illustrates Jupiter's infancy on Mount Ida. The participants are set in an idyllic landscape, into which a Barberini bee has penetrated; a nymph sits on one side, and shakes a tambourine, perhaps to absorb the noise of Jupiter's crying; and the goat stands imperturbably on the other side, nectar and ambrosia streaming from her horns, while the infant Jupiter drinks voraciously from her udder. All the elements of the tableau were given by Ligorio in a section of *Libro X* entitled DE GIOVE, ET DE AMALTHEA:

> Jupiter, the son of Saturn and Rhea, was removed to Mount Ida and given to be nursed to the nymph Amaltheia, so that Saturn would not find him. Amaltheia then is represented in two ways. On the one hand, it was claimed that she was a most beautiful woman with the horn of an ox in her hand. This horn was broken by Hercules from the River Achelous, who was changed into a bull; and then, full of fruits, it was presented by Hercules at the table of the gods, as Ovid says. They say that Amaltheia was Jupiter's nurse among the Curetes on Mount Ida on the island of Crete, and that she brought him up among the goats with the milk of those animals. From this the poets say that Jupiter, having been placed by Rhea on the said mountain, was raised with the milk of the goat Amaltheia, which, as Suidas says, poured nectar from one horn and ambrosia from the other—both foods of the gods.[65]

---

assedere che intrecciava una ghirlanda di Rose et l'Aurora veniva abraccie aperte davante al carro del sole."

[64] *Kasino*, 37.

[65] NBN, MS XIII. B. 3, 64: "Giove fu figliuolo di Saturno et di Rhea, il quale fu asposto nel monte Ida et dato a nodrire alla Nympha Amalthea accio che Saturno non lo trovasse. Amalthea

A few lines further on, in the same section, Ligorio described an antique altar on which Amaltheia was represented with the infant Jupiter at her udder.

Originally, the segmental pediment at this end of the loggia had contained only the coat of arms of Pius IV. Now Pius IV's arms are flanked by the coats of arms of Urban VIII and Cardinal Matteo Barberini, commemorating a restoration carried out during the pontificate of Urban VIII.[66]

As was discussed earlier, the garden façade of the loggia (Fig. 15) now bears little resemblance to its original appearance. However, one can reconstruct something of the original appearance from early descriptions and engravings, and some of the original stucco and sculpture does survive in the niches above the *peschiera*. In his description of the garden façade of the loggia, Giovanni Pietro Chattard mentioned the Pans and described three statues of female figures.[67] The sculptures still occupy their niches, although the position and larger function of the central figure have been altered. Streams no longer pour from Cybele's rocky base, as Chattard described, and she has been exiled to an artificial plinth.[68] As a result, she now sits above the pool, associated with it in a passive way, rather than being actively responsible for it. The niches of the southeast and northwest ends of the loggia also

---

dunque si figura in dui modi: nell'una si fingeva una Donna bellissima col corno de Bove in mano che fu da Hercole rotto ad Acheloo fiume mutato in Tauro et poi pieno di frutti, il quale presento attavola delli Dij, come dice Ovidio, costei dicono esser la nodrice di Giove tra i Cureti nel monte Ida nell'insula di Crete il quale allevo tra le capre con latte di essi animali. Onde i poeti dicono che essendo asposto Giove da Rhea nel sudetto Monte fu allevato con latte della capra Amalthea, la quale come dice Suida versava per le sue corna dall'uno il Nettare, et dall'altra l'Ambrosia, ambe due vivande degli Dij."

[66] For the coats of arms, see Chacon, *Vitae*, IV, 403 and 493–494.

[67] *Nuova descrizione*, III, 233: ". . . tre non ignobile statue di marmo, rappresentanti quella di mezzo una *Cibele* seduta sopra di un eminente scoglio, da cui ne sgorgano rivi d'acque, con la testa coronata di Torri, e l'altre laterali, due Femmine di vaga panneggiatura rivestite, e tutto molto antiche."

[68] This has happened since the Anderson photograph was taken. A drawing by Frans Floris, representing the Cybele before her restoration for the Casino, is now in the Museum of the City of Bruges. (See C. Van de Velde, "A Roman Sketchbook of Frans Floris," *Master Drawings*, VII, 1969, 277–278, Pl. 15b.) The Cybele was drawn twice at the Casino by Giovannantonio Dosio. One drawing, in the Berlin Codex, bears the inscription "DEA CYBELE nel bosco di beluedere"; the other, in the Biblioteca Marucelliana in Florence, is inscribed "CYBELE La dea cibele e nel boschetto." (See C. Hülsen, *Das Skizzenbuch des Giovannantonio Dosio im Staatlichen Kupferstichkabinett zu Berlin*, Berlin, 1933, Pls. LXXV and CXLIII.) In the Berlin Codex there is also a sheet containing a drawing of the sculpture in the right niche on the garden facade of the loggia. Dosio identified this figure as IVVENTAS, and indicated that she and the FIDES on the same sheet were at the Casino. (*Ibid.*, Pl. C: "La venere col cupido sono in belvedere e le altre 2 figure [the Iuventas and the Fides] sono nel boschetto." Other sculptures drawn by Dosio and identified as being at the Casino of Pius IV appear in Pls. LXXXVII and LXXXVIII.)

contained antique statues, although they were not mentioned by Chattard. The inventory of 1566 listed five seated figures around the base of the fountain-loggia, a *Fede*, a *Cibele*, a *Pudicizia*, a *Gioventù* and a *Flora*.[69] In the late nineteenth century, Paul Letarouilly recorded the inscriptions FLORA and FIDES below the niches on the southeast and northwest ends respectively.[70] Since the figure in the centre of the garden façade is certainly Cybele and that in the right niche is identified as IVVENTAS by Dosio, the figure in the left niche must be the *Pudicizia*.

Chattard identified Cybele by the fact that she was crowned with towers, and this is still the figure's distinguishing feature. Ligorio's most extensive discussion of Cybele begins, apparently almost by accident, in a section of *Libro X* entitled DI MERCURIO ET DI ISIDE DETTA IO, and is continued in the next section, entitled DE CORYBANTI ET DI ISIDE ÒVERO OPE. Ligorio began the first section by referring to various antique medals representing Mercury guiding a bull-calf or heifer. He explained that the bull-calf was Jupiter, who transformed himself into such an animal to abduct Europa, and continued: "The cow is Io, daughter of the River Inachus, king of the inhabitants of Argos, named Isis by the Egyptians. She came to be interpreted as mother of all the gods of Egypt. For some she became the symbol of the toilsome and unchanging earth, and as the producer of nourishment they named her Nature-Generatrix."[71] Because Isis' qualities were so numerous and varied, Ligorio explained, she was given many names, was worshipped in many ways and had statues of many strange forms dedicated to her. The Cybele at the Casino is much less exotic than those which Ligorio described and drew under the many names of Isis. Nonetheless, one is surely justified in lending some of the qualities of those figures to the lady below the loggia. The following passage gives an indication of the wealth of interpretation which is possible:

> They say that her head is crowned with towers, because the circumference of the earth, symbolized by the crown, is covered with cities, castles, villages and other buildings; and the presence on occasion of stars [on the crown] symbolizes the way in which the heavens surround the earth. Her dress is woven with herbs of various colours, and she is surrounded by leafy branches, so that she represents the trees and plants of many thousands of varieties which cover the earth. In her hands she holds the sceptre which symbolizes ruling power, or rather all kingdoms and human riches; and she

[69] Michaelis, "Belvedere," appendix II, 62, nos. 78–82.

[70] *Le Vatican*, III, Pl. 7.

[71] NBN, MS XIII. B. 3, 558–559: "La Vacca è Io figliola di Inacho fiume ò pure re degli Argivi, detta dall'Aegitij Iside, et viene interpretata madre de tutti gli Dei dell'Aegypto, et è stata da alcuni figurata per la terra laboriosa et stabile, et come laboratrice de i beni alimentali la dissero Natura-generante."

is seen to be the source of all the riches which govern the power of all the rules of the earth. By the tympanum which she carries are intended the winds gathered in the sphere of the earth, between it and the sky, as Suidas says. The clashing sounds made by striking the tympanum are the uproar of the winds. The tympanum can also be interpreted as symbolizing the division of the earth into two parts, one known as the lower and the other the upper hemisphere.[72]

When Ligorio discussed the significance of the keys of the *Magna Mater*, one of her most frequent attributes, he emphasized Isis' role as guardian of the seasons. According to Ligorio, "Isidorus writes that sometimes the *Magna Mater* of the gods was depicted with keys in her hand to show that in winter time the earth locks itself up, shuts itself in on itself, and seals up the seed scattered upon it, which, after germinating, pushes up in spring, and then the earth is said to open up."[73]

The decoration of the fountain architecture is not restricted to the statuary. The ends of the loggia substructure are encrusted with mosaic decoration which represents water plants (apparently growing from the pool itself), marine creatures and river-gods (Fig. 17). The garden façade also retains some further remnants of its original decoration (Fig. 15). Above the lateral niches are small reliefs with marine scenes, and above those are small panels containing inscriptions which read: PIVS · IIII · PONTIF · MAXIMVS LYMPHAEVM HOC CONDIDIT ANTIQVIS QVE STATVIS EXORNAVIT. In addition, the interiors of the niches are decorated with numerous stucco reliefs. The smaller panels represent marine scenes of a general kind, but the most conspicuous scenes, directly behind the sculptures, depict identifiable figures. In the right niche the Hours reappear, winged and interlaced in a gentle dance, much as they were represented on the façade of the casino. The niche on the left also contains a group of three female figures. The central figure presents her back to us, and her

[72] *Ibid.*, 559: "Vogliono che habbi la testa coronata di Torri, per che il circuisce la terra, a guisa di corona è tutta piena di città, et di castella, di villaggi, et d'altri edificij, et per esservi stelle anchora alcuna volta, ne denota la circundatione del cielo attorno della terra. La veste tessuta di herbe, di colori diversi, circondata di rami fronduti, per che mostri gli arbori, et le piante, che cuprono la terra di mille migliaia de infinite varieta. Ha il scettro nelle mani, che significa il regimento overo i regni tutti, et tutte le richezze humane, et mostra esser autrice, che porge le richezze, che l auttorita de signori terreni governano. Per lo Timpano che ella porta si intendono i venti inclusi nella rotondita della terra tra essa et il cielo, come dice Suida. I tintinnabuli da percuotere il timpano sono i strepiti de venti. Il Timpano ancho viene interpretato il sito della terra spartito in due parti, che l'una è detta Hemisphero inferiore, et l' altra parte l'Hemisphero superiore."

[73] *Ibid.*, 564: "Scrive Isidoro che la gran madre degli Dij esser fatta talhora, con le chiavi in mano per mostrare che la Terra al tempo dell'inverno si serra et in se ristrigne et chiude il seme sopra lei sparso, qual germugliando poi vien fuori al tempo della primavera, et alhora la terra è detta aprire."

companions support flowing urns, which they rest on plinths. Ligorio mentioned that one of the roles of the Hours was to refresh the earth, parched by the heat of the sun, by sprinkling water upon it from bowls or urns.[74] This might suggest that this panel also represents the Hours. However, apart from the fact that the figures are not winged, they are composed in a way which is usually reserved for the Three Graces. In fact, in a section of *Libro X* entitled DELLE GRATIE DELL' HORE ET DELLA DEA NATURA Ligorio described the significance of this grouping as follows:

> Turning now to the Graces, it is clear that usually one of them was sculptured with her face almost entirely concealed and her shoulders turned, symbolizing . . . the gift of the giver—which, once given, he must never again think of or covet in any way. The second uncovers her face rather more than do the other sisters, signifying the recipient of the gift, who should always remember the gift and stand with face and heart turned in readiness to the benefactor. The third Grace is represented with part of her face concealed and the remainder revealed, signifying that some return has been made for the gift; the gift received is displayed, the one given is concealed. Therefore it is clear that the Graces must necessarily be three and no more.[75]

A few lines further on, Ligorio also accounted for the figures' urns. He wrote that the Three Graces "always hold flowing urns, placed on columns like firm and steady things."

Staircases on either side of the *peschiera* lead one back to the level of the *cortile*, which one then enters by passing through small triumphal arches (Figs. 16, 19). These entrance portals are elaborately decorated with mosaic, stucco and statuary. Mosaic vines encase the piers, and coats of arms, inscriptions and stucco figures decorate the spandrels and the pediments. In addition, on the northwest portal is the Dirce with the dove, recorded in the inventory of 1566 (Fig. 19).[76] Personifications of Victory and Peace fill the spandrels, and, in almost every case, hold a Medici *palla* as a secondary attribute. Gaggles of griffons stand to attention before candelabra

---

[74] *Ibid.*, 41, 539.

[75] *Ibid.*, 45–46: "Ora tornando alle gratie, è cosa chiara che più delle volte luna di esse fu sculpita col viso quasi del tutto nascosto et volta le spalle significando, come dice i physici, il beneficio di colui che dona: che poscia donato mai più deve pensarci ne far disegno alcuno. L'altra scuopre il viso assai piu che l'altre sorelle, significante il recevitore del beneficio, o cui s'appartiene ricordarsi sempre del recevuto, et starne col viso e col cuore pronto verso del suo benefattore. La terza gratia, una certa parte del viso asconda et il resto palesa tutto significa il beneficio compensato, mostando il recivuto, et celando il donato; et percio in ogni modo parche necessariamente le gratie debbono esser tre et non più . . . et sono accompagnate conla Mnemosine cio conla Memoria madre delle muse, et vogliano esser le gratie nate conle muse, et sempre tengono l'Urne versante, et appoggiate a colonne come cose salde et ferme et perpetuo fonte de benificij."

[76] Michaelis, "Belvedere," appendix II, 62, no. 86. Also see n. 28, chapter 1.

and ornamental frames in the friezes on the sides of the portals. Finally, standing atop the capitals, and overlapping the architraves and friezes of the portals, there are eight young children. They are dressed in a variety of ways, and carry bowls of fruits and flowers, baskets of grain and even small animals. Some of the children are warmly clothed, while others are stripped to the waist, and wear flimsy, virtually transparent shifts. This differentiation from pair to pair suggests that the children on the four faces of the portals represent the Seasons. Apart from the fact that Cartari represented the Seasons in much this way,[77] Ligorio's *Libro X* also lends support to this idea. Discussing the seasonal significance of the Hours, Ligorio wrote: "At other times, the Hours have been depicted with animals as symbols, that is Spring with roe-deer, Summer with geese, and Winter with ducks, cocks and the hare." He continued: "Others have sculpted not three but four Hours, corresponding to the way in which we now divide the year: Spring, Summer, Autumn and Winter. Autumn has grapes in a basket which she carries in her hand and tilts to show the ripeness of the fruits, as she was represented in that cave on the Aventine which was destroyed because of the fortification of the city walls."[78] Unfortunately, Ligorio did not describe the remaining three Seasons.

The interiors of the portals are also richly decorated with mosaics and stucco. The mosaics are concentrated on the walls, and represent predominantly aquatic motifs: ships, sea-creatures, water-birds, fishes and fountains. The barrel vaults are encrusted with stucco. In each case a commemorative inscription appears in the centre of the vault, and is surrounded by four narrative scenes and four oval medallions, which contain marine scenes of a more general kind. The narrative panels in the southeast portal represent *Diana and Actaeon*, the *Rape of Dejeneira*, the *Birth of Venus* (Fig. 42) and *Latona and the Lycian Peasants*. The scenes in the northwest portal represent *Perseus Rescuing Andromeda*, the *Rape of Europa*, the *Triumph of Neptune* and the *Triumph of Galatea*. Clearly, water is the unifying element in the interiors of the entrance portals. Apart from its prominence, whether directly or by proxy, on the walls, all eight narrative scenes in the vaults involve episodes which took place on, across or beside water.

The fountain at the centre of the *cortile* (Figs. 16, 43) is the *Marcus Aurelius* of the Casino of Pius IV. It provides a focus for the oval court, much as does the equestrian monument for the Capitoline Hill, and it may be that its role in the total pro-

---

[77] *Imagini*, 23.

[78] NBN, MS XIII. B. 3, 44: "Altre fiate, hanno fatte lhore con li segni d'animali, cio è La primavera con li caprioli, L'Aestate con le oche, et la invernata con l'Anatre et galli et il lepre. Altri non tre ma quattro hore han' sculpite, all'usanza come hora noi dividemo l'anno: Primavera estate et Autunno et inverno. Quella che significa esso Auttunno ha frutti de Vite in un cestello che porta in mano il qual versa mostrando la maturità de frutti, cosi era dipinta in quello speleo dell'Aventino guasto per la fortificatione de muri della città."

gramme of the Casino is comparable. Ackerman wrote that the "*Marcus Aurelius* was not merely set into the piazza but inspired its very shape."[79] While one cannot claim this kind of preeminence for the fountain at the Casino, formally and iconographically it does reflect the larger shape of the complex.[80] Iconographically, the fountain is something of a hybrid. At the level of the basin the marine affiliations and watery content of the fountain are clear. Two *puttini* and a friendly goose sit astride a pair of dolphins. The dolphins cheerfully spit water at each other, while the *puttini* wrestle manfully with giant seashells. As was the case with the fountain below the loggia, however, the pastoral party is also well represented. In fact, the volutes which support the central part of the fountain basin stand on four hairy Pan feet.[81]

[79] J. S. Ackerman, *The Architecture of Michelangelo*, Harmondsworth, 1971, 166.

[80] Work on the fountain continued for some time after the main fabric had been completed. The estimate and final payment was not made until October 1563, "dopo più discussionj," and the two "puttini di marmo modernj" were not paid for until August and November 1564. (ASR, *CF*, 1521, 91, 115, 122, and Friedlaender, *Kasino*, 128, B. x.)

[81] Various ancient writers tell the story of a goose which fell in love with a young boy, and, apart from the evidence provided by the fountain, Ligorio was certainly familiar with this fable. Two statues of a boy with a goose decorated a fountain in Cardinal di Carpi's gardens. They were described, and one of them was drawn, by Ligorio. (See Mandowsky and Mitchell, *Roman Antiquities*, Cat. Nos. 62, 63 and Pl. 34a.)

# The Meaning of the Stucco Decoration

At this point one is rather in the position of a dramatist who has created a good range of characters, but still has no play. The cast of the stucco decoration has been identified and characterized, but the larger roles of the figures and their relationships to each other have still to be defined. As one would expect, the drama presented at the Casino is a complicated one. It contains a perplexing number of interlaced plots, and the characters possess a chameleon-like ability to accommodate to their various shades. In fact, the Casino's drama appears to have a complexity which calls for the intervention of a *deus ex machina*, that convention of antique theatre and bedroom comedies, to bring together its numerous characters and resolve its various plots in a satisfactory final scene.

The range and variety of the stucco decoration becomes slightly less bewildering if one begins by gathering its main props and personalities into five basic plots or categories. These can be characterized as: the commemorative; the aquatic; the pastoral; the solar; and the humanistic.

Of the five groups the first is surely the most clearly defined and the most consistently apparent. It contains the many commemorative inscriptions, the explicitly congratulatory figures—Fame and Victory on the façade of the casino and the figures in the spandrels of the entrance portals—the liberally scattered Medici *palle* and the numerous coats of arms of Pius and his associates.

Chattard described the Casino as appearing to be surrounded by water,[1] and, even if he intended this to refer primarily to the relationship between the loggia and the fountain below, his description does make one conscious of the importance of water to the vitality of the complex. The volume of water at the Casino of Pius IV is not overpowering, in the way that it is at the Villa d'Este at Tivoli. Nonetheless, one is always pleasantly aware of its presence. Apart from the fountain or *lymphaeum* below the loggia, there are small, free-standing fountains inside the loggia and entrance portico, and, as was mentioned earlier, the focal point of the *cortile* is the black marble fountain with its dolphins, *puttini* and goose. Beyond this, the emphasis of much of the mosaic and stucco decoration suggests that, in one of its roles, the Casino of Pius IV should be considered a fountain house. The mosaics on the sides of

---

[1] *Nuova descrizione*, III, 232.

the loggia and those in the entrance portals are predominantly aquatic or marine in theme, and the same is true of the stucco panels in the vaults of the portals. There, the common denominator is unquestionably water, and the mythological episodes which are represented invariably take place in relation to water. This preoccupation extends too to many of the minor stucco panels and to the antique statuary which originally decorated the Casino. In the niches below the loggia the majority of the small stucco panels represent marine scenes of a general kind. One panel in the archivolt of the northwest portal represents an elephant, and even this can be brought into close relation to the aquatic emphasis. In a passage on fountains in one of the Turin manuscripts, Ligorio explained that the elephant, "more than all the other quadrupeds, worships at the fountain at each new moon, and cleanses itself and descends into the fountain, spraying water into the sky with its trunk."[2] For these reasons, Ligorio added, the elephant was often sculptured on fountains. In the same section, he wrote that fountains were dedicated to Asclepius, Hygieia, Nature-Generatrix, the Graces, the nymphs of Diana and the Muses. Apart from the stucco scenes in which the Muses and the Graces were represented and the Cybele, it is significant that, among the antiquities originally decorating the Casino, the inventory of 1566 recorded an Asclepius in the moat around the casino, two statues of his daughter Hygieia, two of Diana, and a good selection of Muses.[3]

Set as it is in the *boschetto* beyond the Belvedere Court, it would be surprising if the stucco decoration of the Casino of Pius IV did not emphasize the arcadian and idyllic setting of the complex. In fact, Pan himself is present. He occupies a prominent position on the façade of the casino, is accompanied by Cyparissus and two river-gods, and once was supported by four satyrs who stood guard, like rustic commissionaires, before the fountain structure. The pastoral character of the Casino is also enlarged by the scenes on the sides of the loggia. Jupiter is suckled by Amaltheia in a scene which re-creates a blissfully uncomplicated and literally natural level of existence. Similarly, the panel representing Aurora and Tithonus exudes a *plein-air* and picnic air, and, at least after his metamorphosis into a cicada, Tithonus' harsh music had the power to conjure up all the balmy pleasures of a hot summer's day, spent surrounded by a friendly nature.

Since the pleasures of a rustic nature ultimately depend upon Apollo's benevolent presence, the solar decoration of the Casino is closely related to the pastoral group. Apollo is present (or at least is promised) in five of the major stucco panels, and he has a miniature role in the relief representing *Latona and the Lycian Shepherds* in the

[2] Turin, Archivio di Stato, MS J. a. II, 1, DI ROMA: "Sopra à tutti gl'altri quadrupedi venerà al fonte ad ogni nuova luna, et si purga, et scende alla fontana, et colla proboscide sparge al cielo l'acqua."

[3] Michaelis, "Belvedere," appendix II, 62, nos. 83–85, 89–91, 103, 106, 116, 119.

southeast portal. From a literary point of view, the panels in which Aurora appears, either with Lampos and Phaethon or with Tithonus, constitute a prologue to much of the stucco decoration of the court façade of the loggia. When Aurora leaves Tithonus, as she is surely about to do in the lower panel on the southeast end of the loggia, the new day will dawn. Even if Apollo himself is not present in the pediment of the loggia, it is clear that the new day is now properly under way. Aurora gently guides Apollo's four horses which draw his chariot from east to west, and her son hovers in attendance above. In fact, the Aurora scenes are tied to the promise of a new day in yet another way. They decorate the southeast façade of the loggia, and literally look to the rising sun. Apart from his appearance with the Muses on the court façade of the loggia, Apollo also appears with his consort and daughters on the façade of the casino, and it is worth remembering that they too accompanied him on his solar journey.[4]

The eight small boys who personify the Seasons and Flora and Pomona can be considered as a specialized extension of the Apollonian imagery. Insofar as time is measured in relation to Apollo's movements, the division of the year into four parts similarly derives from him. More explicitly, the fruits of the Seasons and of Flora and Pomona are the tangible evidence of the waxing and waning of the generative powers of the sun.

Finally, sections of the stucco decoration suggest an intellectual *vita contemplativa*, rather than simply a lazily pastoral peace. In particular, when Apollo appears as the leader of the Muses, one realizes that he was much more than a health and harvest god. In what amounts to a treatise on the subjects and symbolism of grotesques, contained in one of the Turin manuscripts, Ligorio sketched the larger significance of Apollo and the Muses as follows:

> The good Muses, Clio, Calliope, Erato, Euterpe, Melpomene, Polyhymnia, Therpsicore, Thalia and Urania, their mother Mnemosyne, Apollo, Minerva and Hercules were all painted there to signify the labours and happy days of those who are dedicated to higher things, and who lead man to the everlasting pleasures of the greatest knowledge, to high and profound meditation on seeing with the eyes of the mind how wonderful is the Prime Mover who made the heavens and the earth, so varied in its inspirations. Thus, the force and the essence of the divine light can be recognized in the plants and animals.[5]

[4] NBN, MS XIII. B. 3, 177.

[5] N. Dacos, *La découverte de la Domus Aurea et la formation des grotesques à la Renaissance* (Studies of the Warburg Institute, XXXI), London, 1969, 177: "Le buone Muse, Clio, Calliope, Erato, Euterpe, Melpomene, Polyhymnia, Therpsicore, Thalia et Urania. La madre Mnemosine,

The personification of Truth, the figure of Mnemosyne and the depiction of the grove of the Muses in the *aediculae* of the second story of the loggia clearly complement the representation of Apollo with the Muses, and enlarge the intellectual aspect of the decoration of the Casino, as do the panels on the façade of the casino, where Apollo and Aegle, splendour and beauty, are shown with their daughters Eirene, Dike and Eunomia, the "three divine things, Equity and Peace, Justice and Good Law."[6]

However, Eirene, Dike and Eunomia also illustrate the extent to which the various groups or—to return to the metaphor of the play—the various plots are intertwined. While the Hours certainly had this civic and intellectual significance, they also have parts to play in the solar plot, forming parts of Apollo's retinue and symbolizing the Seasons,[7] and they might also find roles with the marines. In *Libro X*, Ligorio once described the three sisters as carrying "urns on their left shoulders, and with their right hands pouring the water from the vases on to the earth; and the three together made a single fountain."[8]

This, in itself, should indicate the flexibility of the five groups just described. In fact, many of the characters in the stucco programme possess a similar ability to switch comfortably from one role to another.

This is certainly true, for example, for the figures in the tabernacles on the court façade of the loggia. While they belong first with Apollo and the Muses and the more intellectual aspect of the decoration of the Casino, they also have an appropriateness to the character of the building as a fountain house. This is most immediately apparent for the relief in the central tabernacle. There the Castalian Spring or the River Helicon pours from the figure's urn, and appears to spill directly into the *cortile* below. Apart from her maternal relationship to the Muses, Mnemosyne has no visible relationship to this fountain. However, on one occasion Ligorio associated Mnemosyne

---

Apollo, Pallade, Hercole, tutti vi furono dipinte, per significare l'opere et gli giorni felici di coloro che sono dediti alle cose megliori, et conducono l'huomo all'immortali piaceri dell'optimo conoscimento, all'alta et profonda cogitatione in vedere con gli occhi dell'intelletto quanto sia maraviglioso il summo opefice che ha fatti i cieli, et la terra tanto varia delli suoi concetti. Ove puote conoscere nelle piante negli animali, la forza et essentia del divino lume." Dacos, appendix II, 161–182, published the complete text of Ligorio's section on grotesques.

  [6] See n. 17, chapter 3. The idea that the Casino was to be understood as a new Parnassus supervised by Pius, a new Apollo, has a precedent in the pontificate of Leo X, another Medici pope. In 1517 Leo was lauded as a true Apollo, and the Vatican hill was described as a new Parnassus with a new Hippocrene spring. In addition, the papal hunting villa, La Magliana, was decorated during the pontificate of Leo with frescoes representing Apollo and the Muses. (See E. B. MacDougall, "The Sleeping Nymph: Origins of a Humanist Fountain Type," *Art Bulletin*, LVII, 1975, 363 and nn. 71, 72.)

  [7] NBN, MS XIII. B. 3, 43–44.

  [8] *Ibid.*, 539: "Le Hore figliole di Hegle et del sole conle Urne sule senestre spalle, et conle mani destre versavano l'acque de vasi interra et facevano tutti tre un solo fonte." See too n. 18, chapter 3.

with the Castalian Spring and described her as carrying a flowing urn.[9] This is surely sufficient to qualify her for the aquatic programme. Truth also has a well-defined role at this second level of significance. In a section of *Libro X* entitled DELLA VERITA Ò VERA ALITHIA, Ligorio mentioned that, according to Democritus, "[Truth] lives in the depths of a well, and it is extremely difficult to draw her out of it." Ligorio amplified on Democritus as follows:

> There are many who, because of the love which they bear for [Truth], drink as much as they can of the water from her well. But they cannot quench their thirst as they would wish, because wicked people often disturb the clearness of the water, or stir it up; or they shake the hand which holds the cup with which they want to drink the water; or, through irreverence, they seek to disturb the clearness and make it tormented. Although the water may be troubled, because of his longing it is sweet to the taste of him who wishes to drink it, and most often it is clear to many good people. But it is always bitter to all the wicked, so long as they do not wish to hear it or taste its clearness. For this reason, some of the ancients have it that Truth emerges from an urn or, one could say, from a large and beautiful vase, accompanied by the Hours, daughters of Aegle and Apollo.[10]

Apart from demonstrating the iconographic consistency of the triptych on the loggia at this alternative level of meaning, this passage is significant in its association of the tabernacles on the loggia with the arched panels on the façade of the casino. Even

---

[9] See n. 47, chapter 3. For a description by Ligorio of a design for a Helicon fountain involving the symbolic presence of Mnemosyne, see D. R. Coffin, "Pirro Ligorio on the Nobility of the Arts," *Journal of the Warburg and Courtauld Institutes*, XXVII, 1964, 199, n. 33: "Fù mostrato un altro disegno, quiui dentro il primo vaso giaceua dentro una donna, che per le mammelle uersaua acqua, et sopra di essa uolaua il cauallo pegaseo, come che significasse il fonte Helicone, . . . nacque il fonte delle Muse donde nascono duoi fiumi secondo fauolano i poeti. Siche uolendo significare esser il fonte della uirtù, et della Memoria."

[10] NBN, MS XIII. B. 3, 630–631: "Democrito finse che essa [Truth] alberga in una profondità di un Pozzo, et è difficilissima a cavarla fuori di quella. Ma il Tempo le buone occasioni qualche fiata la tira et la porge davante alla Giustitia sua sorella. Sono molti che per lo amore che portano a essa beono quanto possono di quell' acqua del suo pozzo, et non si possano cavare la sette come vorrebbono, percioche molte fiate dali scelerati la chiarezza di quell'acque gli tempestano, ò gli muovono ò fanno tremante la mano che tiene la tazza conche la vogliono bere, ò cercano essi con la impietà di commovere la chiarezza fanno travagliata, et quantunque sia travagliata, per lo buone desiderio è dolce algusto a colui che ne desidera di bere è molte volte chiara a molti buoni, et è amara sempre a tutti i tristi anchor che non la voglio sentire, ò assaggiarla con la sua chiarezza. Per questo alcuni degli antichi finsero che la Verità uscisse fuor di un Urna, ò vogliamo dire di un grande et bello Vaso, accompagnata dele Hore figliole di Egle et del Sole."

58

more tantalizing, however, is Ligorio's introduction of the vase as the source of Truth and of the Hours.

Such a vase crowns the central section of the façade of the casino. Cushioned by swags and elaborately framed, it tilts forward in a manner which suggests that it must pour its contents into the *cortile* below. Truth's companions, the Hours, and their parents appear directly below the vase, on the second story. That this association is not coincidental is clear from the fact that most of the personalities mentioned in this passage in *Libro X* and another vase appear, in a comparable situation, in another of Ligorio's manuscripts. Possibly the earliest of Ligorio's surviving manuscripts, it is preserved in the Bodleian Library at Oxford. The relevant folios begin by describing a variation upon the theme of the *Fata Homerica*, allude to the Pandora story, and end with a passage entitled DI IOVE, E' DEL VASO DEL BENE E' DI QVEL DEL MALE (Fig. 44). This last part reads as follows:

> Seated in his high throne, Jupiter commanded the Hours (that is, Eirene, Dike and Eunomia, the seasons and dispensers of good things), his daughters or nieces (because some have it that they are the daughters of Aegle and Apollo, that is of splendour and light), to return into the diaphanous body or . . . transparent vase of goodness and clearness. Thus the Virtues, which had flown back to earth, rise into the heavens to flee human wickedness. And Jupiter also commanded Mercury to shatter that dark vase in which were imprisoned all evils, and lead them back into the dwellings of ungrateful and unjust men; and to conduct there good and bad will, good and bad passions, and good and evil opinion, with free will and opinion. And he gave them wings on their heads, shoulders and feet, so that their speed might confuse the vain intellects of mortals and circumvent the results of their wickedness, and that they might therefore keep man so busy that he would be forced to return to reason and law in order to distinguish good from evil and recognize Justice, and to be free to make his own choices. [Jupiter] kept that vase with all the good things for the good and worthy; and he ordered and swore irrevocably that no ungrateful man, not one, would ever have a share in these good things or in his grace, in order that their pride might not become puffed up by a false and usurped glory. And the good should always hope for the best from good and generous men, giving them Faith, Hope and Charity to accept as they would; and he ordered that good Hope should be their leader, governor and companion; and for the wicked [he ordered] evil, baseless hope and confusion.[11]

[11] MS Canonici Ital. 138, fol. 84v: "Essendo dunque nel suo alto seggio Iove, comando alle Hore

Apart from confirming the relationship between the vase and the Virtues, this passage provides one with an extremely important key to the meaning of a large part of the stucco decoration. Clearly, at least in the immediate context of the Casino, the Hours have escaped from "the diaphanous body or . . . transparent vase of goodness and clearness." Despite their flight from human wickedness, and despite Jupiter's command that Mercury "shatter that dark vase in which were imprisoned all evils," Eirene, Dike and Eunomia, "dispensers of good things," are free to weave their graceful dance on the façade of the casino. Their freedom is emphasized not only by their presence but also by what might be described as the gesture of the vase itself. The larger meaning of this section of the stucco decoration of the Casino is surely clear. Under the benevolent and virtuous protection of Pius IV, the *cortile* of the Casino becomes a privileged, earthly paradise, within which the Virtues are free to roam once more.

---

cio è a' IRENE et a' DICE, et a' EVNOMIE, che sono le stagioni dispensatrici dei beni, sue figliuole è nepoti per che alcuni vogliono siano figliuole del Sole e' di Egle cio è del Splendore e' dela luce, che ritorna dentro al Diaphono corpo ò vogliamo dire trasparente Vaso del bene dla chiarezza e' cosi le Virtu rivolate in terra salliscono al cielo per fuggir le humane tristitie: e comando a Mercurio anchora che rompesse quel Vaso tenebroso in cui erano rinchiusi i mali, e' che raducessi quelli in casa degli ingrati et ingiusti huomini, et vi conducessi la Volutta buona et cattiva; gli appetiti buoni ei cattivi, le buone oppenioni e' le cattive, col libero Arbitrio et oppenioni e' destinandogli con le ali intesta e' sul'gli homeri e' nei piedi, accio che la loro prestezza ingombrassero i vani intelletti e' circuissero l'opere de la scelerità degli huomini mortali, accio che questi occupassero in modo quelli di necessita, che gli fusse mestiero di ricorrere alle ragioni e' regulationi di conoscere il bene dal male, et la Giustitia, et nel resto fusse in liberta di prender qual volessero. E' quel vaso conli beni conservo presso dise per li buoni e meritevoli: et ordino ò giuro come cosa immutabile: che niuno ingrato gia niuno mai participasse ne di quelli beni felici ne dela sua gratia accio che la superbia loro non facessi prode nell'arrogata et falsa gloria; et gli buoni dovessero sperare sempre bene dai buoni e' Generosi dandole la fede, La Speranza e' la charita per loro cogliere, et ordinò che la buona Speranza fusse loro duce e' governo e' comite; alli cattivi la mala e' ingiusta speranza et la confusione." On this manuscript, see T. Ashby, "The Bodleian Ms. of Pirro Ligorio," *Journal of Roman Studies*, IX, 1919, 170–201; and Coffin, "Ligorio," II, 148–151. A large vase, inscribed VIRTVTVM OMNIVM VAS, appears in Vasari's posthumous portrait of Lorenzo the Magnificent in the Uffizi. (Illustrated in E. Rud, *Vasari's Life and Lives*, London, 1963, Pl. 22. Rud's reproduction, like all the others which I have seen, is cropped slightly at the sides, truncating two of the explanatory inscriptions.) The vase is balanced upon a brutish, bearded mask which symbolizes Vice, and on the plinth below that appears the inscription VITIA VIRTVTI SVBIACENT. The spout of the vase passes through the eye of "una maschera pulita, bellisima," and is inscribed PREMIVM VIRTVTIS. Apart from corroborating the interpretation presented here of the vase at the Casino, this perhaps substantiates further the suggestion made in chapter 2 that Pius IV intended to identify himself as far as possible with the traditions of the Florentine Medici. (For Vasari's own exegesis of the portrait of Lorenzo, see his letter to Alessandro de' Medici at Poggio a Caiano, published in K. Frey, *Die literarische Nachlass Giorgio Vasaris*, Munich, 1932, 17–20.) Another vase, this time inscribed VIRTVTES, appears associated with a Fame in a relief on the tomb of Girolamo and Marcantonio della Torre in S. Fermo, Verona. (See E. Panofsky, *Tomb Sculpture*, New York, n.d., Fig. 299.)

The significance of Truth's appearance on the façade of the loggia is essentially the same. Truth had suffered through an earthly odyssey which was similar in many respects to that experienced by the Hours. According to Ligorio, she too was once sent to earth among mortals, but was so badly treated that Jupiter commanded her to return to his more orderly heaven.[12] As did the Hours, Truth fled the wickedness of the world only to be imprisoned within a miserly vase,[13] and, as is the case with the Hours, at the Casino Truth too is freed to grace a perfect place.

In a sense, the vase is the *deus ex machina* in the Casino's play. While it does not bring about a complete denouement, it does associate a number of the characters in a common theme, which, in turn, can absorb a number of the remaining figures. As Memory, Mnemosyne epitomizes an intellectual truth, is a proper companion for Truth herself, and is a suitable addition to the population of the ideal world of the Casino.[14] The same surely applies to Apollo and the Muses. In addition to symbolizing higher things, they actively lead men to "the everlasting pleasures of the greatest knowledge, to high and profound meditation on seeing with the eyes of the mind how wonderful is the Prime Mover who made the heavens and the earth, so varied in its inspirations."[15] The larger implications of all this is that the Casino of Pius IV is a place so pleasant, so perfect and so privileged that Apollo, the Muses and Mnemosyne can adopt it as another grove of the Muses; and Truth and the Virtues personified by Eirene, Dike and Eunomia can happily inhabit it.

This is a great and graceful compliment to Pius IV's management of his retreat in the Vatican gardens, and ultimately is more impressive than the sum of all the inscriptions, Fames and Victories. However, this comparison of the commemorative and the humanistic or intellectual programmes in itself implies their fundamental relationship. Together, they form a larger and more comprehensive programme, which can be described as the programme for the patron.

If a large part of the stucco decoration of the Casino directly or indirectly compliments Pius IV himself, the remainder equally clearly complements the architectural complex. On the one hand, the aquatic scenes constitute a programme singularly appropriate to a fountain house. On the other, the pastoral, seasonal and solar decoration

---

[12] NBN, MS XIII. B. 3, 630: "Dicono che questa [Truth] fù mandata interra tra mortali . . . incompagnia della Giustitia, della Vergine, della pudicitia, della Concordia, et della Fede, essendo prima malamente trattata dalli principi, dalli Adulatori, poscia dalli advocati, et ultimamente dalle femine et da molte maligne persone, la onde per comandamento di Giove si partirono tutte le sorelle insieme dal cospetto humano si nascosero, et La Verità singolamente da esse si parti, et sene volò incielo."

[13] See n. 10 above. For another case in which Truth is associated with a vase, see NBN, MS XIII. B. 3, 632: "Vogliono anchora che il licore della discrettione La Verita il tiene sempre seco in uno vasetto, per che è sempre poco."

[14] See n. 41, chapter 3.       [15] See above n. 5.

reflects the sympathetic relationship between the Casino and nature, much as the fountains themselves reflect the changing appearance of their surroundings, much as the sun tells the days, and much as season succeeds season.

The five groups distinguished within the stucco decoration of the Casino can now be gathered into two larger and ultimately complementary programmes: one which reflects the humanistic and intellectual aspirations of Pius IV; and one which reflects the character of the Casino as a fountain house and pastoral retreat.

In spite of the tradition for employing pagan or secular imagery in sixteenth-century villa decoration, the total absence of Christian imagery from the stucco decoration of the Casino is rather astonishing. The stucco decoration gives one no indication of the crucial role which Pius IV was to play in the religious drama of the sixteenth century. Pius IV's plans for a General Council were crystallizing more than six months before the first payment was made for the stucco decoration, and he appointed the first legates to the Council almost two years before the stucco work was completed, but there seems to be no hint of this in the stucco programme.

Despite all appearances to the contrary, however, the stucco decoration does conceal a Christian allegory, and God does have His place in the sun at the Casino of Pius IV.[16] Among the emblems collected and published by Jacobus Typotius there is one belonging to Gian Angelo de' Medici (Fig. 45).[17] The engraving shows the sun streaming down upon an ivy-encircled tree, and the motto reads VIX NATA SVSTENTOR. The first sentences of Typotius' commentary explain that the ivy is Gian Angelo de' Medici, the tree is the pope (presumably Paul III, to whom Medici owed his elevation), and the sun is God Himself. The tree feeds and supports the ivy, and, in turn, draws its nourishment and life from the sun. In the same way, the cardinal draws his spiritual nourishment from the pope, and the pope absorbs the divine light of God Himself. Apollo's prominence in the stucco programme and the importance of the sun's physical presence in the *cortile* of the Casino must reflect the allegory of this emblem. Apollo is the sun, and the sun is God Himself. Ultimately, then, it is God who warms and nourishes the *boschetto* containing Pius IV's Casino, just as, presumably, He illuminated Pius himself, after his elevation to the papal throne. Similarly, Pius IV's cardinals and companions, indebted to him for the Casino and

---

[16] On the conflicting attitudes towards the allegorical interpretation of mythology in the second half of the sixteenth century, see J. Seznec, *The Survival of the Pagan Gods*, New York, 1953, 269–278.

[17] *Symbola divina et humana Pontificum, Imperatorum, Regum*, II, Prague, 1602, 11, 14: "Siue de arbore, Mysta, siue de Hedera loquitur, verum est Symbolum: vix nata sustentor. Nam arborem Sol a stirpe fouet: Arbor Hederam. Nec obscura est, clara imago, aut latens sententiae sententia. Nam ut sol arborem, & arbor hederam sustentat: ita se a Pont. Max. prouectum, hunc à Deo ad illud fastigium honoris, intelligit euectum."

its amenities (as the inscription on the façade of the casino made clear), become the clinging and encircling ivy of Gian Angelo de' Medici's emblem.[18]

[18] The article by M. Fagiolo and M. L. Madonna, "La Roma di Pio IV: la 'Civitas Pia,' la 'Salus Medica,' la 'Custodia Angelica,' " *Arte Illustrata*, V, 1972, 388–402, became available to me after this chapter was completed. The authors make a number of interesting suggestions regarding the meaning of the stucco decoration of the Casino, and those can be assimilated comfortably into the argument presented here. They suggest that much of the stucco decoration promises a new golden age, to be characterized by peace, prosperity and abundance (384–385). In this context, they associate Aurora with Astraea, who inhabited the earth during the golden age, and quote a passage from one of the Turin manuscripts demonstrating that Astraea's career was remarkably similar to those of the Hours and Truth, as described here. The section dealing with the "Salus Medica" (388–390) is particularly interesting, and adds a dimension to that part of the programme which presents the qualities of Pius IV. Apart from the Hygieia and Apollo (which are stressed by Fagiolo and Madonna), it is worth mentioning that Asclepius himself once graced the "Fosso attorno alla Palazzina." (See Michaelis, "Belvedere," appendix II, no. 62.) The suggestion that Pius might be identified with Apollo and Christ is fully in keeping with Gian Angelo's emblem (Fig. 45) and with Pius IV's status as *Vicarius Christi*; and the triangular nature of the relationship is strengthened by the fact that Apollo, Christ and Pius were all *Medici*. Apollo was often given the title *Medicus*, and Ambrose and Augustine, among others, emphasized Christ's powers of healing. (See J. P. Migne, *Patrologiae cursus completus, Series Latina* [hereafter P.L.], CCXIX, Paris, 1879, col. 134, *Christus medicus*.) For an intensive treatment of the therapeutic symbolism surrounding Leo X, an earlier and more famous Medici pope, see J. Shearman, *Raphael's Cartoons in the collection of Her Majesty the Queen and the tapestries for the Sistine Chapel*, London, 1972, 15, 17, 77–78. Fagiolo and Madonna's later article, "La Casina di Pio IV," and my "The Stucco Decoration of the Casino of Pio IV" appeared within a few weeks of each other. Fagiolo and Madonna draw mainly on Ligorio's late manuscripts in Turin, rather than the Neapolitan manuscripts which are more or less contemporary with the Casino. Nonetheless, our interpretations converge on many points, although we approach the material in rather different ways. To attempt to assimilate Fagiolo and Madonna's article into this and the preceding chapter would be rather like trying to create a harmonious composition from the tesserae of two superficially similar mosaics. For this reason, apart from paraphrasing or translating the extracts from *Libro X*, I have not altered the text of my article.

For an excellent, recent discussion of the importance and meaning of the *boschetto* and nymphaeum in sixteenth century Italian gardens, see E. MacDougall, "*Ars Hortulorum*: Sixteenth Century Garden Iconography and Literary Theory in Italy," in *The Italian Garden* (First Dumbarton Oaks Colloquium on the History of Landscape Architecture), ed. by D. R. Coffin, Dumbarton Oaks, Washington, D.C., 1972, 37–59. Although the author does not specifically discuss the Casino of Pius IV, her paper is relevant to it in a variety of respects.

# CHAPTER FIVE

# The Interior Decoration

Not much time passed before Cardinal Emulio, to whom the Pope [Pius IV] had given the responsibility, commissioned many young artists (so that the work would be finished promptly) to paint the little palace in the *bosco* of the Belvedere. Begun during the pontificate of Paul IV, it is decorated with many antique statues and a most beautiful fountain, the architecture and design being by Pirro Ligorio. The young artists, who worked to their great honour in this place, were Federico Barocci of Urbino, a young man of great promise, and Lionardo Cungi and Durante del Nero, both from Borgo San Sepolcro, who were responsible for the rooms of the first floor. The Florentine painter Santi Titi painted the first room at the top of the spiral staircase, and acquitted himself extremely well; and Federigo Zucchero, brother of Taddeo, painted the principal room, next to this; beyond this room Giovanni dal Carso the Slav, an excellent master of grotesques, painted another room. Although each of the above performed very well, nonetheless Federigo surpassed all the others in some scenes from the life of Christ which he did there, such as the Transfiguration, the Marriage at Cana and the Miracle of the Centurion's Servant; and of the remaining two scenes Orazio Sammacchini the Bolognese painter did one, and the other was done by Lorenzo Costa of Mantua. Federigo Zucchero also painted the little loggia which overlooks the fish pool.[1]

THIS account of the fresco programme of the Casino of Pius IV carries an unusual authority. It forms part of Vasari's life of Taddeo Zuccaro, a life which was edited, after its publication, by Federico Zuccaro, Taddeo's brother and one of the main participants in the interior decoration of the Casino. It is clear from Vasari that only three of the artists were of major significance: Santi di Tito, "who acquitted himself extremely well," Federico Barocci, the "young man of great promise," and Federico Zuccaro, who surpassed all the others. However, the background to the allocation of the commissions was almost certainly more complex than Vasari sug-

[1] Vasari-Milanesi, VII, 91–92.

64

gested, and politics were probably at least as important as speed in deciding who received the work.

Barocci and Federico Zuccaro were steeped in the tradition of Raphael, and this had certainly recommended them to Pirro Ligorio, whose sympathy with the school of Raphael and antagonism towards Michelangelo were well-known.[2] Beyond this, the selection of two painters from the Duchy of Urbino was consistent with the alliance implied by the marriage in May 1560 of Federico Borromeo, one of the nephews of Pius IV, to Virginia della Rovere, daughter of Guidobaldo II, Duke of Urbino. In fact, the Duke was in Rome when his daughter entered the city in December 1560, and was therefore in a position to influence the selection of the painters to decorate the Casino.[3]

Guidobaldo II and his son, Francesco Maria II, were the most important patrons of Federico Barocci's maturity, but the Della Rovere family also had a significant role to play in his early career in Rome. On his first visit to Rome Barocci painted a portrait and other pictures for Cardinal Giulio della Rovere, and this protection continued during the period of his activity in the Casino. When Barocci became dangerously ill, shortly after the completion of the decoration of the Casino, Giulio della Rovere looked after him and called in the very best doctors.[4]

The Zuccari also had a long-standing relationship with Guidobaldo II. In 1551 Guidobaldo summoned Taddeo Zuccaro to Urbino to complete the decoration of the choir of the cathedral. Although this project was not completed, Taddeo did paint a number of portraits for the Duke, and he carried out a variety of decorative projects during the two years which he spent in the Marches.[5] Probably in May 1560, Taddeo returned to Urbino to paint a portrait of Virginia della Rovere on the occasion of her marriage to Federico Borromeo. At that time, Taddeo was also commissioned to make designs for a maiolica service, which Guidobaldo intended to present to Philip II of Spain, and it is possible that Federico collaborated with his brother on this commission.[6]

In addition to his close association with the court of Urbino, Taddeo Zuccaro had also been involved with the papal court since the beginning of Julius III's pontificate. He painted various decorations for Julius' coronation, had a sizeable role in the decoration of the Villa Giulia, and painted in the Belvedere of Innocent VIII.[7] During the pontificate of Paul IV, Taddeo painted in the tower of Nicholas V and in an apartment

---

[2] Coffin, "Pirro Ligorio on the Nobility of the Arts," 193, 205–206.

[3] Pastor, *Popes*, xv, 98–101.

[4] Bellori, *Vite*, 171–174.     [5] Gere, *Taddeo Zuccaro*, 30–31.

[6] Gere, "Taddeo Zuccaro as a Designer for Maiolica," *Burlington Magazine*, cv, 1963, 313–314; and Gere, *Taddeo Zuccaro*, 93, n. 2.

[7] Vasari-Milanesi, vii, 79, n. 1, 81–82.

65

adjacent to it.[8] Finally, Pius employed Taddeo from the very beginning of his pontificate. During 1560 he had him paint in various locations in the Vatican Palace and in the Palazzo di Aracoeli.[9]

Taddeo Zuccaro's involvement with the papal court and the Della Rovere family meant that he was in an ideal position from which to promote his younger brother. In any case, by October 1561 Federico Zuccaro had completed an independent commission in the Vatican.[10] In November of the same year he received his first payment for the decoration of the Casino of Pius IV, and in December he received a further payment for the Casino, the Torre Borgia and the Ruota.[11] Federico's graduation to independent status took place smoothly, and, almost certainly, the credit and the blame were partly Taddeo's.

Probably Taddeo Zuccaro also helped Barocci make his way into the Vatican, and he may even have encouraged him to return to Rome soon after the beginning of Pius IV's pontificate. According to Bellori, Taddeo looked after Barocci on his first visit to Rome, and this relationship was probably resumed when he returned to Rome. Such generosity was characteristic of Taddeo, and was probably a reaction to the difficulties which he had experienced in making his own start in Rome.[12]

It is likely that Taddeo maintained a discreet interest in the decoration of the Casino even after the commissions had been awarded. In at least one case, Federico Zuccaro used a drawing by his brother for the decoration of the Casino,[13] and Barocci's continuing reference to Taddeo is also clear when one compares his preparatory studies for the Casino with Taddeo's drawings from the same period.[14]

---

[8] *Ibid.*, 84; and Ackerman, *Cortile*, 85, documents 121, 124, 126.

[9] Vasari-Milanesi, VII, 90–91.

[10] On 31 October 1561 Federico Barocci was paid fifteen *scudi* for painting a "Giustizia et Equita fatta intorno all Arme di N° S°ʳᵉ nel Tribunal della Ruota" (ASR, *CF*, 1520, fol. 78, and ASR, *CF*, 1521, fol. XXXIII v). In 1563 the fifteen *scudi* were deducted from the total payment to Barocci and his associates and transferred to Zuccaro's account, with the explanation that "quale errore nacque dalli istessj nomi" (ASR, *CF*, 1520, fol. LXXVIII).

[11] In November Federico Zuccaro received 25 *scudi* "a conto della Pittura della quinta stanza del Boschetto" (ASR, *CF*, 1521, fol. XXXVII r), and in December he received a further 25 *scudi* "per la quarta stanza del Boschetto e per lo fregio di Torre Borgia e per la Rota" (*ibid.*, fol. XL v). Zuccaro received an earlier payment, in November 1561, "per la Pittura d'una delle stanze del Boschetto e per la Ruota e nella camera di Torre Borgia" (*ibid.*, fol. XXXVIII r).

[12] Bellori, *Vite*, 171ff. In addition to Barocci and Federico Zuccaro, artists such as Girolamo Muziano, Bartolomeo Passarotti and Niccolò Martinelli seem to have had access to Taddeo's drawings. (See J. A. Gere, "Girolamo Muziano and Taddeo Zuccaro: A Note on an Early Work by Muziano," *Burlington Magazine*, CVIII, 1966, 417–418; and J. A. Gere, "Drawings by Niccolò Martinelli, Il Trometta," *Master Drawings*, I, 1963, 8.)

[13] G. Smith, "A Drawing for the Interior Decoration of the Casino of Pius IV," *Burlington Magazine*, CXII, 1970, 108–110.

[14] Gere, *Taddeo Zuccaro*, 66–67.

The reasons for the selection of Santi di Tito are less clear. Born in Sansepolcro and trained in Florence, he is thought to have moved to Rome in 1558 or 1559. He remained there until late 1563 or early 1564, decorated a chapel for Bernardo Salviati in his palace on the via della Lungara, and received payments for work in the Vatican between November 1561 and June 1563.[15] Michelangelo's influence on the Roman works makes it clear that Santi di Tito did not win his commission in the Casino by being a follower of Raphael. The Salviati Chapel is generally believed to have been Santi di Tito's first Roman commission and, in a sense, the source of his other commissions. However, it is likely that his work in the Casino was in fact earlier.[16] Nonetheless, an association with Bernardo Salviati may have been behind Santi di Tito's receiving a share in the decorative programme of the Casino.

Bernardo Salviati was a grandson of Lorenzo the Magnificent and a nephew of Leo X. In a sense, he was more of a Medici than Pius himself. Pius had cultivated the Florentine Medici earlier in his career, and set out to consolidate the relationship in the first year of his pontificate. In his first creation of cardinals, in January 1560, Pius made Giovanni de' Medici a cardinal, and he entertained Cosimo I in Rome during November and December of the same year. At that time, it was generally believed that Pius would confer a royal title upon Cosimo.[17]

It is possible that Santi di Tito ranked as a member of the larger retinue of Cosimo I, in which case he may have received a share in the decoration of the Casino as a result of Medici affiliations, much as Barocci and Federico Zuccaro benefited from their connections with the Della Rovere family.

The accounts confirm Vasari's description of the decoration of the Casino. Payments to Federico Barocci and his associates began in November 1561, and continued at regular intervals until October 1562. The final payment was entered on 10 June 1563. It specified that the work was done in the two rooms of the first floor, recorded that it was estimated at a total of 1,303 *scudi* and 50 *bolognini*, and emphasized that this amount was to be divided among Pierleone Genga, Barocci and four others.[18]

[15] G. Arnolds, *Santi di Tito, pittore di Sansepolcro*, Arezzo, 1934, 5–19.

[16] Pius IV made Salviati a cardinal in his second creation of cardinals, in February 1561. (See Chacon, *Vitae*, III, 907 v.) The cardinal's arms, joined with those of Pius, appear in an oval frame in the centre of the vault of the chapel. (Illustrated in Arnolds, *Santi di Tito*, Pl. II.) Unless one wants to argue that part of the programme was executed in 1559, and that the coat of arms was added in 1561, the decoration must date after Salviati's elevation. In fact, the paintings in the Salviati Chapel are more accomplished than those by Santi di Tito in the Casino, and the organization of the decoration, particularly the treatment of the centre of the vault, seems to depend upon the scheme used by Barocci in the second room of the casino.

[17] Pastor, *Popes*, xv, 100.

[18] ASR, *CF*, 1521, fol. LXXX: "Per resto et compito pagamento del suo Lauoro fornito che sia, quale è in Belu^re nelle due stanze al p° piano del boschetto di pittura, stucco, et doratura qual opera gliè stata stimata tutta insieme in somma di mille trecentotre scudi 50 bolognini . . . ma è da sapere

Giovanni Pietro Bellori described Barocci's work in the Casino in *Le vite de'* *pittori, scultori ed architetti moderni*, and his description compensates to some extent for the succinctness of Vasari's account and the neutrality of the records of payments. According to Bellori, in one room (Fig. B, i; Figs. 46–50) Barocci painted "the Virtues seated in the four corners and a frieze with *puttini*. Each of the Virtues holds a shield with the name of the pope. In the centre of the vault he painted the Virgin and the Infant Jesus. The Infant extends His hand to the young St. John, presenting the reed cross to him; and St. Joseph and St. Elizabeth are also there." In the vault of the next room Barocci painted the *Annunciation* (Fig. B, ii; Fig. 52), "in which the figures are smaller, but exceptionally well executed."[19] Barocci painted six of the Virtues rather than eight, and he was responsible for a number of other figures in the first room, but the surviving drawings do confirm Bellori's description in essentials.

Only seven Barocci drawings for the Casino had been recognized when Friedlaender published *Das Kasino Pius des Vierten*. More recently, Harald Olsen listed seventeen drawings associated with the decoration of the first two rooms of the interior. The drawings can be gathered into three relatively distinct categories: some drawings appear to be for the over-all decorative scheme or for details within it; more common are studies for individual figures within the general scheme, such as the Virtues in the corners of the coves or the personifications in the central sections of the long coves (Figs. 54a, 54c); and the majority are preparatory studies for the major compositions in the centres of the vaults, the *Holy Family with St. John, Elizabeth and Zachariah* (Figs. 51a, 54b, 54d, 54e), and the *Annunciation* (Fig. 52a).[20]

Earlier writers believed that a sheet in the Uffizi (Figs. 53a, 53b), containing three studies for the decoration of a vault supported by pendentives, represented Barocci's preliminary ideas for the general organization of the first two rooms.[21] There

---

che in detto m^to ui sono stati nominati compagni insieme m° Leonardo dal Borgo, et m° Dante scultore et m° Giouanni da Montepulciano, et m° Filippo Gamberasi stuccatorj et questo pche erano tutti compagni insieme benche tutti li denari p^a hauutj fossero caminati in nome solo di m° Federigo borrocchio, et m° Pier Leone Zenga."

[19] *Vite*, 173–174.

[20] For information on the drawings, see Olsen, *Barocci*, Cat. No. 8. Olsen mistakenly identified the figure on the *recto* of Uffizi 11281 F (Fig. 54c) as a study for *Felicitas* (Fig. 47). As Friedlaender recognized (*Kasino*, 110), the drawing is in fact a finished study for the figure to the left of the *Baptism* (Fig. 46). Unfortunately, catalogues of the great Barocci exhibitions held in Bologna and Florence late in 1975 came to hand too late to be taken into account here. (A. Emiliani and G. G. Bertelà, *Mostra di Federico Barocci* [ix Biennale d'arte antica], Bologna, 1975, and G. G. Bertelà, *Disegni di Federico Barocci* [Gabinetto disegni e stampe degli Uffizi, xliii], Florence, 1975.)

[21] 907 E. The drawings on the *recto* were connected with the Casino by A. Schmarsow, "Federigo Baroccis Zeichnungen in der Sammlung der Uffizien zu Florenz," *Abhandlungen der philologisch-historischen Klasse der Königlich Sächsischen Geselleschaft der Wissenschaften*, xxvi, 5, 1909,

are two drawings on the recto (Fig. 53a), one on either side of a central fold, and there is a third on the verso (Fig. 53b). Apart from the treatment of the corner compartment in the study to the left of the fold, the relationship between the drawings on the recto and the completed decoration is of a rather general kind. Some details, such as the oval central field, appear to associate the drawings with the second room, while others seem to connect them with the first room.

The drawing on the verso is quite different from the decoration actually carried out in the Casino. It experiments with an architectural extension of the vault, similar to the scheme employed by Raphael for the third and fifth bays of the *Logge*, and aims at a complete illusionism and a thorough confusion of paint, stucco and reality. In fact, there is a detail which removes this drawing still further from Pius IV's Casino. Seated on a cornice above the pendentives are three *putti* who support large oval escutcheons. Although the coats of arms are represented in a general manner, there is sufficient detail to prove that they do not belong to Pius IV. The fields are quartered, and, in the case of the larger shield, the dexter base has diagonal hatching and the sinister base has vertical hatching. Pius IV's almost obsessive fascination with his own coat of arms is well-known, and it is unlikely that Barocci forgot it, even at the early stage of a preparatory study. In fact, the coat of arms in the Uffizi drawing almost certainly belongs to a member of the Della Rovere family, and may belong to Cardinal Giulio della Rovere (Fig. C), mentioned earlier in this chapter as Barocci's first Roman patron.[22]

However, there are two less familiar drawings which do demonstrate Barocci's responsibility for the organization of the decorative programme of the first room.

In the Detroit Institute of Arts is a preparatory study for the central section of one of the long coves of the first room (Fig. 55).[23] In pose and in the arrangement of her draperies, the figure on the right-hand side of the drawing compares closely with the woman on the right of the *Baptism* (Fig. 46). The Detroit drawing came early in Barocci's preparation, and a great many alterations were made between the drawing and the final decoration. The elaborate, tasselled canopy was discarded, and in the

---

33–34, XVIII. Friedlaender, *Kasino*, 104, noted that the drawings show a vault supported by pendentives, but explained this by suggesting that the studies were done before the final form of the vaults was settled. Olsen, *Barocci*, 46, seems to accept this explanation.

[22] For Cardinal Giulio della Rovere's coat of arms, see Chacon, *Vitae*, III, 730. In this context, it is interesting that in September and November 1560 Pietro Venale, who later worked in the Casino, received three payments, amounting to fifty *scudi*, "a conto della Pittura che fa nell Appartamento del sacro Palazzo doue alloggia il cardinal d Urbino" (ASR, *CF*, 1520, fol. 30). On the other hand, since there is no sign of a cardinal's hat over the coat of arms, the drawing may be connected with some unrecorded project for Guidobaldo II.

[23] 34. 139. On this drawing, see G. Smith, "Two Drawings by Federico Barocci," *Bulletin of the Detroit Institute of Arts*, LII, 1973, 83–91.

Figure C. Arms of Cardinal Giulio della Rovere. From A. Chacon, *Vitae et res gestae Pontificium Romanorum et S. R. E. Cardinalium*, iii, Rome, 1677, 730, LXVI

fresco the women are associated instead with great swags of fruit, flowers and vegetables. The woman on the left side of the drawing is essentially the mirror image of her companion, and Barocci was obviously unsatisfied with this element of repetition. In the final scheme she assumes an independent pose, one leg slung across the other and her head tightly encircled by the curve of her arm. Clearly, Barocci's ideas became more elaborate as he worked on this section of the vault.[24]

However, Barocci was also an economical artist. Rather than entirely discarding the ideas contained in the Detroit study, he used them in other sections of the decoration of the first room. The general composition was adapted for the organization of the corners of the coves (Figs. 47–50), and the canopy became a perfect motif for successfully filling the awkward spaces at the apexes of the coves. Similarly, the knotted draperies and blazing chalice reappear in rather modified form in the short coves at either end of the room (Figs. 46, 56).

The second drawing (Fig. 57) refers to the central panels in the short coves, and concentrates on the arched head of the stucco frame and the painted area above.[25]

[24] There is a squared drawing for the left-hand figure in the Uffizi (11281 F., *recto*). Schmarsow, "Federico Baroccis Zeichnungen," 33, xvii, was the first to connect this drawing with the Casino. (Illustrated in Friedlaender, *Kasino*, Fig. 29, and Smith, "Two Drawings by Federico Barocci," Fig. 5.)

[25] *Urbania, Biblioteca Comunale*, No. 275, *recto*. L. Bianchi, *Cento disegni della Biblioteca*

70

Again, there are significant changes between the preparatory study and the completed panel. The *putti* become more child-like and frivolous, appear less constricted by the segments of the stucco frame, and are less reminiscent of Michelangelo's Times of Day in the Medici Chapel. In this case, too, there exists a drawing which came between the composition study and the completed decoration (Fig. 58). Exhibited at Colnaghi's in 1965, it is a finished study for the head of the right-hand child.[26]

Clearly, Barocci worked with a number of assistants in the first room of the casino. The accounts tell us as much, and they are confirmed by the range in style and quality. Justice and Immortality (Fig. 50), the *Navicella* and its flanking personifications (Fig. 59), the *Baptism* (Fig. 60), *Christ and the Samaritan Woman* and *Christ and the Adulteress*[27] appear to have been painted by one artist, probably Pierleone Genga who certainly worked from Barocci's designs.[28]

In the second room Barocci painted only the *Annunciation* (Fig. B, II; Fig. 52), as Bellori stated. The grotesques and the majority of the smaller scenes seem to be the work of the assistants who painted in the first room (Figs. 61–66).

Attached to the corners of the frame of the *Annunciation* are eight small paintings which illustrate the Joseph story (Figs. 62–64, 67–70). Despite the miniature scale, the scenes are extremely lively and imaginative. Poses are sometimes highly ambitious, compositions are elaborate and the settings are often quite complex. The artist responsible for their design was obviously familiar with Michelangelo, and there are also clear references to Taddeo Zuccaro. These scenes were probably also painted by Genga, again with Barocci's help.

In subject matter and style the allegories in the stucco frames (Figs. 62–64) are quite different from the other paintings in the second room and from the entire

---

*Comunale di Urbania*, Urbania, 1959, Cat. No. 1, published the drawing, and connected it with the first room of the casino. On the *verso* is a study of a *putto* from the waist down, seen from the rear. This compares in a general way with the infants in the frieze of the first room. However, it is in fact a study drawing, done after the *putto* with Neptune's trident, in the loggia of the Villa Farnesina.

[26] *Old Master Drawings*, Cat. No. 3, Pl. II. Dr. Harald Olsen kindly brought this drawing to my attention, and suggested that it might be connected with the Casino.

[27] *Christ and the Samaritan Woman* and *Christ and the Adulteress* are illustrated in Friedlaender, *Kasino*, Pl. XXI.

[28] *Ibid.*, 71–72, separated the *Navicella* and its personifications from the other paintings mentioned here. Olsen, *Barocci*, 143, discussed them as a unified group. Apart from the relationships between Justice and Immortality and Barocci's Virtues and between the personifications flanking the *Navicella* and those on either side of the *Baptism*, a Barocci drawing in the *Biblioteca Comunale*, Urbania (No. 258), was used for Christ in the *Baptism*. (See Smith, "Two Drawings by Federico Barocci," Fig. 7, 87 and nn. 10, 11.)

decoration of the first. The question of their attribution will be discussed slightly later in this chapter.[29]

According to Vasari, Federico Zuccaro painted the interior of the loggia (Fig. B, III; Fig. 71) and a room on the second story of the casino. The accounts confirm this, and suggest that he also contributed to the room above the entrance portico, identified in the accounts as the *galleria* (Fig. B, IV; Figs. 73–76). Payments to Zuccaro began in November 1561, and continued until October 1562. The final payment, entered in September 1563, was made to Federico Zuccaro, Lorenzo Costa and their associates, and specified the third room on the second story of the casino and the loggia overlooking the fish pool.[30] The reference to the loggia is quite clear, but the identity of the room on the second story is less so. Earlier payments to Zuccaro had specified the fourth and fifth rooms, *la stanza magg^re del appartam. di sopra* and the *stanza grande di sopra*.[31] The final payment to Giovanni da Cherso refers to the "fourth room or *galleria*," and proves that the fourth room was in fact the *galleria*.[32] This being the case, the fifth room must be the *stanza magg^re* or *stanza grande di sopra*, and must be the room which Vasari described as containing scenes from the life of Christ. This was confirmed by Zuccaro himself when he corrected Vasari's statement attributing to him three of the histories. Federico wrote that he had not painted the scenes from the life of Christ, but stated that they had been done from his drawings.[33]

Federico Zuccaro's contribution to the *galleria* (Fig. 73) is less easy to define. Friedlaender believed that Giovanni da Cherso was responsible for the major part of the decoration, and restricted Zuccaro's contribution to three small paintings, one at the centre of each section of the tunnel vault.[34] The main scene, in the central section of the room, represents the *Mystic Marriage of St. Catherine* (Fig. 74). At the north end is a St. Paul, and the corresponding frame at the south end was certainly intended to contain a St. Peter. In fact, Chattard had attributed the *Mystic Marriage of St.*

---

[29] Friedlaender, *Kasino*, 78–80, suggested that Genga was responsible for the Joseph scenes and the allegories.

[30] ASR, *CF*, 1521, fol. LXXXVIII r: "A m° Federigo Zuccaro et m° Lorenzo Costa pittori, et compagni dugentocinquanta scudi fattogline m:^to conditionato per resto, et compito pagamento di più opere di pittura, stucco et doratura fatte nelle ope palatine forniti che sieno certi pochi residui, cioè la terza stanza di sopra nel boschetto in Belu:^re di pittura, stucco et oro et la loggietta attaccata all'ouato in detto luogo da basso che guarda sopra la peschiera di pittura sola . . ."

[31] See Friedlaender, *Kasino*, 130–131.

[32] ASR, *CF*, 1521, fol. LXXXVII v: "A m° Giouannj da Cherso Venitiano pittore . . . p resto, et compito pagamento del suo lauoro fatto di pittura, stucco et doratura nella quarta stanza ouero galeria di sopra alle stanze del boschetto in Belu^re . . ."

[33] Vasari-Milanesi, VII, 92, n. 1. For a more detailed discussion of Zuccaro's responsibility for this room, see Smith, "A Drawing for the Interior Decoration of the Casino."

[34] *Kasino*, 92–94.

*Catherine* to Zuccaro in the eighteenth century.[35] The composition is very similar to that of Federico's almost precisely contemporary *Adoration of the Magi* in S. Francesco delle Vigne in Venice, and details, such as the dogs accompanying the young St. John, confirm Chattard's attribution.[36]

Federico Zuccaro's part in the decoration of the *galleria* may have been considerably more extensive than Friedlaender believed. The decoration of the *galleria* is more self-consciously archaeological than that of any other room at the Casino. Its yellows, ochres and blacks are typical of late-antique wall paintings, some motifs have precise antecedents in the *Domus Aurea*, and others have equally clear sources in Raphael's *Logge* (as Chattard observed) or the *Stufetta* of Cardinal Bibbiena. This academic quality and the fact that a number of the small paintings in the frieze have points of contact with known works by Federico suggest that he was responsible for the general design of the room, and that Giovanni da Cherso's role was that of executant.[37]

According to the estimate of his work made in June 1563, Santi di Tito was paid for two rooms in the casino, "the vault over the stairwell . . . and the first room which one enters from the said staircase."[38] The reference to the vault of the stairwell (Fig. 77) is unambiguous, but the identity of the second room is less clear. Friedlaender believed that it was the room on the second story with the scenes from the life of Christ (Fig. 78), but there are a number of objections to this, the principal ones being that the room was almost certainly decorated by Federico Zuccaro and his assistants and is *not* the first room which one enters after climbing the stairs. In fact, the first

[35] *Nuova descrizione*, III, 249: "Vien rappresentata a buon fresco nello specchio di mezzo la Sacra Famiglia, tavaglio di *Federigo Zuccheri*, il quale attorniato viene da diversi Cammei, quadretti, e tondi ad uso delle Loggie di Raffaelle." Friedlaender, *Kasino*, 93–94, identified this scene as a *Rest on the Flight into Egypt*. In his review of Friedlaender, Schmarsow suggested that the painting represented the visit of Elizabeth and the Infant John the Baptist to the Virgin and Child, shortly after the Nativity. (A Schmarsow, "Das Gartenhaus Pius' IV.," review of *Das Kasino Pius des Vierten*, by W. Friedlaender, in *Deutsche Literaturzeitung*, XXXIII, 1912, 908.) In fact, a fragment of St. Catherine's spiked wheel is clearly visible, and, guided by Mary, the Infant Christ extends His hand to place the ring on Catherine's finger.

[36] For the *Adoration of the Magi*, see W. R. Rearick, "Battista Franco and the Grimani Chapel," *Saggi e memorie di storia dell'arte*, II, 1958–1959, 136–137, Figs. 22, 23. For similar dogs, see drawings by Zuccaro in the Louvre and British Museum. (*Le XVIe siècle européen: dessins du Louvre*, Paris, Musée du Louvre, 1965, Cat. No. 131; and London, British Museum, Fawkener 5210–29.)

[37] Friedlaender, *Kasino*, 94, attributed the paintings in the frieze to Giovanni da Cherso on the grounds that they were landscapes and seemed Venetian. In fact, with one exception, the small paintings are narrative scenes.

[38] ASR, *CF*, 1521, fol. LXXVIII v: "A Mo Santi di Tito dal borgo pittore sessantatre scudi . . . p resto et compito pagamento del suo lauoro fornito che sia quale è in Belu:re cioè l'opa di pittura, stucco et doratura, a tutte sue spese di due stanze nel boschetto cioè la uolta sopra la scala in ditto luogo, et la pa camera doue s'entra da detta scala."

room is undecorated. Santi di Tito received three payments, amounting to seventy *scudi*, specifically for the second room, and there seems to be no good reason for arguing, as Friedlaender did, that those payments referred to the room on the second story.[39] In fact, the various payments can be shown to be consistent, if one approaches them slightly differently. When one descends the staircase, the first room which one enters is not only decorated but is also the second room on the first story.

Santi di Tito may have painted the four allegories in the second room (Figs. 62–64).[40] Two of the scenes contain muscled, Michelangelesque nudes which bear some relationship to one or two of the figures in the vault of the stairwell. Otherwise, one has to admit that there is little demonstrable relationship between the mundane figures and documentary settings of the scenes in the stairwell and the relatively abstract backdrops and rarified subject matter of the allegories downstairs.

The authorship of the remaining rooms cannot be established with any certainty from the accounts.

Barocci and Genga received payments for the third room, but it is hard to believe that those referred to the room off that containing the *Annunciation*.[41] More probably, the room referred to was in fact the second room, the count in these cases beginning with the entrance portico as the first room. In fact, the Apostles in this room are similar to some of the figures in the room with scenes from the life of Christ, on the second story (Fig. 78), and it appears likely that Zuccaro's assistants were also active here.[42]

The fresco decoration of the entrance portico (Fig. B, v; Figs. 79, 80) was not mentioned in the accounts and was not described until the eighteenth century, when Agostino Taja attributed it to a Giovanni Schiavone.[43] This must be the Giovanni da Cherso Veneziano Pittore who appeared in the accounts in connection with the *galleria* and the Giovanni dal Carso Schiavone, mentioned by Vasari. If Giovanni da Cherso was involved in the decoration of the entrance portico, then it seems that he was working in association with Zuccaro once more. Sections of the decoration, particularly the chariot race in the frieze and the Moses scenes in the recesses at either end, are similar to Zuccaro's paintings in the loggia and the rooms of the second story.[44]

[39] *Kasino*, 129, n. 3, and 130, n. 1.

[40] *Ibid.*, Pl. xxviii, illustrated the fourth allegory.

[41] *Ibid.*, Pls. xxix, xxx.

[42] *Ibid.*, 83, mentioned this relationship, but explained it in terms of a campaign carried out in 1591.

[43] *Descrizione*, 502–503.

[44] Dr. Loren Partridge pointed out to me that one of the flying *putti* in the frieze compares closely with a late Zuccaro drawing for the decoration of the interior of the dome of S. Maria del Fiore, in Florence. (A. E. Popham and K. M. Fenwick, *European Drawings [and Two Asian Drawings] in the Collection of the National Gallery of Canada*, Toronto, 1965, Cat. No. 43.) [W. Vitzthum],

74

If this was the case, it becomes clear that Federico Zuccaro had a much more important role in the decoration of the Casino of Pius IV than Friedlaender suggested, and it becomes easier to understand the emphasis which Vasari placed upon him.

---

review of *European Drawings*, by Popham and Fenwick, in *Master Drawings*, III, 1965, 408–409, was the first to connect the Ottawa drawing with S. Maria del Fiore's *Last Judgment*.

# The Iconography of the Interior Decoration

I F one counts the loggia and entrance portico as part of the interior, there are eight rooms with frescoes at the Casino of Pius IV.

The interior of the loggia (Figs. 71, 72) is an extraordinary confection of fresco and stucco. An exceptionally ornate stucco architecture screens the sides of the tunnel vault, three richly carved stucco frames are set into the spine of the vault, and the remaining space is covered by a lattice of acanthus and other foliage. Frescoes appear in the intercolumniations of this stucco loggia, like scene paintings in an antique *scenae frons*, and alternate with stucco frames containing the nine Muses. Below is a frieze of marine scenes, punctuated by smaller stucco panels representing women in all stages of calm and frenzy.

Friedlaender did not recognize the subjects of the ten small frescoes, but the programme was identified partially by Borghini, in the sixteenth century. He mentioned small paintings of Venus and Adonis, the birth of Bacchus, and other fables.[1] In fact, the frescoes form an unusually rich cycle illustrating the passion of Adonis. The first scene (Fig. 71) represents the full drama of the hunt. A figure of exceptional dynamism, Adonis dominates the foreground. His right arm is raised to hurl his spear at the charging boar, and two hounds are in full cry at his heels. In the second scene the tables have turned. Adonis has fallen, his left hand is raised in a tragic parody of his gesture in the previous scene, one of his dogs stands passively by, and the boar has turned to the offensive. In the third scene a distraught Venus rushes to her lover's side. Two *amorini* are all a flutter in the sky, while a third registers his grief more conventionally and rather sanctimoniously on terra firma at Venus' side.

Only the first three scenes can be said to have their source in the *Metamorphoses*.[2] The remaining scenes elaborate upon Ovid's narrative in a variety of ways. The next four scenes illustrate Love's vengeance upon the offending boar. The first represents two cupids enthusiastically trussing the boar's feet, and the second shows them dragging away the helpless animal. The next scene is badly damaged, but the fourth scene continues the theme of revenge. Assisted by two cupids, Venus is shown sawing

[1] *Il Riposo*, Florence, 1584, 141: "Dipinse Federico Zuccaro ancora nella loggia sopra il vivajo alcune istoriette di Venere e di Adone, e il nascimento di Bacco, e altre favole con graziosa maniera."

[2] Ovid, Penguin Classics (Harmondsworth, 1968), 239–245.

the animal's tusks from its jaws, while the corpse of Adonis sprawls at her feet. The next scene represents what might be described as the last farewell. In a reversed and calmer version of the discovery of Adonis' body, Venus stands by the side of her dead lover, and stretches her right hand over him, reminding one of the ending of Ovid's story:

> [Venus] sprinkled Adonis' blood with sweet-smelling nectar and, at the touch of the liquid, the blood swelled up, just as clear bubbles rise in yellow mud. Within an hour, a flower sprang up, the colour of blood, and in appearance like that of the pomegranate, the fruit which conceals its seeds under a leathery skin. But the enjoyment of this flower is of brief duration: for it is so fragile, its petals so lightly attached, that it quickly falls, shaken from its stem by those same winds that give it its name, anemone.[3]

The last two scenes in the cycle make it clear that the earthly idyll is over. The penultimate scene shows Venus in her chariot, drawn high into the sky by two white doves.[4] Her back is resolutely turned to Adonis. Nothing remains in the last panel but two doves. However, it is obvious that this scene was simply a continuation of the preceding one.

Pirro Ligorio discussed Venus and Adonis at some length in the Naples manuscript, and, citing Theocritus as his source, provided an elaborate and slightly ludicrous appendix to Ovid's tragic story. According to Ligorio:

> Saddened by the death of [Adonis], Venus called the *amori*, and commanded them to go and capture that treacherous boar, and drag him to her by force; and even if he were to wish to come of his own free will, he should not on any account be allowed to come on his own feet, but rather bound and dragged and struck and pierced and torn by their arrows. Thus the miserable boar, barely able to breathe, although he begged fervently for mercy, was brought half-dead before Venus, who was holding her Adonis lifeless in her lap. The boar begged Venus to hear his justification, saying that then he would be content to die, and, although unwilling to consent, nonetheless the goddess allowed the boar to speak. "Know, my lady Venus, that I was not the reason for the death of your Adonis, but rather my own death and his beauty. Having fallen under his arrows, I knew that I was about to die, and was happy to die at his delicate hands. Before I had died or been wounded, I rushed to kiss his thighs. Distracted by his beauty and drawn by the love which I bore him, I longed to kiss him at the end of my life, but the iniquity

---

[3] *Ibid.*, 245.

[4] Venus clearly depends upon her counterpart in the Psyche loggia in the Villa Farnesina.

of my fortune caused my tusk to wound him so cruelly that it killed him. Therefore, you should be satisfied not with my death but with cutting off the culpable tusk. Punish it and not me, who, being in love, was happy to die for him." Appeased by this reasoning, Venus therefore made the *amori* sever the cruel tusk which had wrought so much ill.[5]

The image of the breathless boar, pleading for clemency by transferring the blame to his tusk and his iniquitous fortune, is worthy of Kenneth Graeme, and punctures irretrievably the high tragedy of Ovid's version of the passion of Adonis. However, Ligorio's addendum does account for the problematical scenes in Federico Zuccaro's fresco cycle. Two of the scenes show the animal bound, dragged and pummelled to near asphyxia by Venus' vengeful *amorini*. The damaged scene probably represented the half-dead boar brought before Venus, or what might be entitled the *allocutio apri*, and the following scene commemorates the ritual extraction of "the cruel tusk which had wrought so much ill."

Federico Zuccaro may have been familiar with this version of the story, but it is more likely that Ligorio provided the text for the loggia's fresco cycle, as he had done for the stucco programme. In fact, this appears to be confirmed by Ligorio's discussion of the allegorical significance of the Adonis story.

---

[5] NBN, MS XIII. B. 3, 277: "Venere adolorata dela morte di costui chiamo gli Amori, et le comando che andassero à pigliar quel porco traditore et che lo strascinessero à lei per forza, et si bene volesse venire di bona voglia non gli premetteressero in conto niuno di lassarlo venir' conli suoi piedi, ma ligato et tiratto et percosso et punto et stranito delle loro saette: cosi l'infelice cinghiale nonpotendo quasi più haver' il fiato quantunque assai si raccomandasse fu mezzo morto condotto à Venere che tenea il suo Adoni ingrembo dissanimato. Il porco prega Venere che voglia udire le sue ragioni, è contento poi di morire: et quantunque malvolente aciò consentir' volesse la Dea pure il Cynghiale disse. Sappi Madonna Venere che non fui mai ragione della morte del vostro Adoni ma la morte mia istessa et la sua bellezza. Essendo io caduto sotto le sue saette mi viddi gionto à morte: et contento di morire per le sue dilicate mani: pria che morisse ò fusse ferito corsi per bagnarle le coscie, et dell'amor ch'io gli portava essendo vago della sua bellezza nel fine della vita mia ne volea portar' un bascio: ma la iniquita della fortuna mia, anze del mio dente lo feri si crudelmente che l'uccise: cosi dunque sarebbe contenta non della morte mia ma di tagliar via il dente che ne stato colpevole, à lui date la pena et non a me che micontentava amando morir per lui. Per tanto Venere placatasi dalla ragione fece che gli amori gli scissero il dente crudele che avea fatto tanto male." The poem on which Ligorio based his narrative is now placed on the fringe of Theocritus' writings. (See P. E. Legrand, *Bucoliques grecs*, II, Paris, 1927, 112–113. For a detailed investigation into the probable date of the piece, see J. Labarbe, "Le Sanglier amoureux," *Annuaire de l'Institut de Philologie et d'Histoire Orientales et Slaves*, XII, 1952, 263–282.) The poem was evidently popular in the sixteenth century, and was known to artists other than Federico Zuccaro. In the Uffizi there is a drawing, classified as "Scuola di Taddeo Zuccaro," which represents three *putti* tormenting a boar (864 S. Pen and brown ink on blue-green paper, 193 x 170 mm.). Annibale Caro described a similar scene in a letter to Vasari. (See G. Bottari, *Raccolta di lettere sulla pittura, scultura ed architettura*, II, Milan, 1882, 19–20.)

According to Ligorio, Venus symbolized the generative powers of nature and Adonis symbolized the sun. In fact, Adonis' primary significance was solar and seasonal. After his death, he was allowed to spend half of the year with Venus, and spent the remainder of the year in the underworld with Proserpine. "Therefore, when the sun, symbolized by Adonis, passes through the upper [zodiacal] signs in summer time, Venus has her lover with her, and is exceedingly happy and gay. But later, when she is thought to weep and appear sad, then she sees him descend in winter time into the lower signs."[6] Winter, being the season when human life mourns and loses its vigour, symbolizes and is symbolized by Venus' lament for the death of Adonis.

Nor is the boar lacking in allegorical significance. "This animal symbolizes winter very well . . . It is completely covered with rough, tough bristles, and by choice lives in muddy places, feeding on winter fruits; and it makes itself a protective armour of mud, and sharpens its tusks for battling with other swine, its peers. And winter is like a mortal wound to the sun, because, in a sense, it loses its light and heat."[7]

The story of the death of Adonis is also appropriate decoration for a fountain structure. Ligorio indicated this in the same section of *Libro X*, when he described springs and streams as the eyes of the earth, shedding their tears particularly copiously during the months of Adonis' absence.[8]

At either end of the loggia, separated from the tunnel vault by archivolts, are apse-like recesses covered by half-domes (Fig. 72). The decoration is similar to that in the main section, but smaller in scale. Each recess contains three major stucco panels, clearly intended to be read as triptychs. The central scene at the southeast end shows a number of figures filling vases and pitchers at a circular pool set in a temple precinct. In the panels which constitute the wings of the triptych figures converge upon the pool, carrying a variety of utensils. The central scene at the northwest end represents a rustic feast. In the flanking scenes throngs of people abandon the city, and converge upon the sylvan picnic. One triptych has a specifically aquatic emphasis, and the other has a pastoral one. Both are *all'antica*, and both are generally appropriate to a *diaeta*.

Zuccaro's major frescoes in the central section of the loggia introduce an entirely

---

[6] NBN, MS XIII. B. 3, 276–277: "Quando dunque il sole, il quale è significato per Adoni, va nel tempo dell'estate per li segni disopra: in talhora Venere ha seco il suo innamorato e sta tutta lieta et gioconda. Ma quando poi è creduta piangere, et si mostra mesta, quando lo vede scendere all tempo dell'inverno nei segni di sotto." For a full discussion of the significance of Adonis, see W. Atallah, *Adonis dans la littérature et l'art grecs* (Etudes et commentaires, LXII), Paris, 1966.

[7] NBN, MS XIII. B. 3, 276: "Questo animale rappresenti molto bene l'inverno . . . è coperto tutto di peli duri et aspri, et sta volentieri nei luoghi fangosi, et pascisse di frutti invernali: et si fa una corazza attorno di fango et aguzza il dente per combattare con li altri porci suoi pari et il Verno è quasi ferita mortale al sole, per che perde à un certo modo la luce et il calore."

[8] *Ibid.*, 277.

new category of subject matter. The three scenes are drawn from the Old Testament, and illustrate the exodus of the Israelites from Egypt. The central scene represents the *Crossing of the Red Sea*, that to the left shows *Moses and Aaron before Pharaoh*, and that to the right represents the Egyptians "dead upon the sea shore" (Exod. 14:30), while the Israelites turn their backs on Egypt and the Red Sea.[9]

The decoration of the entrance portico (Figs. 79–81) is quite as lavish, although different in character and emphasis. Smooth pebbles, rough chips of stone and variously shaped and coloured seashells cling to the walls and niches like barnacles to a ship's hull, and suggest that the portico was intended as a grotto of a kind. Winged sea horses and sea dragons fill the spandrels above the niches, and a Diana of Ephesus is set in an arched frame at the centre of the rear wall.

The main section of the portico has a painted frieze representing a chariot race (Fig. 80). Winged *putti* act as charioteers, and the chariots are drawn by a wide variety of possible and impossible creatures. In the lowest section of the vault is what amounts to a second frieze. It is composed of stucco reliefs, representing the four rivers of Paradise, stucco herms, representing ten of the twelve gods of the zodiac and four painted scenes which give glimpses of the early life of man outside Paradise.[10] The first scene shows Eve spinning, and the second represents Adam hewing wood. The scenes on the opposite side of the vault represent Abel, the "pastor ovium" (Gen. 4:2),[11] guarding his flock, and the *Sacrifice of Cain and Abel* (Gen. 4:3–4). Set in stucco frames in the upper sections of the vault are nine narrative scenes illustrating the creation cycle.

The rivers of Paradise and the small painted scenes are clearly pendants to the creation cycle, and it seems that the stucco herms are related to the painted frieze in a similar way. Despite the fact that they are ten rather than twelve, the gods and goddesses certainly represent the cycle of the year,[12] and the chariot race can be interpreted in a similar way. The chariot race was believed to symbolize the race of life,[13] and, in this context, may represent the passage of another and larger unit of time.

The recesses at either end of the portico are similar to those in the loggia, but, in

[9] The three episodes were represented together in Cosimo Rosselli's fresco in the Sistine Chapel. (See L. D. Ettlinger, *The Sistine Chapel before Michelangelo: Religious Imagery and Papal Primacy*, Oxford, 1965, Pls. 3, 18.)

[10] For the gods of the zodiac and their attributes, see Cartari, *Imagini*, 2, and the inset between 2 and 3.

[11] *Abel Tending His Flock* is reminiscent of early Christian representations of Christ the Good Shepherd. In addition, the scene certainly referred to the duties and responsibilities of the pope. For example, Julius II struck a medal from which it is clear that he saw himself as the *pastor* or shepherd of the community of the church. (See Bonanni, *Numismata*, I, 152–156, XIII.)

[12] Ovid *Fasti*, Loeb Classical Library (London, 1931), 4–5, tells us that the original Roman calendar contained only "twice five months."

[13] Vogel, "Circus Race Scenes," n. 48.

this case, the decoration appears to be complete. The main painted scenes form a diptych made up of *Moses Striking the Rock* (Fig. 79), at the southeast end, and the *Gathering of Manna* (Fig. 81), at the northwest end. The frescoes are flanked by aediculae containing the Theological Virtues and Religion. Below are four, small painted panels which appear to be pendants to the Moses scenes. Under Hope is a woman milking a cow; under Religion a woman inspects a goat's cloven hoof; under Charity are three deer; and under Faith appear two lions. The emphasis given to the goat's hoof suggests that the reason for its inclusion was that the goat is one of the clean animals, permitted to the Israelites as food (Lev. 11:2–4). In contrast, the lions, which "go on their paws," are unclean animals. However, the opposition of the clean and the unclean is not carried through in a symmetrical way since the remaining animals, the cow and the deer, are both numbered among the clean animals (Deut. 14:4–6).

At first sight the decoration of the principal room of the interior (Fig. 46) appears bewilderingly complex. However, it does submit to a discipline which is at least as rigorous as that applied to the façade of the casino. Stucco bands divide the vault into fifteen major compartments, and create a taut and symmetrical framework for the organization of the decoration. The bands themselves are decorated. Those in the short coves contain hanging garlands, populated by birds, butterflies, mice and snails, and small panels representing parrots and other birds (Fig. 56); those framing the central bays on the long coves contain elaborate grotesques surmounted by Pius IV's coat of arms and small panels representing friendly Medusa heads (Figs. 59, 61); and those at the ends of the long coves contain small medallions representing the Theological Virtues and the Cardinal Virtues and personifications of Fortune, Friendship, Abundance, Peace and Religion (Figs. 47–50).

The dominant motif in each of the corners of the coves (Figs. 47–50) is an ornate stucco shield, hung with garlands of fruit, crowned with a statue of Diana of Ephesus, and inscribed PIVS IIII PONTIFEX OPTIMVS MAXIMVS. The shields are ensconced in massive, painted thrones, and are attended by Virtues and jubilant *putti*. The Virtues are identified by attributes and inscriptions as LETITIA, FELICITAS, VIRTVS, TRANQVILLITAS, CONCORDIA, LIBERALITAS, IMMORTALITAS and AEQVITAS. To underline that the Virtues belong to Pius IV's permanent staff, a *putto* dangles a Medici medallion over each personification's head. The swags of fruit and Dianas of Ephesus surely imply a fecundity, growth and plenty.

The compliments may run deeper still. Although the thrones in the corners of the coves are not empty, they are only nominally occupied. This being the case, they may allude to the Roman ceremony, *sellisternium,* in which empty thrones were held ready for gods and deified emperors.[14] However, the apotheosis implied here is prob-

[14] E. Panofsky, *Tomb Sculpture*, New York, n.d., 92.

ably no more exclusively pagan than was that on the façade of the casino, since the empty throne also brings to mind the Etimasia, the throne prepared for the second coming of Christ Himself. Further, the thrones with their attendant Virtues had surely suggested the Throne of Solomon and the *sedes sapientiae*,[15] and the shields, with the inscriptions PIVS IIII PONTIFEX OPTIMVS MAXIMVS, had made it clear that Pius had inherited the wisdom of Solomon and was the agent and executor of the wisdom of Christ Himself.

The compartments in the short coves at either end of the room are almost entirely filled by stucco frames containing Pius IV's arms (Fig. 56). In the remaining space, painted *putti* tend a flaming chalice, the base of which is also decorated with the Medici *palle*. Among other possibilities, a flame symbolized Life, Truth and Love of God, and allusions to all three were probably intended here.[16]

The principal features of the central compartments of the long coves are elaborate stucco frames which contain frescoes representing the *Baptism* and the *Navicella* (Figs. 46, 59, 60). Female figures personifying Abundance and Plenty flank each frame, and wrestle with great painted garlands of fruit. A variety of grotesques fill the remaining space. The four remaining compartments on the long coves contain no major figures and no large narrative scenes. Instead, the fields are filled by grotesques and small panels with diminutive figures, and are presided over by Jupiter, Mars, Mercury (Fig. 61) and Venus.

In the lowest section of the vault is a frieze composed of painted panels and stucco medallions. This forms an elaborate predella to the main decoration of the vault. In eight square panels, directly below the Virtues, *putti* playfully toy with the constituents of Pius IV's coat of arms: five plain *palle* and one decorated with the fleur-de-lis, two keys, a stole and the papal tiara. Kidney-shaped medallions containing marine scenes and paired Fames or Victories are placed in the four corners of the frieze, and frames containing river-gods are set at the centre of each side. Two landscapes and two narrative scenes occupy the sections under the compartments containing grotesques. The narrative scenes show Anthony Abbot in search of the Hermit Paul and John the Baptist preaching of Him "that cometh after me" (Matt. 3:11), while Christ Himself appears in the middle distance (Fig. 61). Mysterious, bearded figures, probably representing Daniel, Ezekiel, Isaiah and Jeremiah, the four great prophets, are set in oval frames under the Medusa heads. Finally, there are eight small medallions which contain *putti* who are shown harvesting, hunting and fishing. Despite

[15] See I. H. Forsyth, *The Throne of Wisdom: Wood Sculptures of the Madonna in Romanesque France*, Princeton, 1972, 22–30 and 86–90.

[16] See H. Hibbard and I. Jaffe, "Bernini's Barcaccia," *Burlington Magazine*, CVI, 1964, 160 and nn. 7, 8; and R. Freyhan, "The Evolution of the Caritas Figure in the Thirteenth and Fourteenth Centuries," *Journal of the Warburg and Courtauld Institutes*, XI, 1948, 68–86 and 75, in particular.

the presence of eccentric scenes which show one child with the attributes of Jupiter and another disguised as Juno, the emphasis appears to be on seasonal activities.

The most important and, in some ways, the most curious painting in the first room is Federico Barocci's *Holy Family with the Infant St. John, Elizabeth and Zachariah* (Fig. 51). The scene represented is the first meeting of John and Christ, when John was six months old and Christ was a new-born infant. The subject is entirely apocryphal, and stems from a tradition which became popular in Italy during the fourteenth century.[17] Obviously, the significance and mystery of the subject lies in the symbolic implications of the meeting. During the fifteenth century the meeting became a symbol of Christ's baptism, and, at the end of the century, it became an image foreshadowing His passion and illustrating His and John's foreknowledge of it.[18] Both allusions were probably contained in Barocci's fresco. A shallow basin stands on a table immediately behind the Infant St. John, and brings to mind a baptismal vessel. The significance of the cross, which John presents to the Christ Child, is obvious.

The *Holy Family with the Infant St. John, Elizabeth and Zachariah* is flanked by two smaller scenes which Friedlaender identified correctly as *Christ and the Samaritan Woman* (John 4:5–15) and *Christ and the Adulteress* (John 8:1–11).[19]

The second room is little more than half the size of the first, but its decoration is quite as complex. The central section of the vault is defined by painted bands and sinuous stucco frames. Barocci's *Annunciation* (Fig. 52), set deeply in an elaborate oval frame, almost entirely fills this compartment. What space remains is filled by small symbols of the Evangelists. The stucco frames contain scenes representing *Moses Receiving the Tablets of the Law* and *Moses Presenting the Law to the Israelites* (Figs. 65, 66). Eight small rectangular panels are attached to the corners of the outer frame of the *Annunciation*, and contain a cycle illustrating the story of Joseph, from the description of his dreams to his brothers to the final reunion with his family in Egypt (Figs. 62–64, 67–70).

The coves contain delicately painted grotesques, done on a white ground (Figs. 62–64). Floral mermaids attack dragons, lions and winged bears, captive satyrs are bound to trophies of arms and armour, and sphinxes, griffons and tiny birds play hide-and-seek among delicate branches of foliage and swags of fruit. The only specifically Christian imagery appears in four circular medallions which contain small figures representing Ambrose, Augustine, Gregory and Jerome, the four doctors of the Church. In the centres of the coves are four complex stucco frames containing allegorical scenes. Pius IV's coat of arms appears above two of the frames, and small

[17] M. A. Lavin, "Giovannino Battista: A Study in Renaissance Religious Symbolism," *Art Bulletin*, xxxvii, 1955, 85–101, 87 and n. 19, in particular.

[18] *Ibid.*, 99.                    [19] *Kasino*, 71.

*tondi* representing *Moses in the Ark of Bulrushes* and the *Finding of Moses* are placed above the other two.

The corners of the coves are entirely done in stucco. Each compartment contains three women standing on classical tripods. They probably represent the Hours, who had a prominent place on the façade of the casino, and the fact that they appear in all four corners of the room was probably intended to emphasize their seasonal significance.

The scenes in the stucco frames are the most perplexing paintings in the second room, if not of the entire interior programme. Their subject matter is neither biblical nor classical, and, although the compositions bring to mind the engravings and woodcuts of contemporary emblem books, there do not appear to exist specific patterns for them. In fact, it seems likely that the allegories were conceived and elaborated specifically for the Casino.

The painting in the southeast cove (Fig. 62) shows two women who face each other from vantage points on rocky crags. Each figure holds a shallow patera in one hand, and rests an arm on a flowing vase. Below the rocks are gathered four men, two of whom are clearly associated with the woman on the right, while the remaining two are equally clearly associated with her counterpart. The women are essentially indistinguishable from each other, but the pairs of men are contrasted dramatically. Those to the left calmly accept the liquid, as if they were at some expensive spa, while those to the right ignore it, and appear to be in the throes of death.[20]

No precise prototype for the scene can be found, but its general meaning is clear. Despite the superficial similarities, the women and their offerings are in fact fundamentally different. One offers health and peace of mind, and the other conceals anguish and death.

The scene in the northwest cove takes place in a landscape setting (Fig. 64). A woman is enthroned at the summit of a rocky mountain, and rests an arm on a flowing urn. With her free hand she holds a victor's wreath over the head of a man who has completed the arduous climb to her court. Rather lower on the hillside, a young woman helps a second man begin his ascent, and shows him the ultimate goal. Two nude men appear on the lower slopes on the right side. One sprawls indolently on some draperies, an empty bowl in one hand despite the water which cascades past his shoulder, and gazes helplessly at the scene on the summit. The second figure crawls on hands and knees, and grovels before some dice and playing cards.

In this case too the general meaning is clear. Effort and Indolence are contrasted in a way which reminds one of the Choice of Hercules, the classic *exemplum* of this opposition, where the road to Virtue was always as desperately difficult as its counter-

---

[20] *Ibid.*, 79, n. 1, compared the figure on the extreme right with an antique niobid, whose pose was intended to represent the moment of death.

part was seductively easy.[21] In fact, the sixteenth century argued the difficulties of the path of Virtue with such eloquence that the alternatives must have appeared doubly attractive.[22] However, one can come closer to the precise meaning of the painting by combining the woodcuts which illustrated different versions of an emblem entitled DESIDIAM ABIICIENDAM which appeared in the 1531 and 1534 editions of Andrea Alciati's *Emblematum libellus*. The earlier illustration, published in the Augsburg edition, is remarkably similar in composition to the painting in the casino (Fig. D).

Figure D. DESIDIAM ABIICIENDAM. From A. Alciati, *Emblematum liber*, Augsburg, 1531, leaf A 7 verso

It represents a winged angel standing upon a plinth placed at the top of a small mountain, in the upper right corner. In the lower left corner a man is shown beginning his climb to the summit, and is pulled upwards by a helpful angel, much as is the case in the fresco.[23] The woodcut in the later edition, published in Paris, at first

[21] See E. Panofsky, *Hercules am Scheidewege und andere Antike Bildstoffe in der neueren Kunst* (Studien der Bibliothek Warburg, XVIII), Leipzig and Berlin, 1930.

[22] For example, one medal presented the idea in terms of a flowering bush which forces its way through a bed of thorns. (See G. F. Hill, *The Gustave Dreyfus Collection: Renaissance Medals*, Oxford, 1931, Pl. LXXXII, 348, and 169.) Another shows the altar of *Fides* on the summit of a mountain, approached by a narrow, winding path (*ibid.*, Pl. XLV, 181, and 92). G. F. Hill, *A Corpus of Italian Medals of the Renaissance before Cellini*, London, 1930, Pl. 54, 334, and 84, illustrated and discussed a medal representing a nude female figure, reclining at the summit of a rocky pinnacle. The woman holds a laurel wreath and a trophy of armour. A nude man stands at the foot of the mountain, and has to brave a wall of flames before he can even begin the ascent. The caption, *Perfer*, makes the meaning explicit.

[23] A. Alciati, *Emblematum liber*, Augsburg, 1531, leaf A 7 verso. The text reads: "Quisquis iners

appears quite different. It shows a ragged, dispirited and lethargic man seated with his back to an unforbidding, tree-covered hillock.[24] Clearly, the painting in the second room of the casino illustrates a text very similar to that accompanying Alciati's emblem, and, in a sense, combines or superimposes the separate illustrations of the Augsburg and Paris editions of the *Emblematum libellus*. Equally clearly, Effort is encouraged and rewarded, while Indolence suffers its final degradation.[25] The source of the water is accessible to everyone who can sustain the effort necessary to complete the arduous climb.

The scene in the northeast cove contains four figures set before a landscape (Fig. 63). In the centre of the painting two men attempt to capture *Occasio*, or Chance, as she careers past, knives in hand, forelocks flying and garments streaming.[26] On the extreme left an aged, shrouded woman catches the nearer of the men by his cloak, and is about to strike him down with a fearsome club. This figure almost certainly represents Penitence or Remorse who traditionally followed in the wake of lost opportunity.[27]

The violent intervention of Penitence is unusual, but the significance of the painting is again clear. Despite man's desperate efforts to capture Chance, he is bound to lose her and be condemned to suffering the blows of Penitence and Remorse.[28]

The final scene, in the southwest cove, has faded to near illegibility.[29] Under a triangular pediment in the corner of a crumbling, classical courtyard, one can make out a partially nude woman, seated with one arm resting on yet another flowing urn. A nude boy half kneels before her to receive some of the liquid; a second child awaits his turn; and others leave the court, already refreshed.

The decoration of the third room is much simpler. The coves of the vault contain

---

abeat in chenice figere sedem/ Nos prohibent Samii dogmata sancta senis/ Surge igitur duroq[ue]; manus asuesce labori/ Det tibi dimensos crastina ut hora cibos."

[24] A. Alciati, *Emblematum libellus*, Paris, 1534, 18. The text is the same, apart from minor differences in spelling and punctuation.

[25] Friedlaender, *Kasino*, 80, suggested a similar interpretation for this scene.

[26] Although the scene superficially resembles Cartari's representation of Bellona with her priests (*Imagini*, 191), the attributes of the main figure are certainly those of Chance. (See Alciati, *Emblematum*, 1534, 20; and R. Wittkower, "Chance, Time and Virtue," *Journal of the Warburg Institute*, I, 1937–1938, 313–321.)

[27] Wittkower, "Chance," 315. Also see R. W[ittkower], "Patience and Chance: The Story of a Political Emblem," *Journal of the Warburg Institute*, I, 1937–1938, 173, n. 6, for the following mid-sixteenth century description: "Dopo la Clemenza venne l'occasione con la penitenza che la seguitiva in ogni attione che gli huomini hanno à fare."

[28] Friedlaender, *Kasino*, 80, described the painting as "ein Sinnbild der Gefährlichkeit oder der Zweischneidigkeit des Glückes."

[29] *Ibid.*, 80, Pl. XXVIII.

fourteen compartments which were intended to contain the twelve Apostles and two personifications.[30] As it stands, nine of the Apostles are present, Peter occupying the frame immediately to the right of *Ecclesia*. The compartment intended for the second personification is empty, as is that in the centre of the vault. In the lowest section of the vault is a frieze containing small marine scenes.

Pius IV's coat of arms occupies the centre of the vault of the stairwell (Fig. 77). In the corners of the coves are oval medallions and irregularly shaped stucco panels. One medallion is empty, but the remaining three contain women who personify Summer, Autumn and Winter. Summer is almost completely nude; Autumn is fully clothed, and carries a bowl of fruit; and Winter is warmly dressed, and carries a staff with a bird hanging from it.[31] A bust of Diana appears in the compartment below Winter, together with hunting dogs, bow and quiver. The bow and quiver appear again below Autumn. Apollo is represented in the compartment below Summer with his tripod and griffons, and his lyre appears in the space below the empty medallion.

Clearly, this decoration returns to the theme of the Seasons, not only in the personifications themselves but also in the figures of Apollo and Diana. God of the day, sun and warmth, Apollo symbolized that part of the year in which life is in the ascendant. In contrast, Diana, as goddess of darkness and night, symbolized the Seasons in which "human life mourns and loses its vigour."[32]

There are also four important scenes in the coves of the vault of the stairwell. Borghini described them as representing the parable of the workers in the vineyard (Matt. 20:1–16), and this identification is certainly correct.[33] However, the cycle is given a special significance by the fact that each of the scenes is localized in or near one of the *vigne* belonging to Pius himself. What is probably the first scene in the series takes place in the first *cortile* of the Belvedere Court, with a majestic view of the *Nicchione* in the background. The owner of the vineyard appears in the right foreground addressing a group of labourers, and pointing in the direction of the vineyard. A woman and three children appear in the left foreground. The group does not illustrate part of the narrative, but personifies Charity and surely indicates one of the meanings of the parable. The second scene, in which the owner hires a second group of labourers, takes place outside the northwest portal of the Casino itself. A third group is recruited on the Via Flaminia near the site chosen by Pius for his *palazzina* in 1561.[34] The final scene takes place on the Quirinal Hill, where Pius had another *vigna*, with the horses of the *Dioscuri* rearing in the background. In this scene the owner of the vineyard is shown paying the workers at the end of the day.

Apart from purely ornamental details, the decoration of Zuccaro's *stanza grande*

[30] *Ibid.*, Pls. xxix, xxx.

[32] NBN, MS xiii. B. 3, 277.

[34] See Coffin, "Pirro Ligorio," i, 62.

[31] Cf. Cartari, *Imagini*, 23.

[33] *Il Riposo*, 200.

*di sopra* is thoroughly Christian (Fig. 78).[35] The *Agony in the Garden* is in an elaborate oval frame in the centre of the vault, and the *First Temptation of Christ*, the *Transfiguration*, the *Last Supper* and the *Bearing of the Cross* are set in the coves. The frames surrounding the *Temptation* and *Transfiguration* are pitted with medallions containing Virtues, cherubs and angels with the instruments of Christ's passion. The Cardinal and Theological Virtues gather again in the corners of the coves.

At first sight, the decoration of the *galleria* (Figs. 73, 74) appears as thoroughly pagan as that of Zuccaro's other room on the second story was Christian. Among the decorative grotesques and flimsy temples are marine scenes, Muses and personifications of the Arts. In the main section of the room there are two large transverse fields (Fig. 74), one representing Apollo, with his lyre in his hand and a sphinx at his feet, and the other Hercules, with his club in his hand and Cerberus and a friendly dog as companions. As was mentioned earlier, Apollo and Hercules were proper companions for the Muses, being described as such by Ligorio in his treatise on the subjects and symbolism of grotesques.[36]

However, there is another facet to the programme of the *galleria*. Apart from the *Mystic Marriage of St. Catherine* in the centre of the vault (Fig. 74) and the *St. Paul* at the northwest end of the room, the frieze below the vault contains a predella which is almost entirely made up of biblical scenes. The paintings above the central section of the northeast wall represent *Peter Kneeling before Christ after the Miraculous Draught of Fishes*, *Christ and Peter Walking on the Water* and *Christ Calming the Storm*. The scenes on the opposite wall represent *David Restraining Abishai from Killing Saul* (I Samuel 26:7–12),[37] the *Crossing of the Red Sea* and *Judith and Her Maidservant Fleeing with the Head of Holofernes*. At the northwest end are three paintings, representing *John the Baptist in the Wilderness* (Fig. 75), *Jonah and the Whale* (Fig. 73) and the *Penitence of St. Jerome* (Fig. 76). At the southeast end one scene represents the *Flood*,[38] one contains a topographical view, and the third is too badly damaged to be legible.

[35] The emphasis upon Eucharistic imagery suggests that this room once may have been the chapel.

[36] Dacos, *Domus Aurea*, 177.

[37] Michael Hitchcock kindly identified this scene for me. There is a drawing with this subject in the Uffizi. (11194 F. Catalogued as Taddeo Zuccaro, but more probably by Federico. Pen and brown ink and wash. 156 x 299 mm.) It represents two episodes: David and Abishai taking Saul's jar of water and spear; and David and Abishai displaying the jar and spear from a nearby hillside.

[38] Noah's ark and some drowned figures are just visible in an old Anderson photograph (17586).

# The Meaning of the Interior Decoration

A significant part of the interior decoration can be absorbed by the five groups distinguished in the stucco decoration. This is particularly apparent in the loggia and entrance portico which are, in a sense, acclimatization zones between exterior and interior, but it is also true for the rooms inside the casino.

In the loggia, the Adonis cycle was certainly intended to extend the solar and seasonal aspects of the exterior programme, and, at the same time, contributes to the aquatic category. Similarly, the nine Muses repeat one of the themes of the court façade of the loggia, and swell the ranks of the humanistic group. In the entrance portico, the Diana of Ephesus, the marine mosaics and the rivers of Paradise continue the aquatic allusions, and the stucco herms and painted frieze sustain the theme of the Seasons. The commemorative and humanistic aspects of the programme are most apparent in the first room of the interior. There one finds an especially heavy emphasis on the arms, office and virtues of Pius, but the references to water and the Seasons continue in what might be described as the marginal decoration. The Seasons reappear in the second room, in the persons of the Hours, and form a subordinate theme in the vault of the stairwell. Water figures prominently in three of the four allegories in the second room, and all five groups, with the possible exception of the pastoral, make their final appearances in the *galleria*.

Although there is a strong sense of continuity from exterior to interior, there are also major innovations. Most obviously, these involve the introduction of an entirely new body of subject matter.

On the one hand there are the Old Testament scenes. Moses and Joseph are the most important personalities in this group. There are three Moses scenes in the loggia, two in the entrance portico, four in the second room and one in the *galleria*. Joseph's appearance is restricted to the second room, but an elaborate cycle of eight scenes is devoted to it. In addition, there is the Genesis cycle in the portico and individual scenes such as *David Restraining Abishai from Killing Saul, Judith and Her Maidservant Fleeing with the Head of Holofernes, Jonah and the Whale* and the *Flood* in the *galleria*.

A second group contains New Testament and apocryphal scenes and a small number of paintings involving saints. The most important scenes are Barocci's *An-*

*nunciation* and *Holy Family with the Infant St. John, Elizabeth and Zachariah,* the *Baptism, Navicella, Christ and the Samaritan Woman* and *Christ and the Adulteress,* in the first rooms, the parable of the labourers in the vineyard, in the vault of the stairwell, the five scenes in Zuccaro's *stanza grande di sopra,* and a number of scenes in the frieze of the *galleria.* The *Mystic Marriage of St. Catherine,* in the vault of the *galleria,* is the most important saint picture.

Scenes from the life of Moses are at least as appropriate to the loggia as the Adonis cycle. According to the text of Exodus, Moses was so named because he was drawn out of the water (Exod. 2:10),[1] and many other important episodes in his life, among them his defense of the daughters of Jethro, the changing of the water of the Nile to blood, the crossing of the Red Sea, the sweetening of the waters of Mara and the striking of the rock at Horeb, centred around water. Claus Sluter's *Moses* gave his name to the well in the cloister of the *Chartreuse* at Champmol, there was a tradition of *Mosesbrunnen* in Austria and Switzerland, and, closer in place and time to the Casino, Michelangelo planned a fountain representing *Moses Striking the Rock* for what is now the *Atrio del Torso* in the Vatican Museums.[2]

That Moses was a *typus Christi* was a typological commonplace, which offered great scope for elaboration. Paul saw the Israelites' flight from Egypt, "under the cloud," and their passage of the Red Sea as types of baptism, and interpreted their supernatural food and drink (the manna and the water struck from the rock) as symbols of the spiritual food and drink of Holy Communion (1 Cor. 10:1–4). He was followed by many of the commentators on the Old Testament. St. Augustine, in particular, discussed the baptismal symbolism of the crossing of the Red Sea on many occasions. The passage of the Red Sea symbolized the baptism of Moses and the Israelites, and the Egyptians represented the magnitude and number of their past sins.[3] The crossing represented the Israelites' entry into a new life, and the extermina-

---

[1] According to modern scholarship, Moses is an Egyptian name meaning "child." (See *A New Catholic Commentary on Holy Scripture,* ed. by R. C. Fuller, L. Johnston and C. Kearns, London, 1969, 209, 176g.)

[2] Vasari-Milanesi, VII, 58–59. Michelangelo's idea was not carried out. There seems to be no record of it among his drawings; and there is no mention of it in the Michelangelo literature. For Daniele da Volterra's fresco and stucco decoration in the room, see N. W. Canedy, "The Decoration of the Stanza della Cleopatra," in *Essays in the History of Art Presented to Rudolf Wittkower,* II, London, 1967, 110–118. All the major paintings and stucco figures in the *Stanza della Cleopatra* (the *Navicella, Finding of Moses, Crossing of the Red Sea, Baptism* and *Christ and the Samaritan Woman; Faith, Hope, Charity* and *Justice*) reappear in the Casino of Pius IV, and, as Canedy correctly observed (118 and n. 44), the programmes have a great deal in common. The giant *Moses* in the central niche of Sixtus V's *Fontana dell'Acqua Felice* may loosely reflect Michelangelo's idea, and certainly confirms the suitability of Moses for fountain decoration.

[3] St. Augustine, *Enarrationes in Psalmos,* P.L., XXXVII, col. 1037: "Nihil ergo aliud significabat transitus per mare, nisi Sacramentum baptizatorum; nihil aliud insequentes Ægyptii, nisi abundantiam praeteritorum delictorum."

tion of Pharaoh and the Egyptians symbolized the annihilation of sin in the sacrament of baptism.[4] Through baptism, Christ freed the faithful from a life of sin. By the passage of the Red Sea, Moses freed the Israelites from a life of captivity in Egypt. Pharaoh and the Egyptians died in the Red Sea, just as all our sins are washed away in baptism.[5] Similar interpretations can be found in Tertullian, Hrabanus Maurus and others.[6] Sometimes the emphasis, but not the ultimate meaning, is rather different. In some cases, Pharaoh and the Egyptians become types of the devil, and symbolize iniquities of every kind.[7] By implication, their wickedness was the wickedness of heresy, and their defeat in the Red Sea symbolized the triumph of the church over its enemies.[8]

*Moses Striking the Rock* and the *Gathering of Manna*, in the entrance portico, constitute a diptych on the sacraments of baptism and communion, the central significance of which is underlined by the presence of the Theological Virtues and Religion in the neighbouring frames. Bible commentators consistently interpreted the manna as a type of the body of Christ, "the true bread from heaven" (John 6:32),[9] and the miraculous stream freed from the rock at Horeb was interpreted as a prefiguration of the waters of baptism, flowing from Christ Himself.[10]

Moses was also seen as a precursor of Peter and a type of the *Vicarius Christi*. As the instrument of God Himself, Moses carried out the functions of lawgiver, king and priest. Peter filled the same offices as Vicar of Christ, and his authority was derived directly from Christ Himself.[11] Again the general parallelism was elaborated in more specific relationships. The rock at Horeb was interpreted as a symbol of Christ,

[4] St. Augustine, *De Catechizandis Rudibus*, P.L., XL, col. 335: "Utrumque signum est sancti Baptismi, per quod fideles in novam vitam transeunt, peccata vero eorum tanquam inimici delentur atque moriuntur."

[5] St. Augustine, *Enarrationes in Psalmos*, P.L., XXXVI, col. 917: "Liberatur populus ab Ægyptiis per Moysen; liberatur populus a praeterita vita peccatorum per Dominum nostrum Jesum Christum. Transit populus ille per mare Rubrum; iste per Baptismum. Moriuntur in mari Rubro omnes inimici populi illius; moriuntur in Baptismo omnia peccata nostra."

[6] Tertullian, *De Baptismo*, P.L., I, col. 1209. Hrabanus Maurus, *Commentariorum in Exodum libri quatuor*, P.L., CVIII, col. 66.

[7] St. Zeno, *Tractatus*, P.L., XI, col. 510: "Pharao cum populo suo diabolus et spiritus omnis iniquitatis." St. Augustine, *De Cataclysmo*, P.L., XL, col. 694: "Regem Ægyptiorum populumque ejus, auctorem peccatorum diabolum cum omnibus ministris ejus."

[8] Cassiodorus, *Expositio in Cantica canticorum*, P.L., LXX, col. 1059: "Sicut ille populus per mare Rubrum salvatus est, Pharaone demerso, ita Ecclesia gentium per baptismum de diaboli servitio liberata, et ad veram repromissionis terram, et evangelicam libertatem introducta est."

[9] Hrabanus Maurus, *Enarratio super Deuteronomium*, P.L., CVIII, col. 869: "Manna enim de coelo datum significat carnem Christi." St. Ambrose, *Enarrationes in Psalmos*, P.L., XV, col. 1462. St. Augustine, *In Joannis Evangelium tractatus CXXIV*, P.L., XXXV, col. 1603.

[10] Tertullian, *De Baptismo*, P.L., I, col. 1210: "Haec est aqua, quae de comite petra populo defluebat. Si enim petra Christus, sine dubio aqua in Christo Baptismum videmus benedici."

[11] Ettlinger, *Sistine Chapel*, 115–117 and *passim*.

but it was also associated with Peter, on the basis of the obvious relationship between *petra* and *Petrus*,[12] and the significance of this etymological coincidence was given visual authority by the fact that the early Christian iconography of Moses striking the rock was adopted for an identical miracle on sarcophagi illustrating the life of Peter.[13] Further, Moses receiving the tablets of the Law and his presentation of the Law to the Israelites were also interpreted in papal terms. On early Christian sarcophagi, the giving of the Law on Sinai was sometimes paralleled with the *Traditio Legis*, by which Peter received the New Law from Christ Himself.[14] Similarly, Moses' exposition of the Law to the Israelites prefigured Christ's sermon on the mount, and, by extension, Peter's transmission of Christ's teachings to the community of the church.[15]

In the fifteenth-century programme for the Sistine Chapel, Sixtus IV developed an extraordinarily potent papal propaganda around this facet of Moses' significance. As Ettlinger has shown, the frescoes on the walls of the Sistine Chapel present an elaborately wrought argument for the *primatus papae*, and celebrate the "victory of the monarchic principle [of the church] over the conciliar heresy."[16] The emphasis on Moses in the Casino's decoration suggests that this thinking was still very much alive during the pontificate of Pius IV.

Joseph was also a familiar *typus Christi*, and his life prefigured that of Christ in all its details.[17] Joseph was Jacob's favourite son, just as Christ was preferred by God before all the line of Abraham. Joseph's "long robe with sleeves" (Gen. 37:3) prefigured Christ's seamless tunic, and symbolized all the races who would be united in the body of Christ. In the context of his own life, Joseph's dreams foretold his elevation in Egypt, but the second dream, in which "the sun, the moon, and eleven stars were bowing down to [Joseph]" (Gen. 37:9), prefigured the adoration of Christ at His Nativity. Jacob sent Joseph to his brothers, just as God sent His Son into the world. Joseph's humiliation at the hands of his brothers and his imprisonment in the pit symbolized Christ's Crucifixion and His descent into Limbo, and Joseph's release prefigured Christ's Resurrection. Judah sold Joseph to the Midianites for twenty pieces of silver, and Judas betrayed Christ for thirty. Joseph's life in Egypt corresponded to Christ's life on earth, and the attempt by Potiphar's wife to seduce Joseph symbolized the Synagogue's attempted seduction of Christ. Joseph's elevation in Egypt

[12] See Christ's statement: "Et ego dico tibi quia tu es Petrus et super hanc petram aedificabo ecclesiam meam" (Matt. 16:18).

[13] See M. Besson, *Saint Pierre et les origines de la primauté romaine*, Geneva, 1929, 167–169, Figs. 114–118, Pl. VII.

[14] Ettlinger, *Sistine Chapel*, 100–101.   [15] *Ibid.*, 89.

[16] *Ibid.*, 117.

[17] According to Migne, P.L., CCXIX, col. 246: "JOSEPH sive somnians, sive mortis in lacum missus, vel a fratribus venditus, aut in Ægyptum traductus, et enutriens esurientes Ægyptios, etc., etc., per omnes vitae suae eventus Christum Salvatorem mundi exprimebat."

prefigured Christ's Ascension and His elevation beside God Himself. Finally, Joseph's reconciliation with his brothers symbolized the ultimate conversion of the Jews.[18]

However, Joseph, like Moses, was also a *typus Petri*. His elevation to the rank of Pharaoh's first minister became a symbol of the establishment of the ecclesiastical hierarchy, and Joseph himself became an example of the bishop or pontiff. The fact that Joseph scenes were incorporated into the Throne of Maximian shows that this thinking was established pictorially as early as the sixth century,[19] and the fact that Clement VII struck a medal in which he clearly identified himself with Joseph shows that it was still alive in the sixteenth century.[20]

The Joseph cycle in the second room of the casino continues the line of argument established by the Moses scenes. However, there are also significant differences. Moses was the instrument of a militant and vengeful God, and his career was punctuated by episodes of violence, such as his murder of the Egyptian and his defense of the daughters of Jethro, which bring to mind Peter's fiery temperament, even if they do not precisely prefigure his attack on Malchus (John 18:10). In contrast, Joseph possessed a mildness and magnanimity more in keeping with Christ Himself. The last of the eight scenes in the second room represents Joseph embracing Benjamin (Gen. 45:14), while the other brothers prostrate themselves before him, much as their sheaves bowed down to Joseph's, in the first dream. This took place after Joseph "had made himself known to his brothers" (Gen. 45:1). It is astonishing and important that Joseph made his revelation without bitterness. Instead, he emphasized that God, not his brothers, had sent him into Egypt, and explained that He had done this to preserve "a remnant on earth" (Gen. 45:7) for Joseph's people and a haven where they could survive the five years of famine which were still to come.

The coalition of Joseph and Moses in the interior programme implies a pontiff who combined the charity and love of the former with the militant discipline of the latter, and suggests a church which might become a haven for extramural sinners, while still possessing the power to annihilate its enemies. As will be seen, both the dove and the hawk had their places in the pontificate of Pius IV.

The *Crossing of the Red Sea*, in the *galleria*, is the only painting to repeat one of the subjects discussed so far. However, the other small paintings introduce no new themes. From early Christian times, the Flood and Jonah's miraculous escape from the "great fish" (Jonah 1:17) promised salvation, prefigured the sacrament of baptism, and symbolized Christ's Resurrection.[21] The story of Judith and Holofernes prefigured

---

[18] Hrabanus Maurus, *Commentariorum in Genesim libri quatuor*, P.L., CVII, cols. 622–644.

[19] M. Schapiro, "The Joseph Scenes on the Maximianus Throne in Ravenna," *Gazette des Beaux-Arts*, 6th ser., XL, 1952, 27–38.

[20] See Bonanni, *Numismata*, I, 189–191, VII.

[21] See U. Steffen, *Das Mysterium von Tod und Auferstehung: Formen und Wandlungen des Jona-Motivs*, Göttingen, 1963, *passim*.

the triumph of the church over the devil. Judith was a familiar *typus Ecclesiae* and an example of chastity,[22] and Holofernes was considered one of the most malevolent persecutors of the church of Christ and a clear *typus diaboli*.[23] David was a popular *typus Christi*, whose life, rather like Joseph's, prefigured a great many aspects of the life of Christ. David overcame Goliath, just as Christ defeated the devil. Saul persecuted David as the Jews persecuted Christ. Saul pursued David into the wilderness of Ziph, and the Jews harried Christ throughout His life. However, Christ no more destroyed the Old Law than David killed Saul. Instead, he replaced it with the New Law, just as David ultimately became king over Judah.[24] The painting in the *galleria* emphasizes that David prevented Abishai from killing Saul, and this was interpreted (by the author of the *Pictor in Carmine*, for example) as a prefiguration of Christ's restraining Peter and saving Malchus, during His arrest in the Garden of Gethsemane,[25] and a symbol of the strength and charity of Christ's church. The Old Testament scenes in the *galleria* therefore illustrate a compound of strength of arm and largeness of heart, which is similar to that suggested by the alliance of Moses and Joseph.

Three of the New Testament scenes in the casino illustrate the selection of Peter as Christ's successor and first *Vicarius Christi*, many of them emphasize the sacrament of baptism, and a number refer to the charity and accessibility of the church.

The *Navicella* is one of the most prominent scenes in Barocci's first room, and it also occupies the central place in the frieze on the northeast wall of the *galleria*. This episode was interpreted in a variety of closely related ways. Christ's summons to Peter symbolized His foundation of the church on Peter, and His saving Peter from the

[22] St. Jerome, *Epistola*, P.L., XXII, col. 732: "[Judith] in typo Ecclesiae, diabolum capite truncavit." St. Jerome, *Praefatio Hieronymi in librum Judith*, P.L., XXIX, col. 41: "Accipite Judith viduam, castitatis exemplum." For further Judith symbolism, see E. Wind, "Donatello's Judith: A Symbol of 'Sanctimonia,'" *Journal of the Warburg Institute*, I, 1937–1938, 62–63.

[23] Hrabanus Maurus, *Expositio in Librum Judith*, P.L., CIX, col. 546: "Holofernem hunc aut gentium principatum, qui persecutus est Ecclesiam Christi, aut ipsum etiam iniquorum omnium caput, et novissimum, perditionis filium possumus intelligere."

[24] *Hrabanus Maurus, Commentaria in libros IV Regum*, P.L., CIX, col. 66: "Iterum item David fugiens a facie Saul in castra regis, cum dormientem offendisset, non percussit, non occidit; sed solam lanceam, quae ad caput ejus erat, et lenticulam sustulit. . . . Quid ergo hoc est, nisi quod persequebantur Christum Judaei? Sed persequendo dormiebant, quia non vigilabant corde. Duritia enim cordis obdormitio est. Dormiunt in vita veteri: non vigilant in nova. Venit Christus: non eos occidit, sed tulit ab eis scyphum aquae, id est, gratiam legis; tulit et sceptrum regale, regni scilicet potestatem, quam pro magno habebant, et unde se protegebant temporaliter, et quam adversus Dominum per incredulitatem gerebant. Deinde victor David noster de castris eorum regressus transcendit in altitudinem montis coelorum." *Hrabanus Maurus, De Universo*, P.L., CXI, col. 58: "Hic [David] Salvatoris nostri expressit imaginem, sive quod in sectatione Judaeorum injustam persecutionem sustinuit, sive quod manu fortis fortem vicit diabolum atque alligavit, ejusque spolia in toto orbe distribuit."

[25] M. R. James, "Pictor in Carmine," *Archaeologia*, XCIV, 1951, 160, XC.

waves illustrated dramatically and unambiguously the support and supreme authority which He transferred to him. The beating waves and contrary winds symbolized the challenge which would be levelled against the church in the future, and the ensuing calm demonstrated its ultimate invincibility and invulnerability. Finally, the scene was interpreted as an image of baptism.[26] *Peter Kneeling before Christ after the Draught of Fishes*, also in the frieze of the *galleria*, had a similar significance. The scene combines elements of the calling of Peter, as described in Luke 5, and the appearance of the Risen Christ by the Sea of Tiberias, as described in the last chapter of John, but the meaning is clear. Whether it illustrates Christ's reassuring "Do not be afraid; henceforth you [Peter] will be catching men" (Luke 5:10), or His command, made three times, "Pasce oves meas" (John 21:15–17), it symbolizes the foundation of the Christian church, and, in the second case, demonstrates that Christ entrusted Peter with the responsibility of feeding and shepherding His entire flock in His place.[27] In fact, in a discourse entitled *In Consecratione Pontificis Maximi*, Leo III chose the latter passage to demonstrate that Christ conferred the primacy upon Peter *post passionem* in addition to conferring it *ante passionem* and *circa passionem*. On the first occasion Christ intended to indicate Peter's *sublimitas potestatis*, on the second his *constantia fidei* and on the third his *pastura gregis*. The pastoral responsibility involved providing an example by which to live, preaching the word of Christ, and offering the sacrament of Holy Communion.[28]

[26] See W. Paeseler, "Giottos Navicella und ihr spätantikes Vorbild," *Römisches Jahrbuch für Kunstgeschichte*, v, 1941, 150–160 in particular. For the ship as a symbol of the church, see Hibbard and Jaffe, "Bernini's Barcaccia," 163–164 and n. 15.

[27] Slightly earlier in the same chapter John tells us: "Jesus said to them, 'Bring some of the fish that you have just caught.' So Simon Peter went aboard and hauled the net ashore, full of large fish, a hundred and fifty-three of them; and although there were so many, the net was not torn" (10–11). St. Gregory the Great, *Homilae XL in Evangelia*, P.L., LXXVI, col. 1185, commented upon this passage, and connected it with the later verses: "Captis autem tam magnis piscibus, *Ascendit Simon Petrus, et traxit rete in terram* [John 21:11]. Jam credo quod vestra charitas advertat quid est quod Petrus rete ad terram trahit. Ipsi quippe sancta Ecclesia est commissa, ipsi specialiter dicitur: *Simon Joannis amas me? Pasce oves meas (Joan. XXI, 15, 16)*. Quod ergo postmodum aperitur in voce, hoc nunc signatur in opere. Quia ergo praedicator Ecclesiae nos a mundi hujus fluctibus separat, nimirum necesse ut rete plenum piscibus Petrus ad terram ducat." St. Augustine, *Sermones*, P.L., XXXVIII, col. 1159, saw the two draughts of fishes, one *ante passionem* and the other *post passionem*, as symbolizing Christ's two churches: "Recolamus ergo vobiscum duas illas piscationes discipulorum factas jubente Domino Jesu Christo, unam ante passionem, alteram post resurrectionem. In his ergo duabus piscationibus tota figuratur Ecclesia, et qualis est modo, et qualis erit in resurrectione mortuorum. Modo enim habet sine numero multos, et bonos et malos: post resurrectionem autem habebit certo numero solos bonos."

[28] P.L., CCXVII, cols. 658–659: "Primatum Petri Dominus Jesus Christus et ante passionem, et circa passionem, et post passionem constituit. Ante passionem cum dixit: 'Tu es Petrus, et super hanc petram aedificabo Ecclesiam meam, et quodcunque ligaveris super terram, erit ligatum et in coelis: et quodcunque solveris super terram, erit solutum et in coelis (*Matth.* XIV).' Circa pas-

The *Baptism*, in the first room, and *John the Baptist by the Jordan*, in the *galleria*, illustrate the theme of baptism in a literal way, but the importance of this sacrament is also emphasized by scenes such as the *Holy Family with the Infant St. John, Elizabeth and Zachariah*, the *Navicella* and *Christ and the Samaritan Woman*, in the first room, and the second *Navicella* and the *Mystic Marriage of St. Catherine*, in the *galleria*. The emphasis upon water in three of the four allegories in the second room suggests that they also contribute to the theme of baptism.

The baptismal implications of the *Navicellas* and Barocci's *Holy Family* have been discussed earlier.[29] If anything, the reference to the sacrament of baptism is still more pronounced in *Christ and the Samaritan Woman* and the *Mystic Marriage of St. Catherine*.

John told the story of Christ's encounter with the woman of Samaria (4: 1–42) immediately after describing John the Baptist's testimony and Christ's baptizing. The meeting took place at Jacob's well, and the story centres around the contrast, drawn by Christ Himself, between the water which He requested from the woman and the "living water," which was to become "a spring of water welling up to eternal life," which He offered.[30]

If Christ's conversation with the Samaritan woman alluded to the advisability of receiving the *donum Dei* (the Holy Spirit) in baptism, the mystic marriage of St. Catherine demonstrated its necessity. Catherine's marriage to the Infant Christ took place shortly after her baptism, and the critical importance of that baptism was brought out clearly by Jacobus de Voragine in the *Legenda Aurea* (despite the fact that he added details from the story of Catherine of Siena to his biography of Catherine of Alexandria). Before Catherine was brought to Christ, the Virgin told her: "But yet ye lack one thing that you must receive before ere you come to the presence of my Son; ye must be clothed with the sacrament of baptism, wherefore come on my dear daughter for all things are provided. For there was a font solemnly

---

sionem cum ait: 'Simon, Satanas expetivit, vos ut cribraret sicut triticum: ego autem rogavi pro te, ut non deficiat fides tua: et tu aliquando conversus, confirma fratres tuos (*Luc.* xxii).' Post passionem vero, cum tertio praecepit: 'Si diligis me, pasce oves meas (*Joan.* xxi).' In primo sublimitas potestatis, in secundo constantia fidei, et in tertio pastura gregis exprimitur: quae circa Petrum in hoc loco manifestissime declarantur. Constantia fidei, cum dicitur: *Constituit super familiam*. Pastura gregis, cum dicitur: *Ut det illi cibum*. Cibum dare tenetur, videlicet exempli, verbi, sacramenti. Quasi dicat: Pasce exemplo vitae, verbo doctrinae, sacramento eucharistiae. Exemplo actionis, verbo praedicationis, sacramento communionis."

[29] See above, 83, 94–95.

[30] St. Augustine, *In Joannis Evangelium*, P.L., xxxv, col. 1515, interpreted the contrast as one between the visible and invisible and the material and spiritual: "Quid evidentius, quia non aquam visibilem, sed invisibilem promittebat? quid evidentius, quia non carnaliter, sed spiritualiter loquebatur?"

apparelled with all things requisite unto Baptism." After the baptism, the Virgin told Catherine: "Now mine own daughter be glad and joyful, for ye lack no thing that longeth to the wife of a heavenly spouse."[31] Zuccaro's fresco in the *galleria* does not illustrate Voragine's narrative, but the Infant St. John's presence in the painting suggests that it too makes the point that baptism is a necessity, if one is to be accepted by Christ. The placement of Peter and Paul, the twin leaders of the church, in close relationship to the *Mystic Marriage of St. Catherine* indicates what might be described as the institutional aspect of baptism.

Christ's meeting with the woman of Samaria was given a second interpretation, which enables one to associate the painting with *Christ and the Adulteress*, its companion in the first room, and the cycle illustrating the parable of the labourers in the vineyard, in the stairwell. John wrote that "Jews have no dealings with Samaritans," and made a point of the Samaritan woman's astonishment at Christ's asking her for a drink (4:8). The Samaritans were a mixed people, despised by the Jews, who considered their Judaism unorthodox and heretical.[32] In fact, commentators interpreted the Samaritan woman both as a *forma Ecclesiae*[33] and a *typus Synagogae*,[34] and her conversion has been interpreted as referring to the first apostolic mission outside orthodox Jewry. At one level, then, Christ's conversation with the Samaritan woman indicated His accessibility and charity, and demonstrated His readiness to offer the *donum Dei* to heretics and schismatics, if they would only accept Him.

Christ's charity and mercy are also central to the story of the woman caught in adultery (John 7:53–8:11). When all the accusers had stolen away, Christ looked up, and said: " 'Neither do I condemn you; go and do not sin again' " (John 8:11). This conclusion concentrates upon Christ's wisdom, love and forgiveness.[35] However, the earlier verses emphasized the sins of the accusers, and this facet of the story enables one to reintroduce the theme of baptism. The scribes and the Pharisees represented

---

[31] [J. de Voragine], *The Golden Legend or Lives of the Saints*, trans. by W. Caxton, London, 1900, VII, 13–14.

[32] St. Augustine, *In Joannis Evangelium*, P.L., XXXV, cols. 1513–1514: "Samaritani ad Judaeorum gentem non pertinebant: alienigenae enim fuerunt, quamvis vicinas terra incolerent. Longum est originem Samaritanorum retexere, ne nos multa teneant, et necessaria non loquamur: sufficit ergo ut Samaritanos inter alienigenas deputemus."

[33] *Ibid.*, cols. 1510–1522.

[34] Hrabanus Maurus, *De Universo*, P.L., CXI, col. 82: "Mulier Samaritana mystice intelligitur Synagoga, quinque libris legis, quasi quinque viris, secundum sensum carnis subjecta; quam misericorditer Dominus provocat haurire aquam vivam, lavacri scilicet percipere gratiam, vel secretam legis intelligentiam."

[35] St. Augustine, *In Joannis Evangelium*, P.L., XXXV, cols. 1647–1651. Hrabanus Maurus, *De Universo*, P.L., CXI, col. 82: "Mulier adultera, quae offertur Domino a Judaeis lapidanda, Ecclesia est; quae prius, relicto Deo, in idolis fuerat fornicata, quam volebat Synagoga zelans interficere; Christus salvat per remissionem delicti, nec sinit eam perire, qui novit veniam condonare peccantibus."

the Synagogue and the Old Law, and their impurity reflected their rejection of the remission of sin and spiritual purification promised by Christ's baptism. Significantly, the story of the adulteress follows closely upon Christ's statement: "If anyone thirst, let him come to me and drink. He who believes in me, as the scripture has said, 'Out of his heart shall flow rivers of living water'" (John 7:37–38). Clearly, this passage echoes Christ's conversation with the woman of Samaria, provides an additional reason for associating the adulteress and the Samaritan woman, and reinforces the baptismal significance of both episodes.

Commentators consistently identified the householder of the parable of the labourers in the vineyard as Christ, the vineyard is clearly the "vineyard of the Lord of hosts" (Isaiah 5:7), and the *denarius* received at the end of the day's work is the prize of eternal life.[36] The labourers recruited at the first, third, sixth, ninth and eleventh hours of the morning symbolized the succession of the patriarchs, prophets and apostles, or the various times of life at which man may receive Christ's summons.[37] Christ's perpetual love and eternal vigilance are indicated by the fact that the house-

[36] St. Hilarion, *Commentarius in Evangelium Matthaei*, P.L., IX, col. 1209: "Patremfamilias hunc, Dominum nostrum Jesum Christum existimari necesse est: qui totius humani generis curam habens, omni tempore universos ad culturam legis vocaverit. Vineam vero, legis ipsius opus et obedientiam; denarium autem, obedientiae ipsius praemium significari intelligimus." St. Jerome, *Expositio in Evangelium secundum Matthaeum*, P.L., XXX, col. 574: "Denarium diurnum, vitam aeternam." St. Augustine, *Sermones*, P.L., XXXVIII, col. 533: "Quia denarius ille vita aeterna est, et in vita aeterna omnes aequales erunt." Hrabanus Maurus, *De Universo*, P.L., CXI, col. 77: "Paterfamilias qui operarios ad vineam conduxit et denarii mercedem promittit, Christus est, qui vocat omnes ad cultum fidei, promittens eis praemium perfectae beatitudinis."

[37] St. Jerome, *Expositio in Evangelium secundum Matthaeum*, P.L., XXX, col. 574: "Prima hora venit Abel: tertia hora Noe, et filii ejus: sexta hora venit Abraham: nona hora venit Moyses et David: undecima hora venit populus gentium. Alio modo, prima hora, id est infantia: secunda hora adolescentia: sexta juventus: nona senectus: undecima decrepita aetas." Hrabanus Maurus, *De Universo*, P.L., CXI, cols. 77–78: "Operarii qui hora prima conducti sunt, hi sunt qui a rudimentis infantiae cultum fidei consecuti sunt; qui autem hora tertia, hi sunt qui in adolescentia ad fidem accesserunt; qui vero hora sexta conducti sunt, hi sunt qui in juventutis aetate crediderunt, qui autem hora nona accesserunt, illi sunt qui a juventute in senectutem declinantes, Christi gratiam perceperunt; qui vero ultima hora, illi sunt qui jam decrepiti et in extremo vitae suae tempore vocati ad Christi venerunt: qui tamen prioribus parem mercedem aeternae beatitudinis accipiunt, in illis conservans Christus justitiam, qui a prima hora nativitatis operati sunt, in istis impendens misericordiam, qui una vitae hora laboraverunt." St. Jerome, *Commentarius in Evangelium secundum Matthaeum*, P.L., XXVI, col. 146: "Mihi videntur primae horae esse operarii Samuel, et Jeremias, et Baptista Ioannes, qui possunt cum Psalmista dicere: *Ex utero matris meae Deus meus es tu* (*Psal.* XXI, 11). Tertiae vero horae operarii sunt, qui a pubertate servire Deo coeperunt. Sextae horae, qui matura aetate susceperunt jugum Christi. Nonae, qui jam declinante (*Al.* declinant) ad senium. Porro undecimae, qui ultima senectute: et tamen omnes pariter accipiunt praemium, licet labor sit. Sunt qui hanc parabolam aliter edisserant. Prima hora volunt missum esse in vineam Adam et reliquos patriarchas usque ad Noe; tertia, ipsum Noe usque ad Abraham et circumscisionem ei datam; sexta, ab Abraham usque ad Moysen, quando lex data est; nona ipsum Moysen et prophetas; undecima, apostolos et gentium populum, quibus omnes invident."

holder constantly returned to seek new labourers for his vineyard, and Christ's generosity is symbolized by the fact that all the workers received the same payment (and by the personification of Charity, in the first scene), whether they were recruited early in the morning or at the eleventh hour.

However, the vineyard also symbolized Christ's earthly patrimony,[38] and it is plausible to interpret the *procurator* or steward as a type of the *Vicarius Christi*, whom Christ appointed to administer His earthly church. This being the case, the localization of the illustrations to the parable before Pius IV's own *vineae* or *vigne* underlines his position as Peter's successor and *Procurator vineae Christi*.

One can now see that, in addition to the subjects carried over from the exterior, three tightly interwoven new themes run through the entire decorative programme of the interior. First of all, there is an almost obsessive emphasis upon baptism and the benefits which flow from it. Secondly, there is a constant preoccupation with the institution of the papacy, its history and prehistory, and its supreme authority. Finally, there is a nicely balanced selection of *exempla* illustrating the charity, love and accessibility of Christ's church, on the one hand, and its power of punishment, on the other. The material drawn upon to interpret the interior decoration in these ways formed part of the familiar and venerable tradition of biblical exposition.[39] However, the allegories and meanings were not fossilized, even if they had become standardized. In fact, they could be adapted to contemporary situations, and could sustain contemporary meaning. This was the case with the fifteenth-century decoration for the Sistine Chapel, and it will become clear that the scenes chosen for the interior of the Casino, and the themes which they illustrated, had a precise relevance to the pontificate of Pius IV.

This is apparent at a number of levels. Pius IV's shade still clings to the vaults of the Casino, like bats to the walls of a cave, in the forms of coats of arms, inscriptions and Virtues, and, in a more vital and more personal sector of the decoration, Pius himself still manages his Roman *vigne* in his dual role as householder of the parable and new guardian of the "vineyard of the Lord of hosts."

[38] St. Jerome, *Expositio quatuor Evangeliorum*, P.L., xxx, col. 574: "*Vinea* id est Ecclesia."

[39] For the origins of this tradition, see J. Daniélou, *From Shadows to Reality*, London, 1960. It may be worth emphasizing that in this chapter I do not mean to suggest that the specific passages cited from Augustine, Jerome or Hrabanus Maurus, for example, lay directly behind particular paintings. Rather, I want to demonstrate that well-established traditions existed for interpreting particular scenes in the ways proposed. While one would have liked to trace the immediate sources of the exegetical tradition drawn upon by the author of the interior programme, there can be no serious methodological objection to using sources as authoritative and representative as those chosen here. In fact, it is entirely possible that the author of the programme went directly to the earlier sources, rather than using sixteenth-century commentaries. (For a discussion of questions of this kind and an attempt at establishing certain "controls," see Shearman, *Raphael's Cartoons*, 45–47.)

# The Interior Decoration and the Pontificate of Pius IV

THE completion and closure of the Council of Trent have been described as the "essential content" of the pontificate of Pius IV.[1]

The convocation of the Council preoccupied Pius IV from the beginning of his pontificate. The continuation of the Council was proposed in the election capitulation, read in conclave on 8 September 1559, and was confirmed in a bull of 12 January 1560. Less than a week after his election, Pius told the Imperial ambassador that he intended to summon a General Council as soon as possible. He confirmed this in a Congregation of Cardinals on 4 January 1560; and, during February, he spoke repeatedly of the Council to the Spanish ambassador. During May, Pius IV's intentions for the Council were accelerated and crystallized by the decision of France to convene a national council of the members of the Gallican church. Almost immediately, Pius commissioned Marcantonio da Mula to approach Venice concerning the possibility of holding the Council in Venetian territory; and, early in June, he formally announced his decision to hold the Council to the ambassadors of the Emperor, Spain, Portugal, Florence and Venice. The Council was to be continued in Trent to avoid delays and disputes over its location. The spread of heresy made immediate action essential, and Pius made it emphatically clear that the Council was not to be delayed.[2]

Despite this, the bull of convocation, *Ad ecclesiae regimen*, was not published until 29 November 1560. Ercole Gonzaga and Giacomo Puteo were appointed legates to the Council in February 1561, and three further legates were chosen in March. Pius IV's personal involvement in the final preparations for the Council is apparent from a record by Marcantonio da Mula of a conversation which he had with the pope on 14 February; and it is confirmed by a report written by the Mantuan ambassador on 28 February. Marcantonio da Mula tell us:

[1] H. Jedin, *Crisis and Closure of the Council of Trent: A retrospective view from the Second Vatican Council*, London, 1967, 1.

[2] This paragraph and much of this chapter are based upon material drawn from: H. Jedin, *A History of the Council of Trent*, 2 vols., Edinburgh, 1957 and 1961; H. Jedin, *Crisis and Closure*; and Pastor, *Popes*, xv and xvi. I should also like to acknowledge my general indebtedness to L. D. Ettlinger's *The Sistine Chapel before Michelangelo: Religious Imagery and Papal Primacy*, Oxford, 1965.

[Pius] started towards the Belvedere, saying that I should follow him, if the walk did not trouble me; and every now and then he beckoned to me, and spoke a few words, saying, among other things, that he had made two legates for the Council, and asking what I thought of them. I praised them both highly. He added: "We shall create three others, and if among the existing cardinals we do not have enough who are willing, we shall create new ones, theologians and jurists, who will be worthy; and if those are not sufficient, we shall create others; and we ourselves shall go if we see it to be necessary." And when I said that the undertaking was a great one, and that it was necessary for His Holiness to redress the errors of the past, he sighed and prayed to God that he might succeed and not fail completely in every imaginable way; and he said that everyone should pray to God to aid him in this most difficult enterprise.[3]

Francesco Tonina, the Mantuan ambassador, put it more succinctly. According to him, Pius IV had "four capital Cs" on his mind—"Cardinals, Carafa, Council, Colonnas."[4] After more than two years of preparation, the Council was formally opened on 18 January 1562, the feast of the Cathedra of St. Peter, in the Cathedral of St. Vigilius at Trent.

The fabric and exterior decoration of the Casino of Pius IV were essentially complete and the interior decoration was well under way by the time the Council of Trent reopened, and the final payments for the interior decoration were all made some months before the final session of the Council took place on 3 and 4 December 1563. This being the case, one can hardly argue that the decorative programme of the Casino illustrated directly the issues which were discussed in the congregations and formulated in the nine sessions of Pius IV's Council. However, although Tonina did not single it out as such, the Casino *was* a fifth "capital C," which preoccupied Pius during 1561, and continued to preoccupy him during 1562 and 1563, as did the Council of Trent. It would be surprising indeed if the interior decoration of the Casino did not mirror the issues under discussion at the Council in some way. In fact, although

---

[3] Pastor, *Popes*, xv, 243, n. 5: "Et ella si avviò verso Belvedere, dicendo che, se non m'aggrava il caminare, io la seguisse, e tal volta mi chiamava colla mano dicendo qualche parola e tra le altre che haveva fatto duoi legati per il concilio e domandando, che me ne pareva, laudai grandemente l'uno e l'altro. Ella soggiunse: Ne faremo tre altri, e se non ne havemo de' fatti cardinali che siano al proposito, gli faremo di nuovo, teologi e legisti che siano da bene, e se non bastaranno quelli, ne faremo degli altri e ci andaremo ancora noi, quando conoscoremo che sia bisogno. E dicendo io che l'impresa è grande e che bisogna che Sua Santità sia correttore degli errori del tempo passato, ella sospirando pregava Dio che lo potesse fare e che non mancheria di tutto quello che si sapesse immaginare e che tutti dovessero pregare Dio che l'aiutasse in questa difficilissima impresa."

[4] *Ibid.*, 164, n. 2: "Dicono che S.S^ta diceva haver quattro C grandi ch' l travagliavano la mente cioè: Cardinali, Caraffa[sic], Concilio, Colonnesi."

it does not provide a correspondent's view of the Council, the interior decoration of the Casino does document the problems which brought the Council into being, it does reflect the dangers which the Council carried with it, and it does present the position of the Church on a number of the critical issues defined during the second convocation of Paul III.

The struggle against the supremacy of the papacy was one of the essential characteristics of the Reformation. However, the Protestants were not the only ones to threaten the monarchical constitution of the Church of Rome. There were clear precedents in conciliarism, which had remained restlessly alive throughout the fifteenth century, despite Eugenius IV's victory at the Council of Florence with the Bull of Unity, *Laetantur Coeli* (described by Jedin as "the *Magna Carta* of the papal restoration"[5]), and despite Pius II's renewed attacks on conciliar theory in the bulls *Execrabilis* and *Infructuosos palmites*. In fact, conciliarism was still dangerously vital towards the end of the fifteenth century and into the sixteenth. This is clear from the bulls *Qui monitis* and *Suscepti regiminis*, promulgated by Sixtus IV and Julius II respectively, and is graphically apparent from the sustained propaganda on the *Primatus Papae* presented by the fifteenth-century decoration in the Sistine Chapel.[6]

Almost by definition, conciliar theory was bound to flourish in the context of general councils, and the mere threat of a council became an effective weapon against the papacy. This being the case, it was entirely predictable that the Council of Trent would be accompanied by some resurgence of conciliar thinking. In fact, the possibility of a crisis in papal authority was apparent from the first convocation of the Council under Paul III. Despite Paul's repeated emphasis on the duty of attendance, only ten bishops had arrived in Trent seven months after the date fixed for the opening.[7] This lack of response to papal authority was a portent of things to come. Papal supremacy was directly challenged during Paul III's second convocation, and debates around the primacy of the pope twice threatened to wreck Pius IV's Council.

The first major threat to papal authority came in the discussions on the duty of residence, which took place from the spring of 1546 up to *Sessio* VII.[8] The reality of this obligation was not disputed. Rather, the controversy centred on the nature of the obligation—that is, whether the duty of residence stemmed directly from divine ordinance (*ius divinum*), or was simply a law of the church (*ius commune*). The dangers of the *ius divinum* argument were clear. Its acceptance would at once limit papal authority, by restricting or eliminating the concession of dispensations, and would increase episcopal autonomy. That this was the direction of thinking of part of the Council was clear from the memorials on the *impedimenta residentiae*, prepared

[5] *Council of Trent*, i, 20.

[6] *Ibid.*, 62–75, in particular; and Ettlinger, *Sistine Chapel, passim*.

[7] Jedin, *Council of Trent*, i, 474.         [8] *Ibid.*, ii, 317–369.

102

in June 1547. Those expanded the discussion of episcopal jurisdiction by tabulating the inroads made upon it by exemptions and unions, by the Curia and by secular powers. Although the question of papal authority was eliminated from the reform decree accepted in *Sessio* VII on 3 March 1547, it had been raised in debate, and it was to appear again during the convocation under Pius IV.

The question of the duty of residence was raised again in the general congregation held on 11 March 1562, and resulted in a fundamental rift within the Council. One party maintained that the only effective way of ending dispensations and ensuring that pastoral duties be carried out was to declare the duty of residence to be a divine commandment. The second party opposed this on a number of grounds, one being that the adoption of the principle of the *ius divinum* would erode the authority of the pope. Between 7 and 20 April 1562, nine general congregations were devoted to discussing the *ius divinum*. When the question was put to the vote on 20 April, sixty-seven members of the Council voted *placet*, thirty-five voted *non-placet*, and thirty-four voted neither for nor against, but referred their votes to Pius for his decision. Pius responded by reserving his decision and forbidding further discussion of the *ius divinum* at that stage.[9]

The second great crisis of Pius IV's convocation arose in the discussions of the sacrament of ordination, held in general congregation between 13 and 20 October 1562. The point at issue on this occasion was closely tied to that in the disputes over the duty of residence. In this case, the fundamental question was whether the episcopal office stemmed directly from Christ Himself, or depended from Peter and the Church. On 10 December 1562, the question of the duty of residence was put before the Council once more, and discussion continued until 18 January 1563. During this phase of the Council, Pius became increasingly convinced that the debates were bound to lead to a direct challenge of the primacy of the papacy, and he considered appointing a delegation of cardinals to defend the doctrine of the supremacy of the pope.[10]

As it turned out, the *Primatus Papae* and its relationship to the episcopal jurisdiction were not defined formally by the Council of Trent. However, the wording of many of the canons acknowledged implicitly the primacy of the pope, and the final submission of the decrees of the Council to Pius for his confirmation did amount to a *de facto* recognition of papal supremacy.[11]

Whether in response to the Protestant denial of papal primacy, in memory of the debates on the *ius divinum* in Paul III's second convocation, or in anticipation of the similar crises in his own convocation, much of the interior decoration of Pius IV's Casino presents what might be described as the loyalist view of the *Primatus Papae*.

[9] Jedin, *Crisis and Closure*, 41–58, 50–51 in particular.
[10] *Ibid.*, 80–100.  [11] Pastor, *Popes*, xv, 370–371.

The Joseph cycle, the Moses scenes and selected New Testament scenes, such as the *Navicella* and the *Pasce Oves Meas*, clearly present the monarchical tradition of the papacy, in opposition to conciliar and Protestant outlooks. Finally, the topographical treatment of the parable of the labourers in the vineyard makes the personal and topical application of the argument unmistakable.

The Council of Trent condemned the errors of the Protestants concerning the sacraments in general and baptism in particular in *Sessio* VII under Paul III. Indirectly, the canons *de sacramentis in genere* and *de baptismo* defined the Catholic position, and formed the basis for the corresponding sections of the *Catechism of the Council of Trent* or *Roman Catechism*, nearly completed under Pius IV and published under Pius V in 1566.[12]

Two of the canons on baptism are especially important for understanding the contemporary significance of the interior programme of the Casino of Pius IV. The fifth canon unequivocally enforced the traditional doctrine of the necessity of baptism: "If any one saith, that baptism is free [optional], that is, not necessary unto salvation; let him be anathema."[13] Equally unambiguously, the third canon asserted the exclusive rightness of the Church of Rome's doctrine concerning the sacrament of baptism: "If any one saith, that in the Roman church, which is the mother and mistress of all churches, there is not the true doctrine concerning the sacrament of baptism; let him be anathema."[14]

Earlier in *Sessio* VII, the third canon on the sacraments in general had defined the number and general nature of the sacraments, had affirmed their intrinsic worth, and had indicated the existence of a hierarchy within the septenary number. The last proposition was formulated in the third canon: "If any one saith, that these seven sacraments are in such wise equal to each other, as that one is not in any way more worthy than another; let him be anathema."[15] The *Catechism of the Council of Trent* expanded upon this, explaining that three of the sacraments are more necessary than the others, and reminding one that Christ Himself had stated the absolute necessity of baptism: "Truly, truly, I say to you, unless one is born again of water and the Spirit, he cannot enter the kingdom of God" (John 3:5).[16]

This material accounts for the extraordinary emphasis upon the sacrament of baptism in the interior of the Casino of Pius IV. The very number of scenes referring

---

[12] Jedin, *Council of Trent*, II, 370–395.

[13] *The Canons and Decrees of the Sacred and Oecumenical Council of Trent*, trans. by J. Waterworth, London, 1848, 56.

[14] *Ibid.*, 56.          [15] *Ibid.*, 54.

[16] *Catechismus ex decreto SS. Concilii Tridentini ad parochos Pii V. Pont. Max. jussu editus*, Bassani, 1833, 105: "Baptismum enim unicuique sine ulla adjunctione necessarium esse, Salvator his verbis declaravit: *Nisi quis renatus fuerit ex aqua & Spiritu sancto, non potest introire in regnum Dei.*"

to baptism indicates the primacy of this sacrament among the seven; that it is frequently administered by a *typus Petri* (such as Moses in the *Crossing of the Red Sea* or the *Striking of the Rock*), or undergone by Peter himself (in the *Navicella*) indicates its inextricable relationship to the Catholic church; and its absolute necessity is made clear unmistakably by the *Mystic Marriage of St. Catherine* in the *galleria*. These scenes are straightforward, simply asserting the facts of the sacramental doctrine of the Church of Rome. Other scenes are more didactic, and set out to demonstrate the efficacy and sole validity of the Catholic church's doctrine of baptism.

In the first of the allegories in the second room (Fig. 62), the woman on the left peak surely symbolizes *Ecclesia Romana* administering the waters of true baptism. Superficially similar in appearance, but catastrophically different in effect, the woman on the right peak must represent the corrupted sacrament offered by the schismatic churches. The second allegory (Fig. 64) may also reflect the Tridentine decrees on baptism. As Jedin put it, canons six to ten "insist that at baptism we assume not only the obligation to believe, but also that of keeping God's commandments and of fulfilling the whole law of Christ."[17] The emphasis placed by the allegory upon the virtue of perseverance suggests that the figures sprawled on the lower slopes of the mountain are doomed, not because they never received baptism, but because they failed to meet the responsibilities assumed with it. If it is not too far-fetched to identify fickle Fortune with Protestantism, the third allegory (Fig. 63) may also have an ecclesiastical content, indicating the dangers consequent upon being tempted by either. Finally, the female in the fourth scene may also symbolize *Ecclesia Romana*, "which is the mother and mistress of all churches," the only source of the true *donum Dei*.

The Casino's lesson on baptism is most apparent in the *Christ and the Samaritan Woman*. John distinguished clearly between the spiritual water which Christ offered and the merely physical water of Jacob's well, and it is easy to translate this distinction into an opposition between the true baptism offered by the Catholic church and the spurious baptism offered by the Protestant churches.

The emphasis placed by the interior decoration upon the accessibility and powers of forgiveness of the Church of Rome is also in keeping with Pius IV's personal outlooks. Partly as a reaction against his predecessor's repressive pontificate, and partly as a reflection of his own inclinations, Pius preferred a policy of conciliation and moderation on matters of reform.[18]

When Pope John XXIII opened the Second Vatican Council on 11 October 1962, he emphasized that, although the Catholic church had condemned errors with great severity in the past, "now the Bride of Christ takes pleasure in offering the medicine of mercy rather than taking up the arms of severity."[19] While the interior programme

[17] Jedin, *Council of Trent*, II, 390.   [18] Pastor, *Popes*, XIV, 421; *ibid.*, XV, 126.
[19] G. Ceriani, *L'Ora del Concilio: cronache e primo bilancio del Concilio Vaticano II*, Milan,

of the Casino leaves one in no doubt that Pius IV could wield the arms of severity, scenes such as *Christ and the Samaritan Woman, Christ and the Adulteress* and *David Restraining Abishai from Killing Saul* and the cycle illustrating the parable of the labourers in the vineyard make it very clear that he too preferred the medicine of mercy.

---

1963, 226–227: "Ora la sposa di Cristo si compiace di offrire la medicina della misericordia piuttosto d'impugnare le armi della severità."

# CONCLUSION

Τhe interior and exterior programmes of the Casino of Pius IV possess a certain autonomy, but they are not entirely independent of each other. The two programmes overlap in the loggia and entrance portico; the complimentary allusions to Pius, prominent in the exterior decoration, are continued in the interior with little or no modification; and the other themes of the exterior programme are also carried over, although less emphatically.

More important than the impact of the exterior decoration on the interior is the retroactive effect of the interior programme upon the exterior. The vase on the façade of the casino again provides the key. Baptism was one of the most sustained themes of the interior, and it dominates the programme of the *galleria*. The stucco vase crowns the façade of the casino, but it can also be seen as an *impresa* for the *galleria* which stands immediately behind it. If this can be accepted, it may not be too fanciful to imagine a metamorphosis of the good things contained in the vase into the spiritual waters of baptism, thereby transforming the oval *cortile* and its fountains into a gloriously ornate baptismal font. The gifts of the first of the gods are therefore transformed into *the* gift of the true God.

The decoration of the Casino of Pius IV teaches and preaches, but it does not crusade—the programme is too private and personal for that. It is as if the various themes of the decoration were thoughts committed to a diary. In fact, it is these qualities of intimacy and introspection which distinguish the Casino from Pius IV's other commissions and from other papal programmes.

Pius IV was obsessed with building, as his contemporaries recognized.[1] It was believed that he spent one and a half million gold *scudi* on architecture and fortifications during the first three years of his pontificate,[2] and thirteen of his medals commemorate architectural undertakings.[3] In the Vatican, Pius completed the Belvedere Court, restored the Sistine Chapel, renovated and redecorated much of the Palace, and continued the construction of St. Peter's. In June 1564 he planned a great piazza before St. Peter's, and demolition "for the expansion and beautification of the piazza" began in November of the same year.[4] Pius also repaired the Aurelian Walls, reorgan-

---

[1] In June 1563, the Venetian ambassador remarked: "Ha una inclinazione grandissima al fabricare, . . . non vi essendo ormai luogo in Roma che non abbia il nome suo." (See E. Alberi, *Le relazioni degli ambasciatori veneti al Senato durante il secolo decimosesto*, X, Florence, 1857, 76–77.) On Pius IV's building activity in general, see: Fagiolo and Madonna, "La Roma di Pio IV," *passim*; Lewine, "Città Leonina," 224–229; Pastor, *Popes*, XVI, 413–457; D. Redig de Campos, *I Palazzi Vaticani*, Bologna, 1967, 146–165.

[2] Alberi, *Relazioni*, 132, 134, n. 1.    [3] Bonanni, *Numismata*, II, 271–290.

[4] Pastor, *Popes*, XVI, 457, n. 1.

ized the Città Leonina, and strengthened Castel S. Angelo. To protect Rome against Turkish invasion, he improved the coastal fortifications at Ostia and Civitavecchia.

Pius IV's building activity in the city of Rome was at least as impressive, and was commemorated by the epigram:

Marmoream me fecit, eram cum terrea, Caesar
Aurea sub Quarto sum modo facta Pio.[5]

Pius restored a series of Roman churches, including the Pantheon, Ss. Giovanni e Paolo, Ss. Apostoli and S. Giovanni in Laterano; and he transformed the Baths of Diocletian into the great church of S. Maria degli Angeli. He improved the water supply of the city, entirely renewing the Acqua Vergine, opened new streets (the Via Angelica and the Via Pia), built the Porta Angelica and the Porta Pia, and rebuilt the Porta del Popolo. Pius was still full of grandiose plans for the city in June 1564. A report by Galeazzo Cusano, the Imperial ambassador, tells us that Pius celebrated mass in S. Giovanni in Laterano, "and then rode through old Rome; and for the entire morning he did nothing but plan streets and buildings which, if he lives for a few more years, will modernize the city in such a way that it will be unrecognizable."[6]

The intimacy and relaxation of the Casino are also missing from Pius IV's less monumental undertakings. In particular, the decoration of the apartments behind the *Nicchione* is very different from that in the Casino, despite the fact that many of the same artists were involved in it.

Barocci and Federico Zuccaro were in charge of a room *accanto l'hemiciclo a man destra*, and painted sixteen frescoes illustrating the early chapters of Exodus, from God's first appearance to Moses to the crossing of the Red Sea.[7] The cycle is unusually elaborate, but has surprisingly little in common with that in the Sistine Chapel. All ten plagues are represented in Pius IV's series, in addition to the more usual episodes such as God appearing to Moses in the burning bush, the miracle of the rod and the crossing of the Red Sea. In contrast, none of the plagues appear in Sixtus IV's cycle, and, of the three scenes shared by the two series (God appearing to Moses in the Burning Bush, Moses and Aaron before Pharaoh and the crossing of the Red Sea), only the crossing of the Red Sea has a prominent place in the Sistine programme. To find monumental narrative cycles which emphasize the plagues to the extent that Pius IV's

[5] P. Masson, *De Episcopis Urbis*, Paris, 1586, fols. 411v–412r. (Quoted from Coffin, "Ligorio," II, 18, n. 44.)

[6] Pastor, *Popes*, XVI, 457, n. 2: "et di poi cavalcò per Roma vecchia et tutta la mattina non fece che disegnar strade e fabriche che si vive ancora qualche anni la innoverà in modo che la non si riconoscerà."

[7] On this cycle, see Redig de Campos, *I Palazzi Vaticani*, 149.

108

series does, one has to go back to early Christian cycles, such as those in S. Paolo fuori le Mura, the old basilica of St. Peter and S. Maria Maggiore.[8]

There is no mixture of the biblical and the pagan in this programme. The cycle documents God's appointment of Moses as His minister, and emphasizes divine retribution. The relentless presentation of the ten plagues conjures up an impression of obsessive and vengeful militancy, remote from the moderation of the Casino's programme. In this cycle, the *Crossing of the Red Sea* (Fig. 82) probably symbolizes the apocalyptic destruction of heresy rather than referring to the promise of salvation through baptism.[9]

The hawkish mood continues in a second apartment in the Belvedere, decorated by Santi di Tito and Niccolò Circignani.[10] The eight frescoes illustrate the saga of Nebuchadnezzar, king of Babylon, told in the book of Daniel. The first scene illustrates Nebuchadnezzar's dream of the five kingdoms (Dan. 2) (Fig. 83). The *statua grandis* (clearly modelled upon Donatello's Medici and Martelli *Davids*) stands on a low plinth in the centre foreground; Nebuchadnezzar lies abed, "his spirit . . . troubled, and his sleep [having] left him," in the left background; and David interprets the dream in the right background. The second fresco combines the worship of Nebuchadnezzar's *statua aurea* (modelled upon Cellini's *Perseus*) and the miraculous immunity of the three Hebrews to the fiery furnace (Dan. 3) (Fig. 84). The third and fourth frescoes show Daniel interpreting Nebuchadnezzar's dream of the great tree (Dan. 4). In the right background of the first scene (Fig. 85) all the "beasts of the field" are shown gathered in the shade of the tree, and the "birds of the air" are shown fluttering through its branches. The second scene shows the beasts and birds fleeing from the tree, when the "watcher," sword in hand, came to fell it and lop off its branches. The following two scenes represent the fulfillment of the dream—God's sentence upon Nebuchadnezzar on the roof of the royal palace at Babylon; and Nebuchadnezzar's madness, "when he was driven from among men, and ate grass like an ox, and his body was wet with the dew of heaven till his hair grew as long as eagles' feathers, and his nails were like birds' claws" (Dan. 4:28-33). The penultimate scene represents Nebuchadnezzar's recovery, when, as he himself put it: "I, Nebuchadnezzar, lifted my eyes to heaven, and my reason returned to me, and I blessed the Most High, and praised

---

[8] Ettlinger, *Sistine Chapel*, 43–44.

[9] It is significant that the *Crossing of the Red Sea* is placed between the *Plague of Frogs* and the *Plague of Lice*, rather than at the end of the cycle, as it should be. This may have been intended to give special prominence to the *Crossing of the Red Sea*, since it is placed over the door on the east wall of the room. There is a similar but less serious adjustment to the biblical chronology in the north west corner of the room, where *Moses and Aaron before Pharaoh* appears before rather than after *Moses Meeting Aaron*.

[10] See Arnolds, *Santi di Tito*, 9–16; and Redig de Campos, *I Palazzi Vaticani*, 150.

and honoured him who lives for ever" (Dan. 4:34). The final fresco shows Nebuchadnezzar reestablished on his throne receiving the homage of his people (Fig. 86).

The general meaning of this cycle is clear. Nebuchadnezzar's exile and madness were caused by his persisting in sins and iniquities, despite Daniel's warning. His recovery and reinstatement came about when he knew "that the Most High rules the kingdom of men, and gives it to whom he will" (Dan. 4:25). That this is the moral of the story is confirmed by various inscriptions which appear in a number of the frescoes: HABITATVRVS SVB DIO in the first of the scenes illustrating the dream of the great trees; DVS OB · IMPIETATE[M] AD · INSANIA[M] · REDEGIT in Nebuchadnezzar's madness; and DEVM · TIMENTIBVS · OMNIA · BENE · SVCCEDVNT in the final scene.[11]

Daniel was a familiar type of Christ,[12] but the similarity of his powers of interpretation to those of Joseph and the analogies between his position at Nebuchadnezzar's court and Joseph's at the court of Pharaoh suggest that he too can be interpreted as a *typus Petri*. If this is the case, the Nebuchadnezzar story nicely parallels the mid-sixteenth century religious situation. Daniel's superiority over "the magicians, the enchanters, the Chaldeans, and the astrologers" (Dan. 4:7) reminds one of the pope's supreme position as source and interpreter of the mysteries of divine truth; and Nebuchadnezzar's madness and isolation suggest immediate comparison with the aberrations of the Protestants and their self-imposed exile from the church of Rome.

However, the Nebuchadnezzar cycle has a second aspect. It records a conflict between the spiritual and temporal powers, and states the supremacy of the former. Although it belonged to an essentially medieval conception of the papacy, this issue did preoccupy the papacy during the Counter Reformation, and was the dominant theme in the decoration of the Sala Regia.

The decoration of the Sala Regia (Fig. 87), the setting for papal audiences with secular princes, was begun by Perino del Vaga and Daniele da Volterra during the pontificate of Paul III, but was less than half-finished when Pius became pope. Pius ordered a new campaign in 1561, and entrusted its direction to Alessandro Farnese and Marcantonio da Mula. Initially Daniele da Volterra competed with Francesco Salviati for the commission, the former being supported by Pius IV and Michelangelo and the latter being backed by Farnese and, according to Vasari, Ligorio. Vasari himself was offered the commission in September 1561 but refused it. In the end, the decoration was parcelled out to a number of painters so that it would be completed quickly.[13]

[11] Borromeo presented Nebuchadnezzar as an example of vainglory. (See *Sermoni familiari di S. Carlo Borromeo*, Padua, 1720, 74.)

[12] L. Réau, *Iconographie de l'art chrétien*, II, 1, Paris, 1956, 391, 402–403.

[13] This solution, which apparently followed a suggestion made by Ligorio, reminds one of the *modus operandi* at the Casino. The accounts for Pius IV's campaign in the Sala Regia are collected in G. Smith, "A Drawing for the Sala Regia," *Burlington Magazine*, CXVIII, 1976, 102–106.

The majority of the paintings in the Sala Regia commemorate donations made to the Holy See by secular princes, and demonstrate the proper relationship between pope and prince. In general, the frescoes done for Pius present an elaborate statement on the religious and political primacy of the *Vicarius Christi*. The *Submission of Frederick Barbarossa to Alexander III* (Fig. 87, extreme left), begun by Francesco Salviati and completed by Giuseppe Porta, was the first scene executed for Pius IV. The scenes from Pius IV's main campaign are: *Peter of Aragon Offering his Kingdom to Innocent III* by Livio Agresti (Fig. 88); the *Donation of Charlemagne* by Taddeo Zuccaro (Fig. 87, near over-door panel, left side); *Otto I Restoring the Territories of the Church to Agapetus II* by Orazio Samacchini (Fig. 87, far over-door panel, left side);[14] the *Taking of Tunis* and two female personifications by Taddeo Zuccaro (Fig. 87, rear wall); *Gregory II Receiving Liutprand's Confirmation of the Donation of Aripert* by Giovanni Battista Fiorini (Fig. 87, far over-door panel, right side, and Fig. 89); the *Donation of Pepin* by Girolamo Siciolante da Sermoneta (Fig. 90).[15]

From this list of subjects it is clear that the decoration of the Sala Regia presents its argument in a much more direct manner than did the cycles in the Belvedere apartments. The theme is stated by direct example, choosing equivalent episodes from the history of the church rather than biblical ones.[16] In fact, Pius infiltrated himself into the historical scene in almost every case. He is Alexander III in the *Submission of Frederick Barbarossa* (Fig. 91), Agapetus in *Otto I Restoring the Territories of the Church*, Innocent III in *Peter of Aragon Offering his Kingdom to Innocent III* and Gregory II in *Liutprand's Confirmation of the Donation of Aripert*. In addition, Pius IV's *impresa* appears in many of the scenes.

The Sala Regia was one of the most important ceremonial settings in the Vatican, and it would be surprising if its decoration had more in common with that of the Casino. The Sala Regia bombards us with full-blown propaganda, while the Casino gently makes us privy to Pius IV's private reflections. The Belvedere apartments are less grandiose than the Sala Regia and more formal than the Casino, but their programmes belong securely in the category of public decoration.

Pius IV's cycles in the Belvedere apartments and the Sala Regia underline the

---

[14] A *modello* for this fresco is in the *Gabinetto disegni e stampe degli Uffizi*. (*Ibid.*, Fig. 65.)

[15] A *modello* for this fresco is in the *Cabinet des dessins* at the Louvre. (See J. A. Gere, *Il manierismo a Roma* [I disegni dei maestri, x], 1971, 85 and Pl. xxviii.)

[16] It is interesting that the programme as first formulated was to have had Old Testament scenes. (See Lo Storico, "I fasti del Pontificato nella Sala Regia," *L'Illustrazione Vaticana*, i, 1, 1938, 33.) Pastor, *Popes*, xx, 612, n. 2, published an extract from a manuscript programme for the *Sala Regia*: "Et perche nella Sala Regia gli Imperatori et Re christiani publicamente rendono obedienza al Pontefice Romano . . . si dovesse dipingere alcun fatto o historia memorabile che rappresentasse la debita sugettione et inferiorità del principato terreno verso il sacerdotio."

special character of the decoration of the Casino. The Casino of Pius IV was an unusually private complex. It was the personal extravagance of a pope whose orthodoxy had once been questioned, and whose moderation on matters of reform contrasted dramatically with the militant fervour of his predecessor and successors alike. Like its owner, the decoration of the Casino seems to be a survival from the earlier part of the sixteenth century, rather than an indicator of the direction of its second half. The Casino was decorated during a short-lived period of euphoria and optimism, partly the result of a reaction against the repressive pontificate of Paul IV and partly the product of a willingness to believe in the possibility of reform and reunion. Before its opening, Pius IV's Council had something of the fantasy and idealism of a crusade. When the Council of Trent closed, the impossibility of reconciling the churches had to be admitted. By defining areas of disagreement and by condemning the errors of the Protestants, the Council formally recognized the schism, and, in a sense, drafted a constitution for Catholics and schismatics alike. Combat rather than conciliation lay in the future.

The Casino of Pius IV has all the preciousness and refinement of a *maniera* jewel-casket. However, its richness is also the richness of a Catholic reliquary. The decoration of the Casino mirrors Pius IV's conception of his office and his belief in his ability to fill it; it reflects his confidence in the history and in the future of Peter's church; and it promises the beginning of a new golden age, under the guidance of the new *Vicarius Christi*.

# SELECTED BIBLIOGRAPHY

## Manuscript Material

Naples, Biblioteca Nazionale, MSS XIII. B. 1–10, encyclopaedia on classical antiquities by Pirro Ligorio.

Oxford, Bodleian Library, MS Canonici Ital. 138, manuscript on classical antiquities by Pirro Ligorio and drawings by Ligorio and Giovanni Battista Aleotti.

Rome, Archivio di Stato, *Camerale I Fabbriche* 1520 and 1521, accounts for the pontificate of Pius IV.

—————— Biblioteca Apostolica Vaticana, MSS Ottoboniani Lat. 3364–3381, copies of Ligorio's encyclopaedia on classical antiquities in the Archivio di Stato, Turin.

—————— Biblioteca Apostolica Vaticana, MS Vat. Lat. 3439, copy of sections from Ligorio's encyclopaedia on classical antiquities in the Biblioteca Nazionale, Naples.

Turin, Archivio di Stato, MS J. a. II. 17, bound volume of drawings by Ligorio.

—————— Archivio di Stato, MSS J. a. III. 3–16 and J. a. II. 1–16, encyclopaedia on classical antiquities by Ligorio.

## Printed Works

Ackerman, J. S., *The Architecture of Michelangelo*, Harmondsworth, 1971.

—————— *The Cortile del Belvedere* (Studi e documenti per la storia del Palazzo Apostolico Vaticano pubblicati a cura della Biblioteca Apostolica Vaticana, III), Vatican City, 1954.

—————— "Sources of the Renaissance Villa," in *Acts of the Twentieth International Congress of the History of Art, II. The Renaissance and Mannerism*, Princeton, 1963, 6–18.

Ancel, D. R., "Le Vatican sous Paul IV. Contribution à l'histoire du Palais Pontifical," *Revue Bénédictine*, XXV, 1908, 48–71.

Arnolds, G., *Santi di Tito, pittore di Sansepolcro*, Arezzo, 1934.

Ashby, T., "The Bodleian Ms. of Pirro Ligorio," *Journal of Roman Studies*, IX, 1919, 170–201.

Baglione, G., *Le vite de' pittori, scultori ed architetti*, Rome, 1642.

Bellori, G. P., *Le vite de' pittori, scultori ed architetti moderni*, Rome, 1672.

Bertelà, G. G., *Disegni di Federico Barocci* (Gabinetto disegni e stampe degli Uffizi, XLIII), Florence, 1975.

Bianchi, L., *Cento disegni della Biblioteca Comunale di Urbania*, Urbania, 1959.

Bonanni, P., *Numismata Pontificum Romanorum*, Rome, 1699.

Borghini, R., *Il Riposo*, Florence, 1584.

Bouchet, J., *La Villa Pia, des Jardins du Vatican, Architecture de Pirro Ligorio*, Paris, 1837.

Burns, H., "A Peruzzi Drawing in Ferrara," *Mitteilungen des Kunsthistorischen Institutes in Florenz*, xii, 1966, 245–270.

Canedy, N. W., "The Decoration of the Stanza della Cleopatra," in *Essays in the History of Art Presented to Rudolf Wittkower*, ii, London, 1967, 110–118.

Chacon, A., *Vitae et res gestae Pontificium Romanorum et S. R. E. Cardinalium*, iii, Rome, 1677.

Chattard, G. P., *Nuova descrizione del Vaticano o sia del Palazzo Apostolico di San Pietro*, iii, Rome, 1767.

Coffin, D. R., "Pirro Ligorio and Decoration of the Late Sixteenth Century at Ferrara," *Art Bulletin*, xxxvii, 1955, 167–185.

——— "Pirro Ligorio and the Villa d'Este" (unpublished Ph.D. dissertation, Princeton University, 1954).

——— "Pirro Ligorio on the Nobility of the Arts," *Journal of the Warburg and Courtauld Institutes*, xxvii, 1964, 191–210.

——— *The Villa d'Este at Tivoli*, Princeton, 1960.

Contini, F., and Ligorio, P., *Pianta della Villa Tiburtina di Adriano Cesare*, Rome, 1751.

Coolidge, J., "The Villa Giulia: A Study of Central Italian Architecture in the Mid-Sixteenth Century," *Art Bulletin*, xxv, 1943, 177–225.

Dacos, N., *La découverte de la Domus Aurea et la formation des grotesques à la Renaissance* (Studies of the Warburg Institute, xxxi), London, 1969.

Daniélou, J., *From Shadows to Reality*, London, 1960.

Elling, C., *Villa Pia in Vaticano* (Studier fra Sprog- og Oldtidsforskning, No. 203), Copenhagen, 1947.

Emiliani, A., and Bertelà, G. G., *Mostra di Federico Barocci* (ix Biennale d'arte antica), Bologna, 1975.

Ettlinger, L. D., *The Sistine Chapel before Michelangelo: Religious Imagery and Papal Primacy*, Oxford, 1965.

Fagiolo, M., and Madonna, M. L., "La Casina di Pio IV in Vaticano. Pirro Ligorio e l'architettura come geroglifico," *Storia dell'arte*, xv/xvi, 1972 [in fact published in May 1974], 237–281.

——— "La Roma di Pio IV: la 'Civitas Pia,' la 'Salus Medica,' la 'Custodia Angelica,'" *Arte Illustrata*, v, 1972, 383–402.

Falda, G. B., *Li giardini di Roma con le loro piante alzate e vedute in prospettiva*, Rome, n.d.

Falk, T., "Studien zur Topographie und Geschichte der Villa Giulia in Rom," *Römisches Jahrbuch für Kunstgeschichte*, XIII, 1971, 102–178.

Friedlaender, W., *Das Kasino Pius des Vierten* (Kunstgeschichtliche Forschungen, III), Leipzig, 1912.

———— review of *Federico Barocci*, by H. Olsen, in *Burlington Magazine*, CVI, 1964, 186–187.

Frommel, C. L., *Die Farnesina und Peruzzis architektonisches Frühwerk* (Neue Münchner Beiträge zur Kunstgeschichte, I), Berlin, 1961.

Galli, G., "Relazione: Nei giardini del Vaticano," *Rendiconti: Atti della pontificia accademia romana di archeologia*, XII, 1936, 341–352.

Gere, J. A., "Drawings by Niccolò Martinelli, Il Trometta," *Master Drawings*, I, 1963, 3–18.

———— "Girolamo Muziano and Taddeo Zuccaro: A Note on an Early Work by Muziano," *Burlington Magazine*, CVIII, 1966, 417–418.

———— *Il manierismo a Roma* (I disegni dei maestri, 10), Milan, 1971.

———— *Mostra di disegni degli Zuccari* (Gabinetto disegni e stampe degli Uffizi, XXIV), Florence, 1966.

———— "Some Early Drawings by Pirro Ligorio," *Master Drawings*, IX, 1971, 239–250.

———— "Taddeo Zuccaro as a designer for Maiolica," *Burlington Magazine*, CV, 1963, 306–315.

———— *Taddeo Zuccaro: His Development Studied in His Drawings*, London, 1969.

Heydenreich, L. H., and Lotz, W., *Architecture in Italy 1400–1600*, Harmondsworth, 1974.

Hülsen, C., *Das Skizzenbuch des Giovannantonio Dosio im Staatlichen Kupferstich-kabinett zu Berlin*, Berlin, 1933.

Jedin, H., *Crisis and Closure of the Council of Trent: A Retrospective View from the Second Vatican Council*, London, 1967.

———— *A History of the Council of Trent*, 2 vols., Edinburgh, 1957 and 1961.

Lanciani, R., *Storia degli scavi di Roma e notizie intorno le collezioni romane di antichità*, III, Rome, 1907.

Latham, C., *The Gardens of Italy*, London, 1905.

Letarouilly, P., *Le Vatican et la Basilique de Saint-Pierre de Rome*, III, Paris, 1882.

Lewine, M. J., "Vignola's Church of Sant'Anna de' Palafrenieri in Rome," *Art Bulletin*, XLVII, 1965, 199–229.

MacDougall, E., "*Ars Hortulorum*: Sixteenth Century Garden Iconography and Literary Theory in Italy," in *The Italian Garden* (First Dumbarton Oaks Colloquium on the History of Landscape Architecture), ed. by D. R. Coffin, Dumbarton Oaks, Washington, D.C., 1972.

MacDougall, E., "The Sleeping Nymph: Origins of a Humanist Fountain Type," *Art Bulletin*, LVII, 1975, 357–365.

Maio, R. De, *Alfonso Carafa Cardinale di Napoli (1540–1565)* (Studi e Testi, No. 210), Vatican City, 1961.

Mandowsky, E., and Mitchell, C., *Pirro Ligorio's Roman Antiquities: The Drawings in MS XIII. B. 7 in the National Library in Naples* (Studies of the Warburg Institute, XXVIII), London, 1963.

Michaelis, A., "Geschichte des Statuenhofes in Vaticanischen Belvedere," *Jahrbuch des kaiserlich deutschen archäologischen Instituts*, V, 1890, 5–66.

Migne, J. P., ed., *Patrologiae cursus completus, Series Latina*, Paris, 1844–1904.

Moore, F. L., "A Contribution to the Study of the Villa Giulia," *Römisches Jahrbuch für Kunstgeschichte*, XII, 1969, 171–193.

Olsen, H., *Federico Barocci*, Copenhagen, 1962.

Paeseler, W., "Giottos Navicella und ihr spätantikes Vorbild," *Römisches Jahrbuch für Kunstgeschichte*, V, 1941, 49–162.

Pastor, L. Von, *The History of the Popes from the Close of the Middle Ages*, London, 1891–1953.

Percier, C., and Fontaine, P.F.L., *Choix des plus célèbres maisons de plaisance de Rome et de ses environs*, Paris, 1824.

Periali, P., "I fasti del Pontificato nella Sala Regia: L' 'assoluzione' di Enrico IV a Canossa," *Illustrazione Vaticana*, II, 16, 1931, 20–25.

———— "I fasti del Pontificato nella Sala Regia: La 'restituzione' di Carlo Magno," *Illustrazione Vaticana*, II, 7, 1931, 23–29.

*Pontificia Academia Scientiarum: Le Siège*, Vatican City, n.d.

Popham, A. E., and Fenwick, K. M., *European Drawings (and Two Asian Drawings) in the Collection of the National Gallery of Canada*, [Toronto], 1965.

———— and Wilde, J., *The Italian Drawings of the XV and XVI Centuries in the Collection of His Majesty the King at Windsor Castle*, London, 1949.

Redig de Campos, D., *I Palazzi Vaticani*, Bologna, 1967.

Schapiro, M., "The Joseph Scenes on the Maximianus Throne in Ravenna," *Gazette des Beaux-Arts*, 6th Ser., XL, 1952, 27–38.

Shearman, J., *Raphael's Cartoons in the Collection of Her Majesty the Queen and the Tapestries for the Sistine Chapel*, London, 1972.

Schmarsow, A., "Federigo Baroccis Zeichnungen in der Sammlung der Uffizien zu Florenz," *Abhandlungen der philologisch-historischen Klasse der Königl. Sächsischen Gesellschaft der Wissenschaften*, XXVI, 5, 1909.

———— "Das Gartenhaus Pius' IV.," review of *Das Kasino Pius des Vierten*, by W. Friedlaender, in *Deutsche Literaturzeitung*, XXXIII, 1912, 901–910.

Seznec, J., *The Survival of the Pagan Gods*, New York, 1953.

Smith, G., "A Drawing for the Interior Decoration of the Casino of Pius IV," *Burlington Magazine*, cxii, 1970, 108–110.

——— "A Drawing for the Sala Regia," *Burlington Magazine*, cxviii, 1976, 102–106.

——— "The Stucco Decoration of the Casino of Pius IV," *Zeitschrift für Kunstgeschichte*, xxxvi, 1974, 116–156.

——— "Two Drawings by Federico Barocci," *Bulletin of the Detroit Institute of Arts*, lii, 1973, 83–91.

Lo Storico, "I fasti del Pontificato nella Sala Regia," *Illustrazione Vaticana*, i, 1, 1931, 31–38.

——— "I fasti del Pontificato nella Sala Regia, I: La 'donazione' di Ariperto e di Liutprando," *Illustrazione Vaticana*, ii, 1, 1931, 28–32.

——— "I fasti del Pontificato nella Sala Regia, II: La 'donzione' di Pipino," *Illustrazione Vaticana*, ii, 4, 1931, 33–38.

Tanzer, H. H., *The Villas of Pliny the Younger*, New York, 1924.

Taja, A., *Descrizione del Palazzo Apostolico Vaticano*, Rome, 1750.

Typotius, J., *Symbola divina et humana Pontificum, Imperatorum, Regum*, Prague, 1602.

Vasari, G., *Le vite de' più eccellenti pittori, scultori ed architettori*, ed. by G. Milanesi, Florence, 1878–1885.

Velde, C. Van De, "A Roman Sketchbook of Frans Floris," *Master Drawings*, vii, 1969, 255–286.

Venturi, A., *Storia dell'arte italiana*, Milan, 1901–1937.

Venuti, R., *Accurata e succinta descrizione topografica e istorica di Roma moderna*, Rome, 1766.

Vogel, L., "Circus Race Scenes in the Early Roman Empire," *Art Bulletin*, li, 1969, 155–159.

Voss, H., review of *Das Kasino Pius des Vierten*, by W. Friedlaender, in *Monatshefte für Kunstwissenschaft*, v, 1912, 381–383.

Wurm, H., *Der Palazzo Massimo alle Colonne*, Berlin, 1965.

"Zucchero Drawings," *Connoisseur*, xciv, 1934, 259–261.

# INDEX

ILLUSTRATIONS

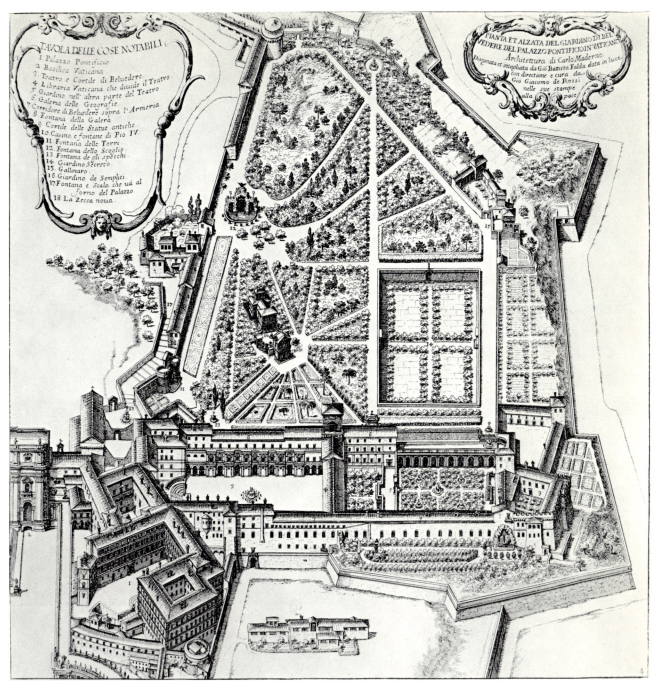

1.  G. B. Falda, View of the Belvedere Court and Vatican Gardens. From *Li giardini di Roma*
*con le loro piante alzate e vedute in prospettiva*, Rome, n.d.

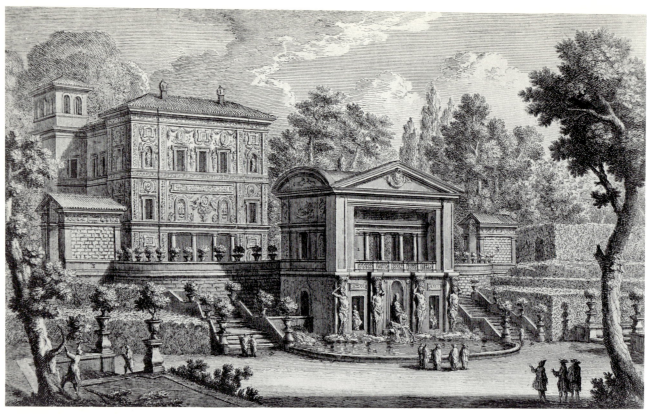

2. G. Vasi, The Casino of Pius IV. From *Raccolta delle più belle vedute antiche e moderne di Roma*, Rome, 1803

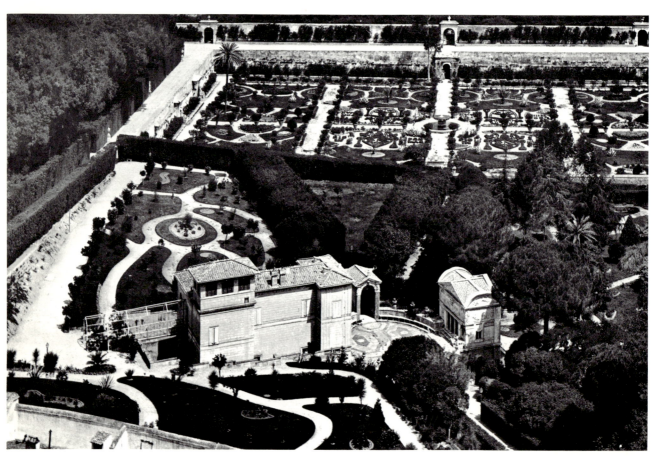

3. Casino of Pius IV, view from the dome of St. Peter's

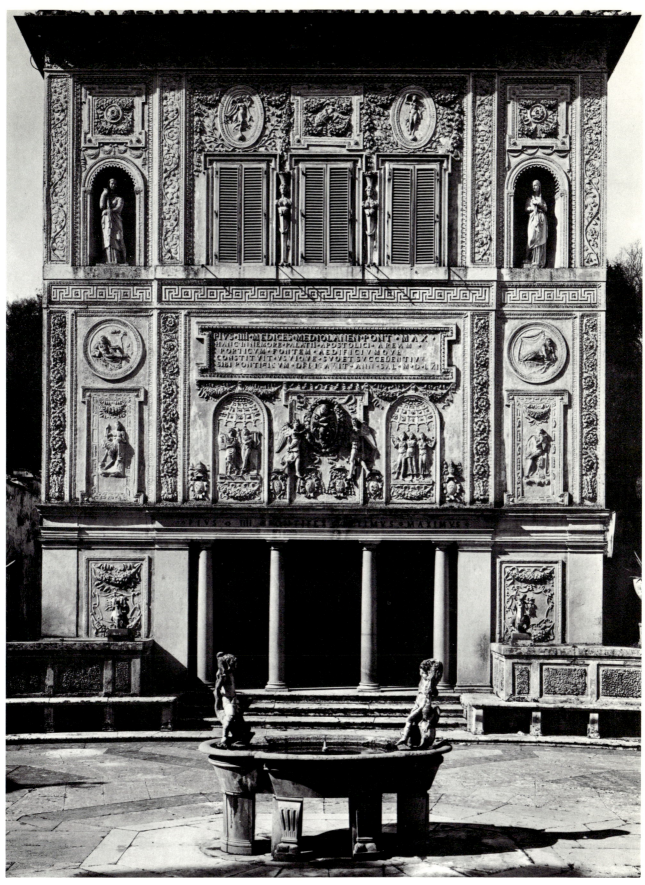

4. Casino of Pius IV, façade of the casino

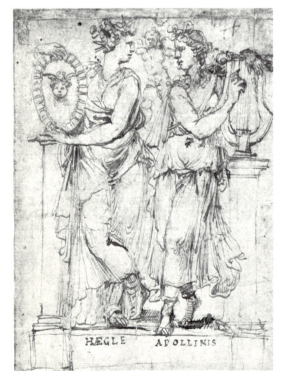

PIVS · IIII · MEDICES · MEDIOLANEN · PONT · MAX ·
HANC · IN · NEMORE · PALATII · APOSTOLICI · AREAM ·
PORTICVM · FONTEM · AEDIFICIVMQVE ·
CONSTITVIT · VSVIQVE · SVO ET SVCCEDENTIVM ·
SIBI · PONTIFICVM · DEDICAVIT · ANN · SAL · M · D · LXI

· PIVS ◊ IIII ◊ PONTIFEX ◊ OPTIMVS ◊ MAXIMVS ·

5. Detail from Fig. 4, Aegle and Apollo (left); Eirene, Dike and Eunomia (right)

6. Pirro Ligorio, *Aegle and Apollo*.
London, British Museum

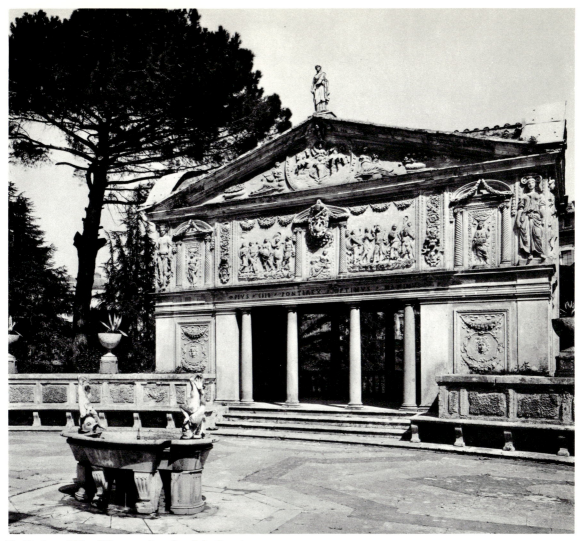

7. Casino of Pius IV, court façade of the loggia

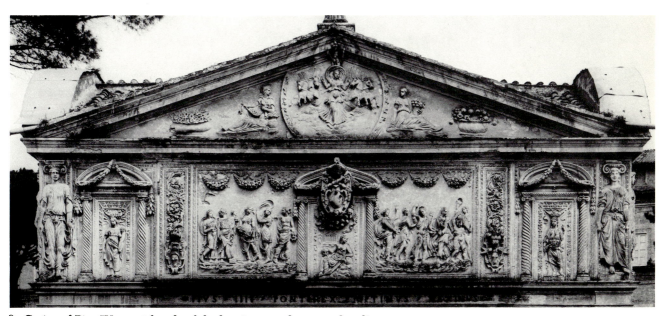

8. Casino of Pius IV, court façade of the loggia, second story and pediment

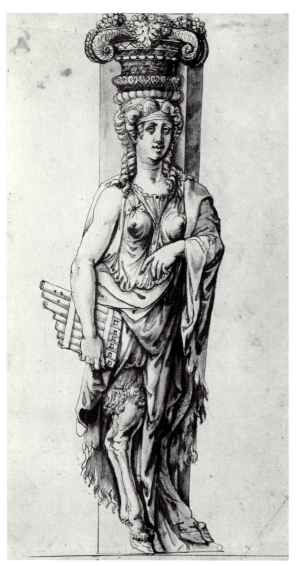

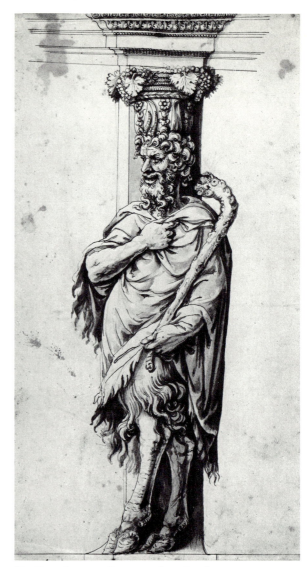

9. Pirro Ligorio, *Panisca*. Windsor Castle,
Royal Library

10. Pirro Ligorio, *Pan*. Windsor Castle,
Royal Library

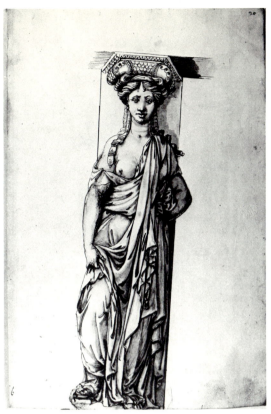

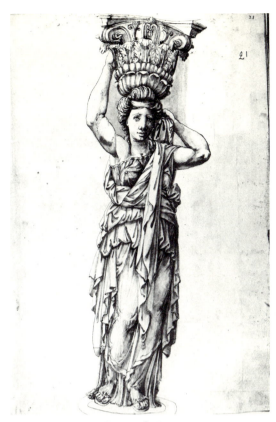

11. Pirro Ligorio, *Caryatid*. Turin,
Archivio di Stato

12. Pirro Ligorio, *Caryatid*. Turin,
Archivio di Stato

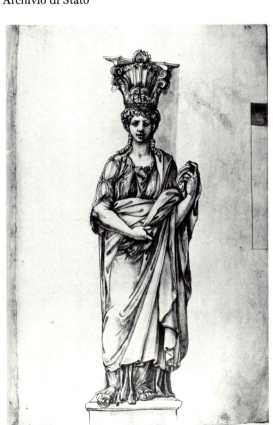

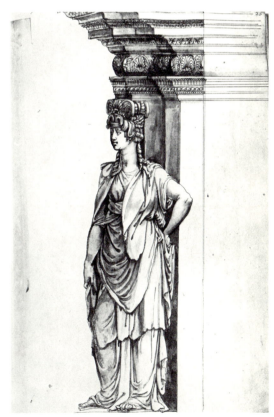

13. Pirro Ligorio, *Caryatid*. Turin,
Archivio di Stato

14. Pirro Ligorio, *Caryatid*. Turin,
Archivio di Stato

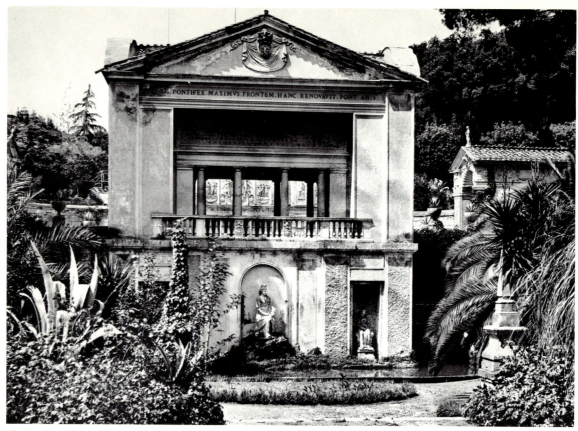

15. Casino of Pius IV, garden façade of the fountain-loggia

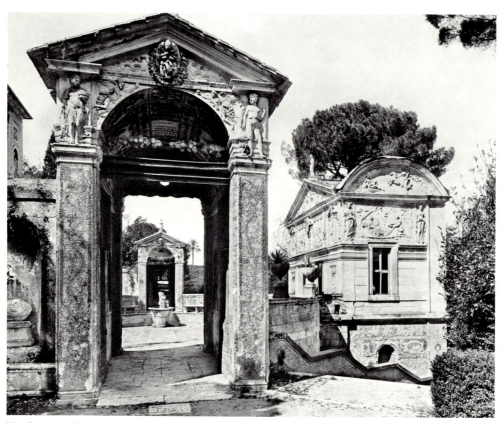

16. Casino of Pius IV, southeast portal, and southeast and court façades of the loggia

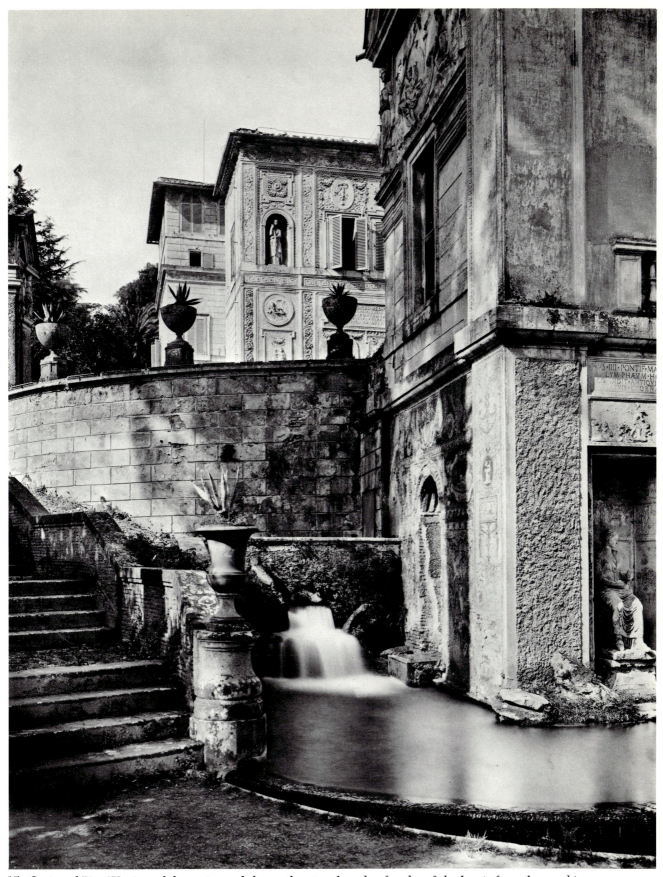

17. Casino of Pius IV, view of the casino and the southeast and garden façades of the loggia from the *peschiera*

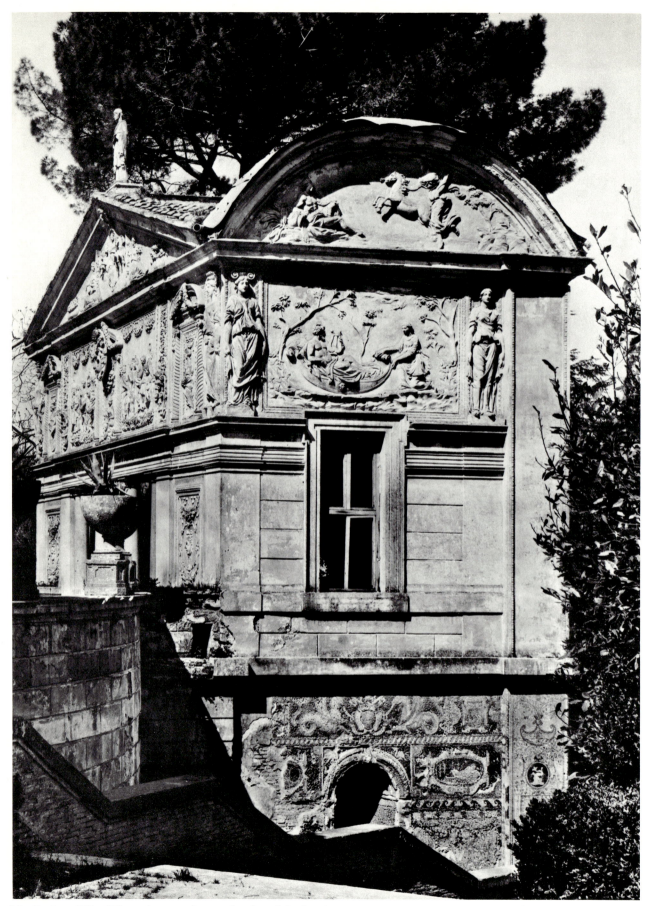

18. Casino of Pius IV, southeast and court façades of the loggia

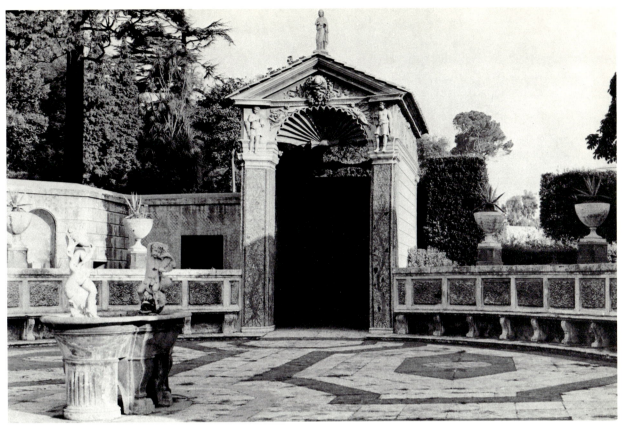

19. Casino of Pius IV, fountain and northwest portal

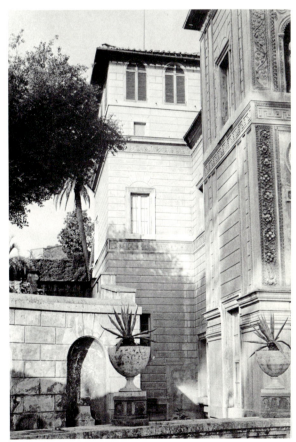

20. Casino of Pius IV, view of the moat
and southeast side of the casino

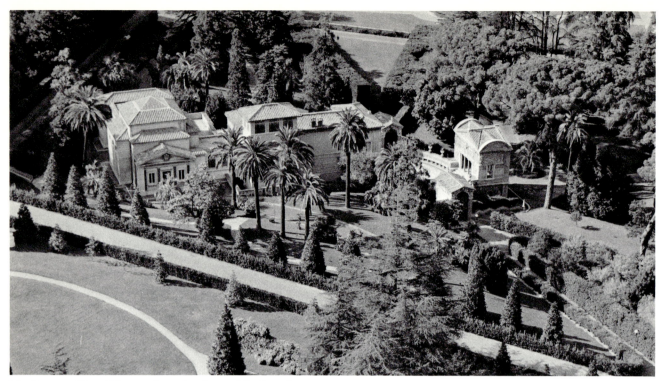

21. Casino of Pius IV, view from the dome of St. Peter's

22. Modern addition to the Casino of Pius IV

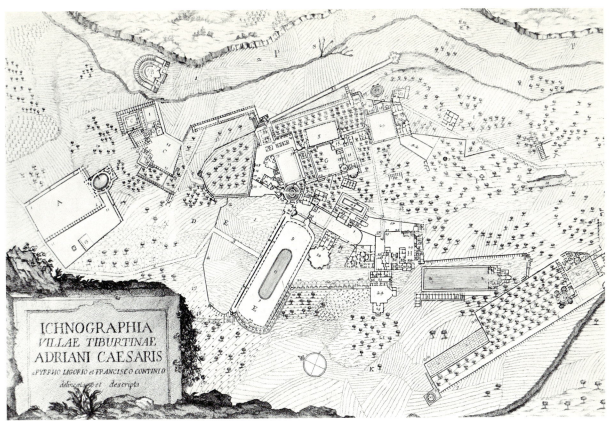

23. Pirro Ligorio, Plan of Hadrian's Villa. From *Pianta della villa tiburtina di Adriano cesare*,
revised and published by Francesco Contini, Rome, 1751

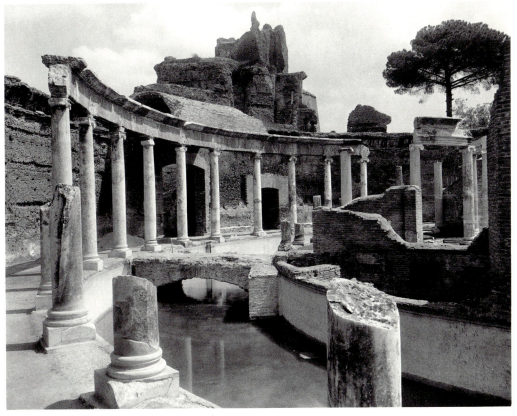

24. Hadrian's Villa, Tivoli, island nymphaeum

25. Pirro Ligorio, Map of Rome, 1561, detail: Naumachia of Augustus

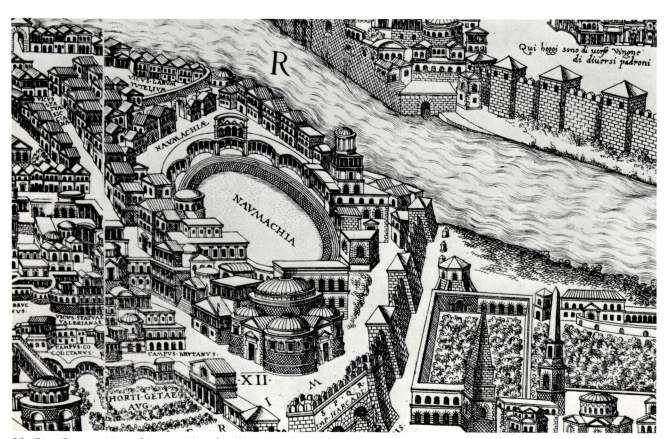

26. Pirro Ligorio, Map of Rome, 1561, detail: Naumachia in Trastevere

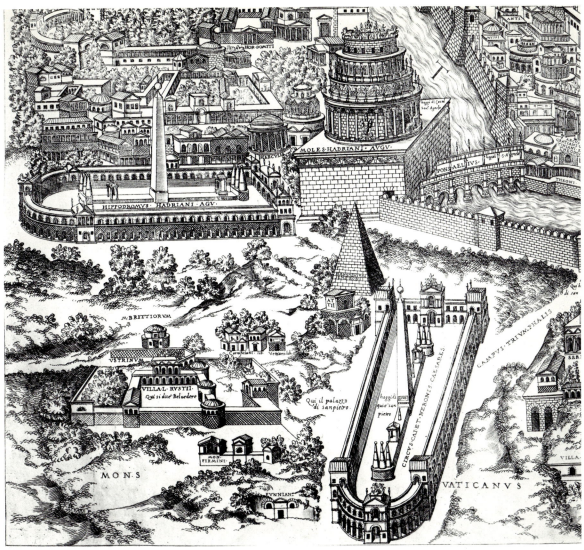

27. Pirro Ligorio, Map of Rome, 1561,
detail: Circus of Nero and Tomb
of Hadrian

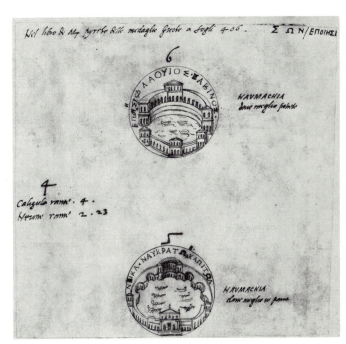

28. Copy of Ligorio, Drawings of coins
depicting naumachias. Vatican City,
Biblioteca Apostolica Vaticana

29.  Palazzo Massimo alle Colonne, Rome

30.  Palazzo Lancellotti, Rome

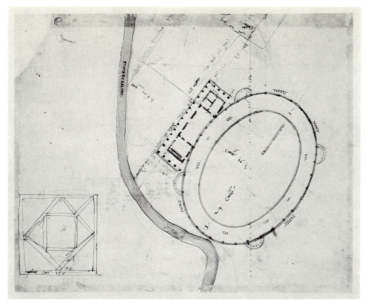

31. Baldassare Peruzzi, Project for the Trivulzi Villa at Salone. Florence, Gabinetto disegni e stampe degli Uffizi

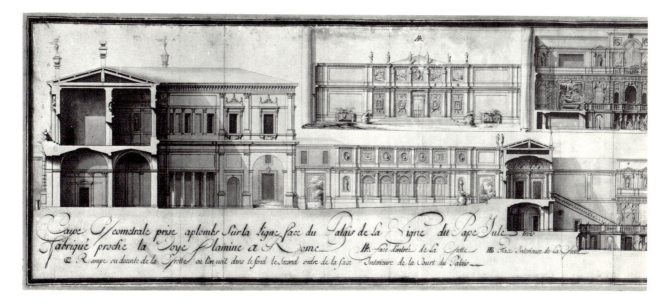

32. Seventeenth-century drawing of the Villa Giulia, illustrated in two sections. Rome, Villa Giulia

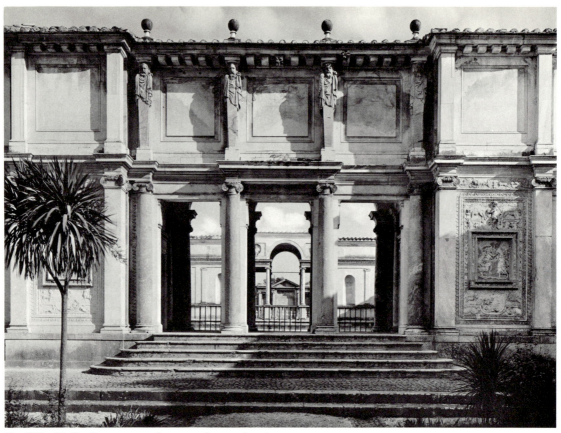

33. Villa Giulia, Rome, second or nymphaeum loggia

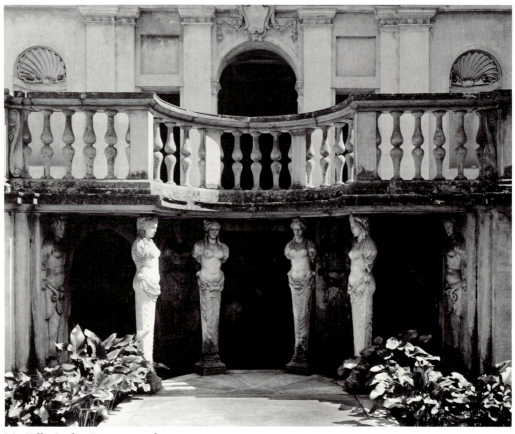

34. Villa Giulia, Rome, nymphaeum

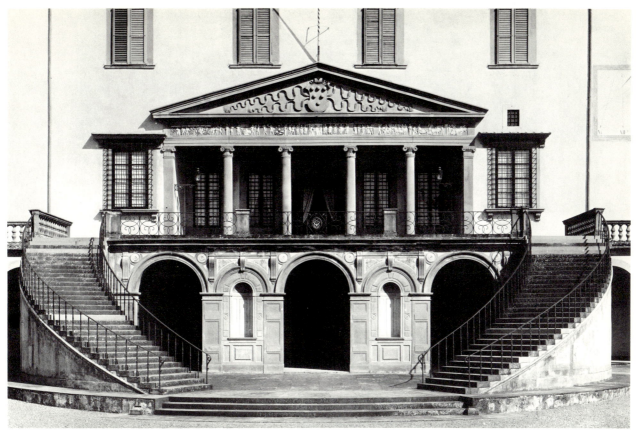

35. Villa Medici, Poggio a Caiano, loggia
and central section of façade

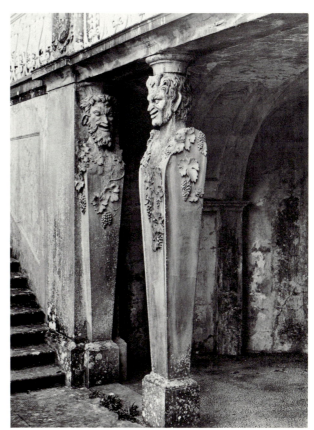

36. Villa Medici, Poggio a Caiano, Pan grotto

37. Federico Zuccaro, *The Vision of St. Eustace.*
New York, Metropolitan Museum of Art,
Rogers Fund, 1962

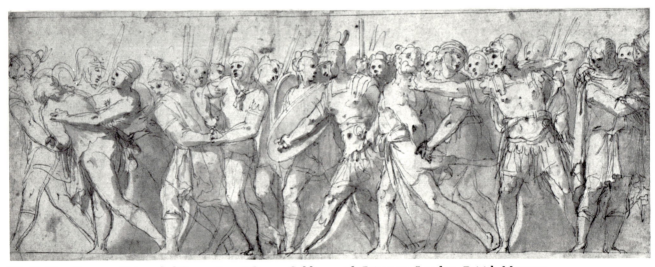

38. Taddeo Zuccaro, *Triumphal Procession of Roman Soldiers with Prisoners.* London, British Museum

39. Casino of Pius IV, façade detail:
*Pan* and a *River-God*

40. Casino of Pius IV, façade detail:
*Cyparissus* and a *River-God*

41. Casino of Pius IV, central section of the third story of the façade

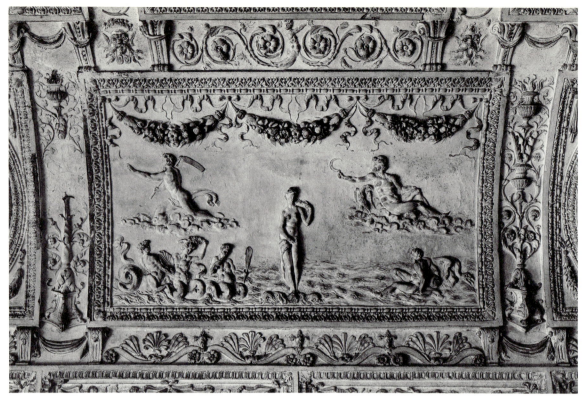

42. Casino of Pius IV, interior of the southeast portal, *Birth of Venus*

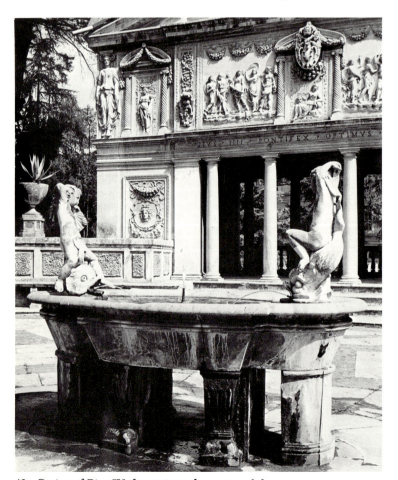

43. Casino of Pius IV, fountain at the centre of the court

45. Device of Cardinal Gian Angelo de'
Medici. From J. Typotius, *Symbola divina
et humana Pontificum, Imperatorum,
Regum*, Prague, 1602

DI IOVE, E' DEL VASO DEL BENE E DI QVEL DEL MALE

44. Pirro Ligorio, Page from MS Canonici Ital. 138. Oxford, Bodleian Library

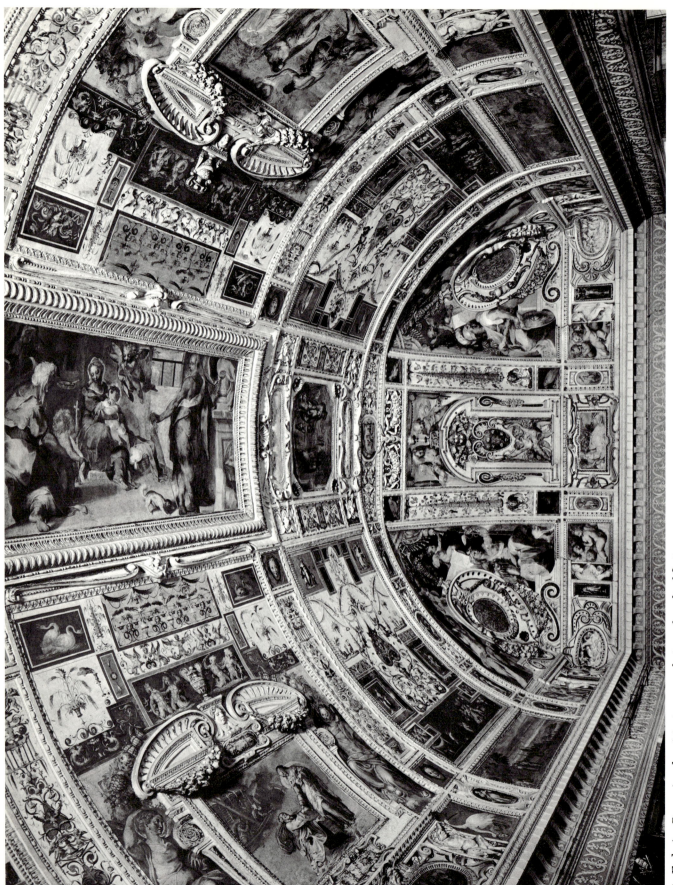

46. Federico Barocci and assistants, general view of vault of first room

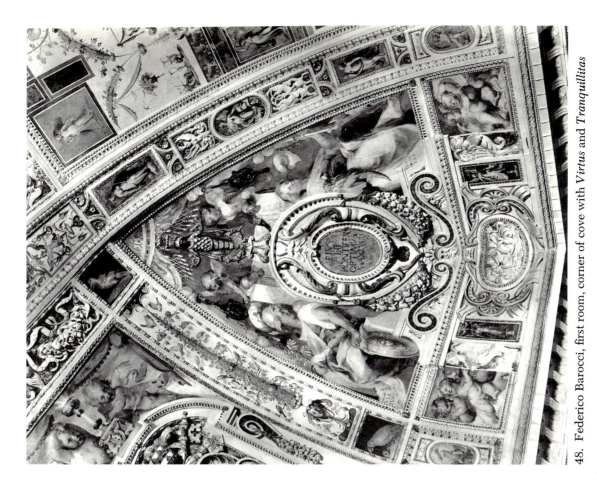

48. Federico Barocci, first room, corner of cove with *Virtus* and *Tranquillitas*

47. Federico Barocci, first room, corner of cove with *Letitia* and *Felicitas*

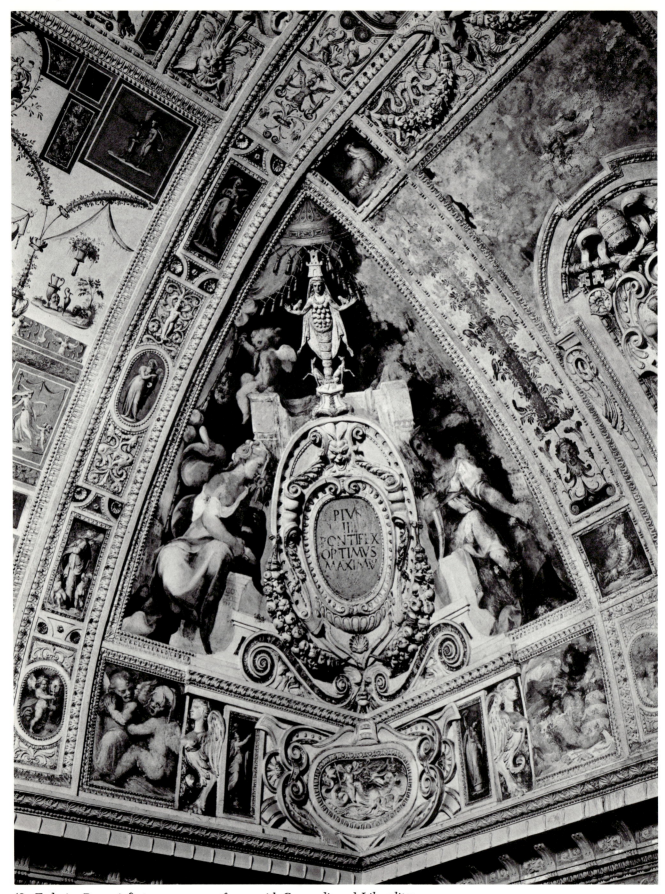

49. Federico Barocci, first room, corner of cove with *Concordia* and *Liberalitas*

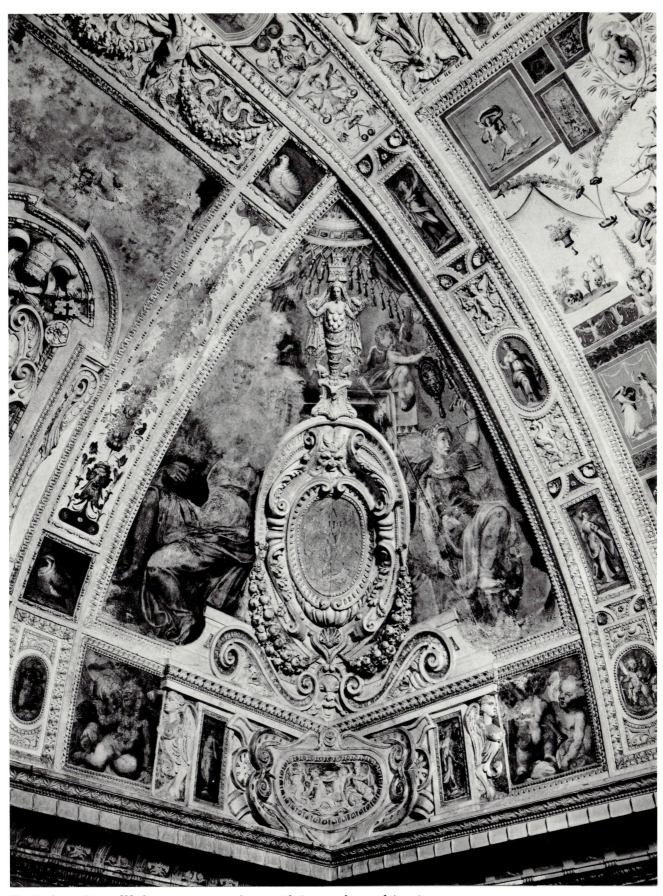

50. Pierleone Genga [?], first room, corner of cove with *Immortalitas* and *Aequitas*

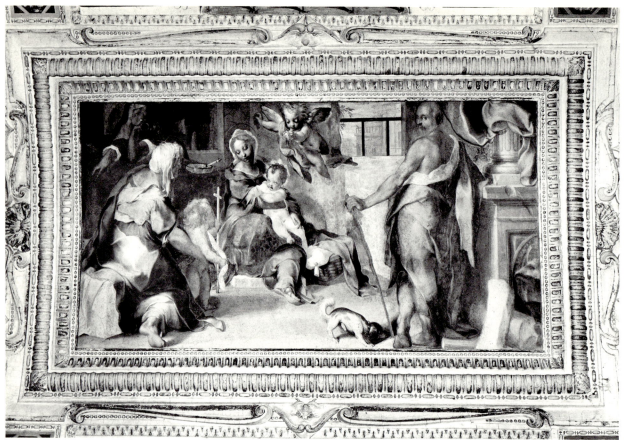

51. Federico Barocci, first room, *Holy Family with St. John, Elizabeth and Zachariah*

51a. Federico Barocci, *Holy Family with St. John, Elizabeth and Zachariah*.
Florence, Gabinetto disegni e stampe degli Uffizi, 11414 F

52.  Federico Barocci, second room, *Annunciation*

52a.  Federico Barocci, Studies for the *Annunciation*. Berlin, Kupferstichkabinett

53a.  Federico  Barocci, Two Studies for the Decoration of a Vault. Florence, Gabinetto disegni
e stampe degli Uffizi, 907 E *recto*

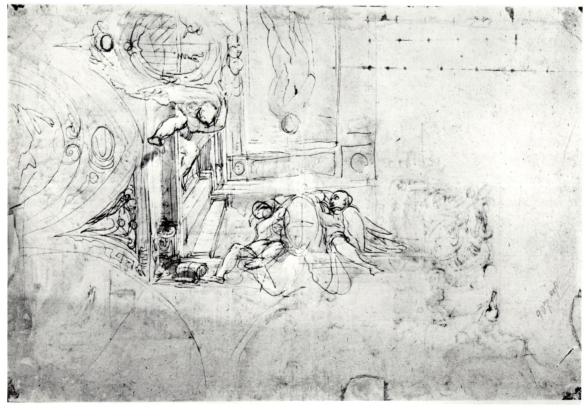

53b.  Federico Barocci, **Study for the Decoration of a Vault.** Florence, Gabinetto disegni
e stampe degli Uffizi, 907 E *verso*

54a. Federico Barocci, Drapery Studies. Florence, Gabinetto disegni e stampe degli Uffizi, 11613 F *recto*

54c. Federico Barocci, Seated Female Figure. Florence, Gabinetto disegni e stampe degli Uffizi, 11281 F *recto*

54b. Federico Barocci, Drawings for Zachariah and other Studies. Florence, Gabinetto disegni e stampe degli Uffizi, 11613 F *verso*

54d. Federico Barocci, Drawings for Zachariah and John the Baptist, and Studies for the *Madonna di Fossombrone*. Florence, Gabinetto disegni e stampe degli Uffizi, 11281 F *verso*

54e.  Federico Barocci, Four Infants' Heads and the Profile of a Woman.
Florence, Gabinetto disegni e stampe degli Uffizi, 11368 *F recto*

55.  Federico Barocci, Study for a Wall Decoration. Detroit, Institute of Arts

56. Barocci and assistants, first room, section of cove with coat of arms and *putti*

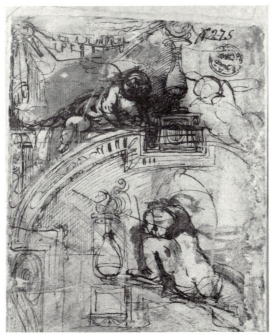

57. Federico Barocci, Study for Stucco Decoration and *Putti*. Urbania, Biblioteca Comunale

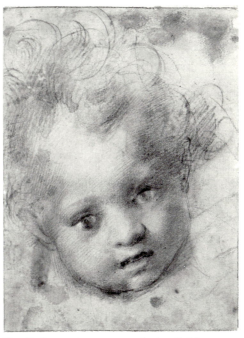

58. Federico Barocci, Head of a Child. Formerly London, P. & D. Colnaghi & Co. Ltd.

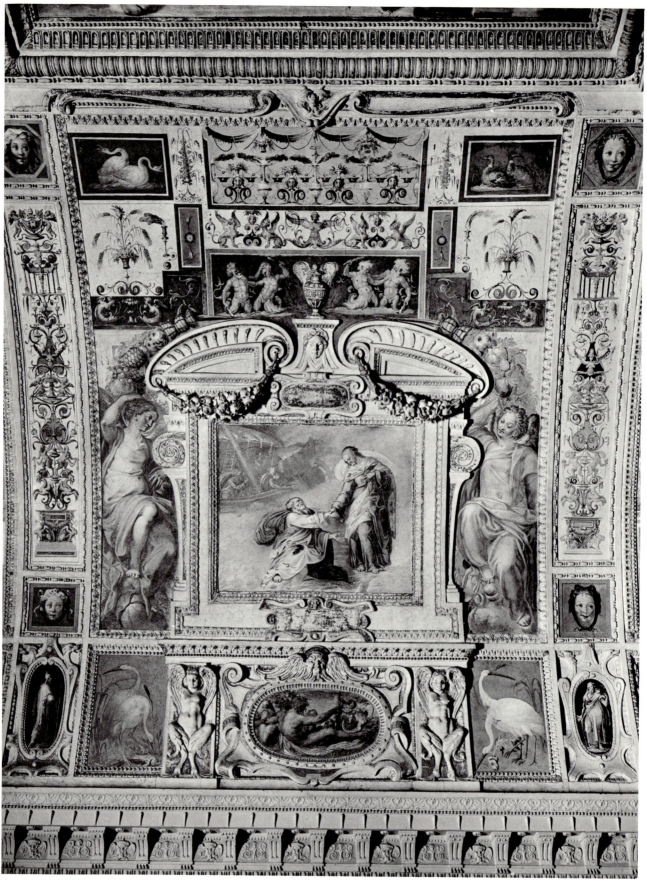

59. Pierleone Genga [?] and assistants, first room, section of cove with *Navicella*

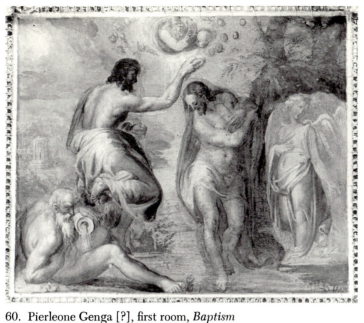

60. Pierleone Genga [?], first room, *Baptism*

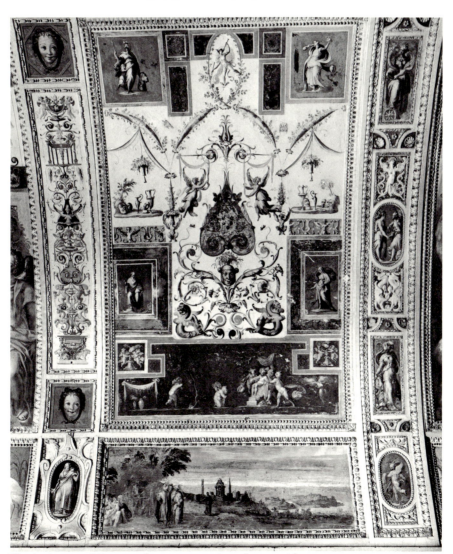

61. Assistants of Barocci, first room, section of cove with grotesques

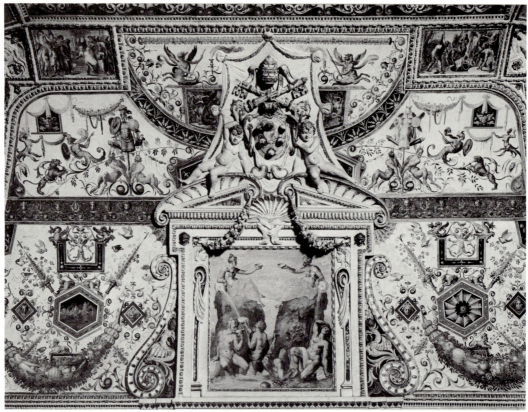

62. Assistants of Barocci, second room, southeast cove

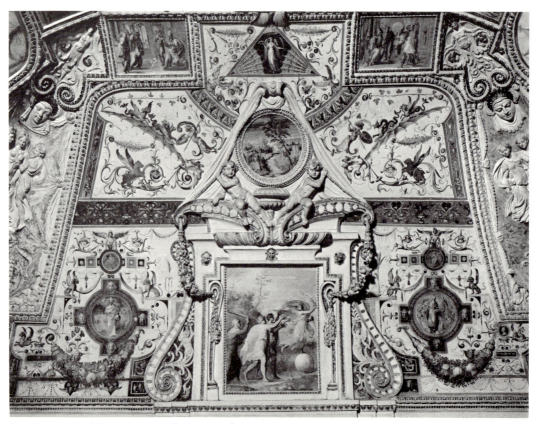

63. Assistants of Barocci, second room, northeast cove

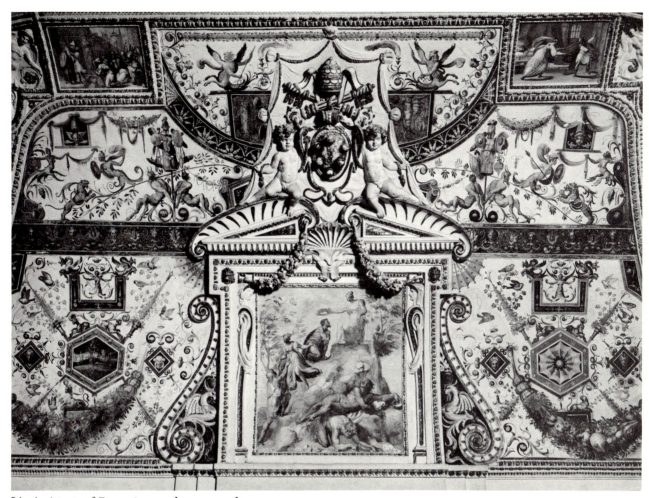

64. Assistants of Barocci, second room, northwest cove

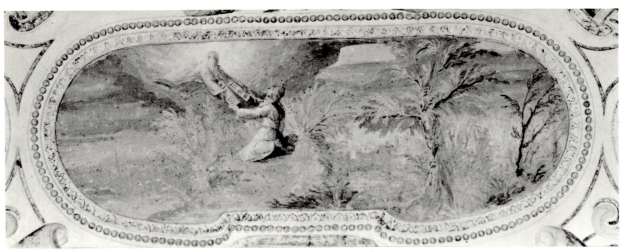

65. Assistant of Barocci, second room, *Moses Receiving the Tablets of the Law*

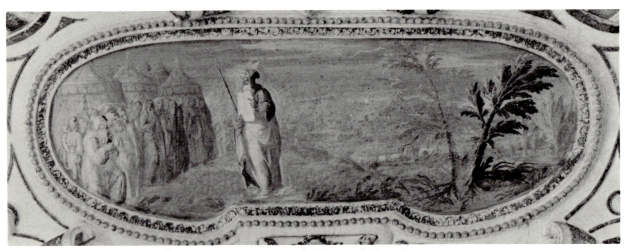

66. Assistant of Barocci, second room, *Moses Presenting the Law to the Israelites*

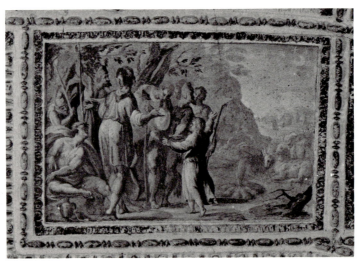

67. Assistant of Barocci, second room, *Joseph Describing his Dreams to his Brothers*

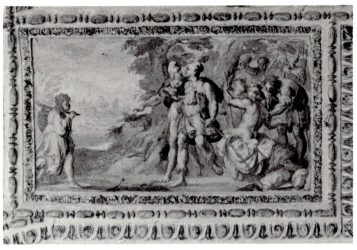

68. Assistant of Barocci, second room, *Joseph Finding his Brothers at Dothan*

69. Assistant of Barocci, second room, *Joseph and Potiphar's Wife*

70. Assistant of Barocci, second room, *Joseph's Reunion with his Brothers*

71. Federico Zuccaro, interior of loggia, Adonis scenes

73. Zuccaro and assistants, *galleria*, northwest end

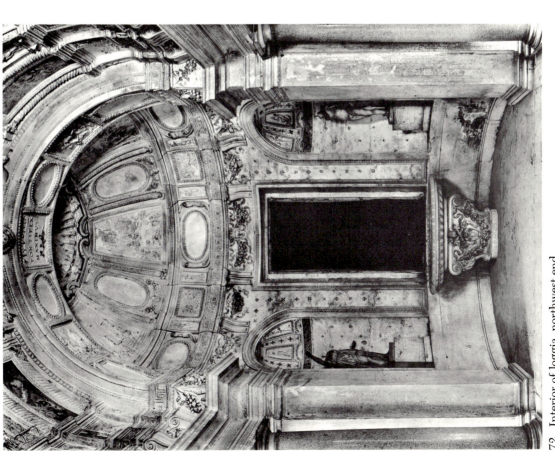

72. Interior of loggia, northwest end

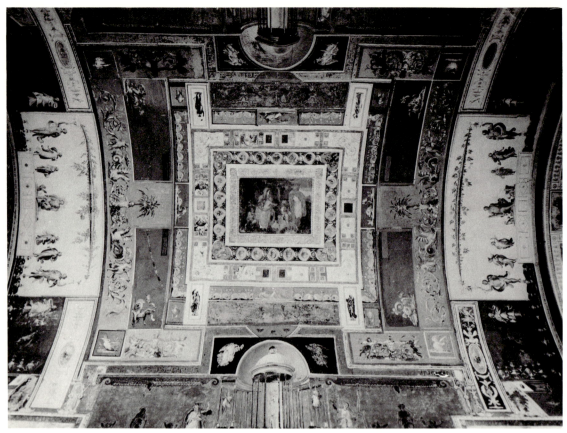

74. Zuccaro and assistants, *galleria*, general view of central section of vault

75. Assistant of Zuccaro, *galleria, John the Baptist in the Wilderness*

76. Assistant of Zuccaro, *galleria, Penitence of St. Jerome*

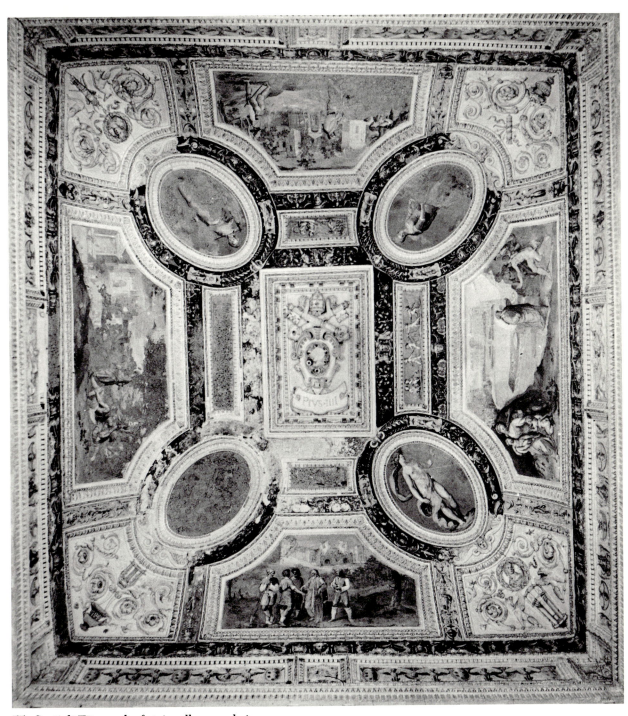

77. Santi di Tito, vault of stairwell, general view

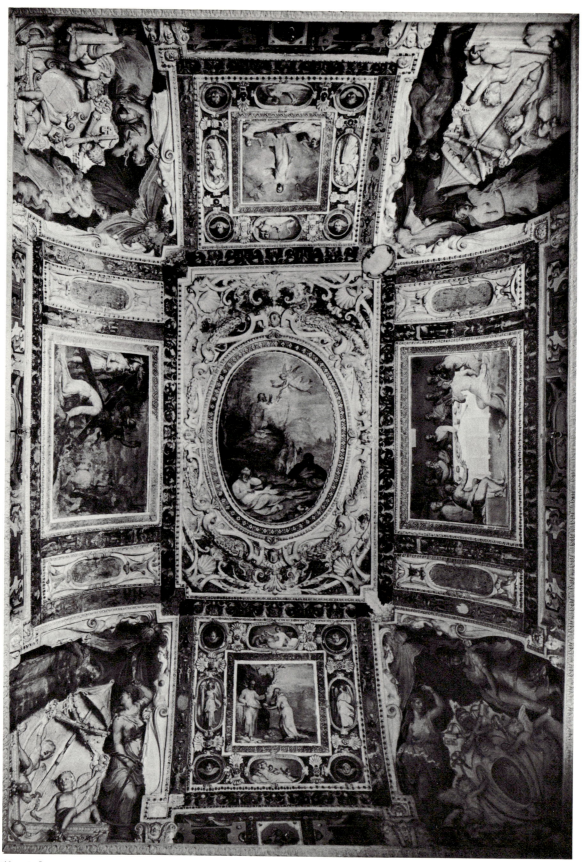

78. Federico Zuccaro and assistants, fifth room, general view of vault

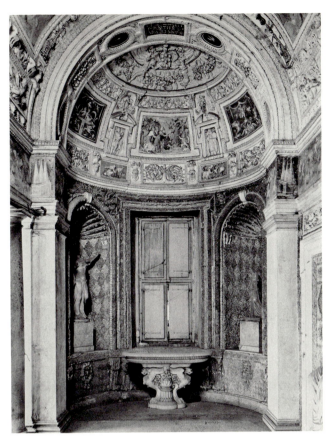

79. Assistant of Federico Zuccaro,
entrance portico, southeast end with
*Moses Striking the Rock*

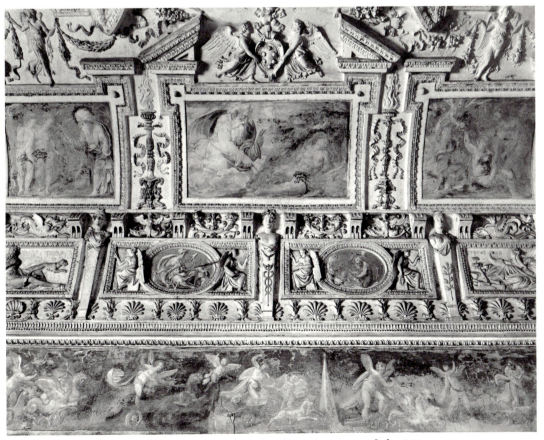

80. Assistants of Federico Zuccaro, entrance portico, Genesis scenes and chariot race

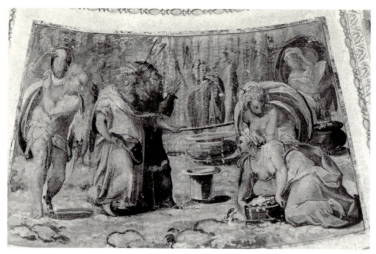

81. Assistant of Federico Zuccaro, entrance portico,
northwest end, *Gathering of Manna*

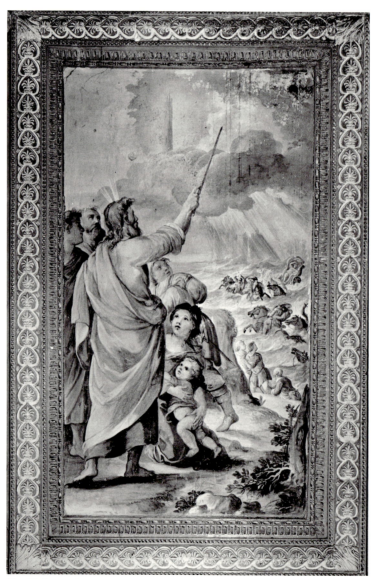

82. Federico Zuccaro, *Crossing of the Red Sea*. Vatican
City, Museo Gregoriano Etrusco

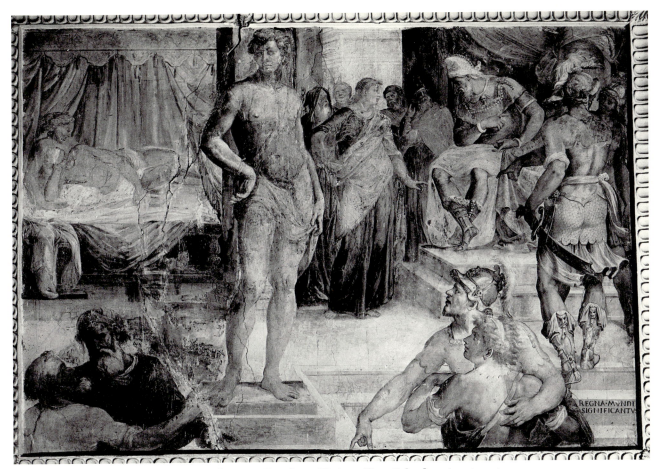

83. Niccolò Circignani, *The Dream of the Five Kingdoms*. Vatican City, Belvedere Apartments

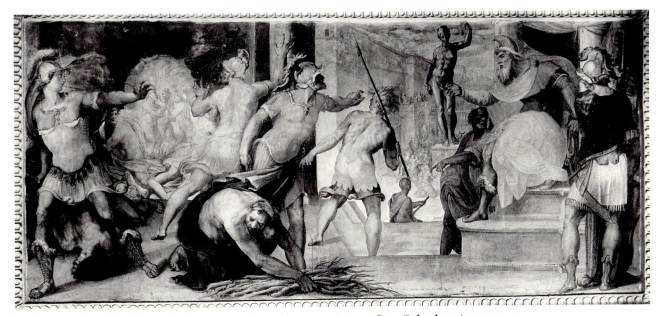

84. Santi di Tito, *The Three Hebrews in the Fiery Furnace*. Vatican City, Belvedere Apartments

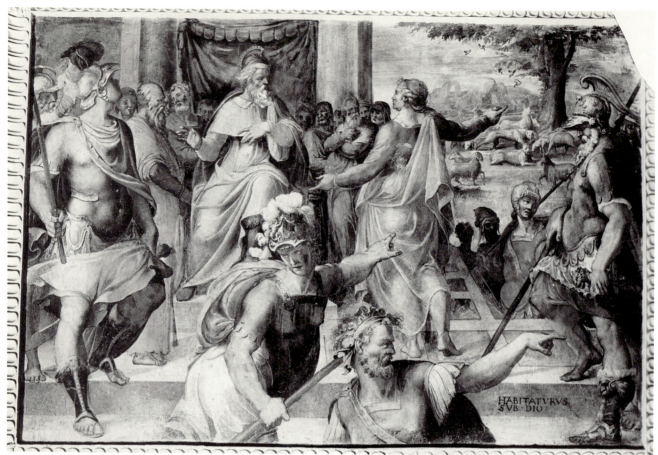

85. Niccolò Circignani, *The Interpretation of the Dream of the Great Tree*. Vatican City, Belvedere Apartments

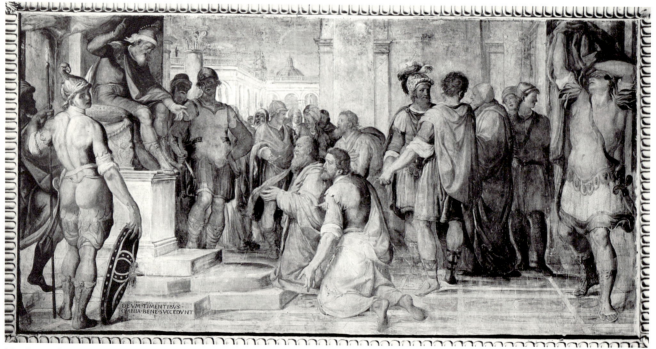

86. Santi di Tito, *Nebuchadnezzar Receiving the Homage of his People*. Vatican City, Belvedere Apartments

87. General view of the Sala Regia. Vatican City

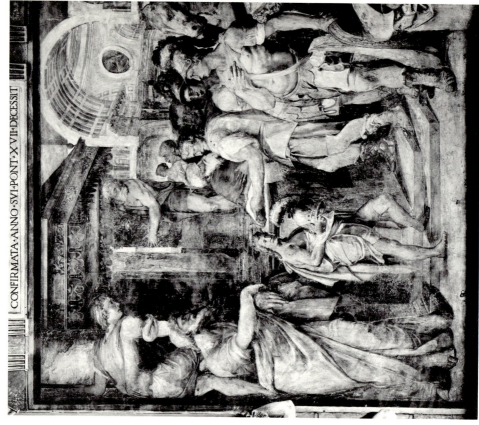

89. Giovanni Battista Fiorini, *Gregory II Receiving Liutprand's Confirmation of the Donation of Aripert*. Vatican City, Sala Regia

88. Livio Agresti, *Peter of Aragon Offering his Kingdom to Innocent III*. Vatican City, Sala Regia

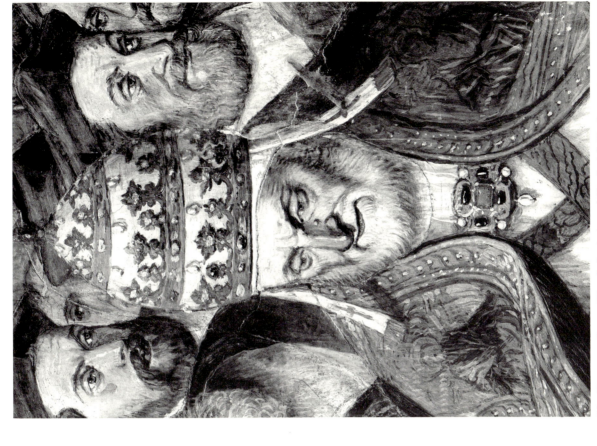

91. Giuseppe Porta, *The Submission of Frederick Barbarossa to Alexander III*, detail: Pius IV as Alexander III. Vatican City, Sala Regia

90. Girolamo Siciolante da Sermoneta, *Donation of Pepin*. Vatican City, Sala Regia